A Note From
Kathy

MORE THINGS
LIKE THIS

Will Call

Phone: _____

Date: _____

Contact: _____

Customer

Library of Congress Cataloging-in-Publication
Data available.

ISBN: 978-0-8118-6716-0

Manufactured in Hong Kong.

Designed by McSweeney's.

10 9 8 7 6 5 4 3 2 1

Chronicle Books LLC
680 Second St
San Francisco, CA 94107

www.chroniclebooks.com

UNITED STATES COURT OF APPEALS
SECOND CIRCUIT

CHAMBERS OF
JAMES L. OAKES
CIRCUIT JUDGE
BRATTLEBORO, VERMONT 05301-0696

MORE THINGS LIKE THIS

289 DRAWINGS WITH FUNNY
WORDS ALSO ON THE SAME
DRAWING

from the editors of
McSWEENEY'S

with an introduction by
MICHAEL KIMMELMAN

and a foreword by
DAVE EGGERS

CHRONICLE BOOKS
SAN FRANCISCO

WELCOME TO THE D.M.V.

FOREWORD
~~FOREWARD~~ BY

DAVE EGGERS

In early 2008 the people at apexart, a lowercase letters–only art space in New York—which by the way is a great place run by very good people—asked me to curate a show there. I said I would, if I could think of a good idea for a show. So I thought about it for a while. I started talking to other editors here at McSweeney's about it, and together we decided we wanted to see a show of a certain kind of art that, come to think of it, had no name.

The same names were mentioned again and again: David Shrigley, Raymond Pettibon, Maira Kalman, Tucker Nichols. They all shared some DNA. They all created art that included images and text and humor—a combination that has been historically quite rare in fine art, but which seemed to be on the rise. So we began collecting more examples of the form. And named or not, we had no problem finding more practitioners of the style. We found them coming from all sides—from the fine art world (Pettibon, Peter Saul), from the world of street art (Banksy) the world of comics (Paul Hornschemeier, R. Crumb, Jeffrey Brown), even from the worlds of music (David Byrne, Leonard Cohen) and theater (David Mamet). And very soon we had more than we knew what to do with. We had dozens of artists involved, and hundreds of works, and yet, still no name for what this kind of thing might be called.

There's no point in dragging out the suspense— we still have no name for it. Thus the book is called simply *More Things Like This*, a play on the title of the show that we mounted in New York at apexart, which was called *Lots of Things Like This*.

At the apexart show "Lots of Things Like This," Nedko Solakov's work was exhibited, in part, via massage table. Gallery visitors were invited to lie face down on the massage table—one person at a time—and peer through the hole in the headrest at a Solakov drawing. This drawing is reproduced on page 160. Another photo from the apexart show appears on page 6.

Now, to clarify what we've collected and why:

We're interested here in the intersection of a bunch of different forms, given the work herein falls somewhere between doodles and cartoons, fine art and comics, sketchbook art and narrative painting, illustration and gag-writing. And though experiments with this kind of thing had been happening for epochs, we find ourselves at a unique moment where this kind of thing—we really tried to come up with a name; it would have made an introduction like this much easier—has found new acceptance in the galleries and even museums of the world.

How did this happen? A bunch of developments factored in. In the '90s there were interesting things happening in the parallel worlds of cartooning, fine art, and illustration. Art Speigelman had brought new attention and distinction to the comics form, with *Maus* and his magazine, *Raw* (co-edited with Francoise Mouly). He was accompanied into the light of mainstream recognition by Robert Crumb, Gary Panter, Daniel Clowes, and many other comics artists whose sensibilities were refined, whose work had real weight and a particularlity of style that owed more to fine art than it did commercial art.

At the same time that comics were being taken more seriously, and were indeed inching toward museum and gallery respectability, the art world was itself sending tendrils out toward comics. And the main such tendril was a man (not a tendril) named

Raymond Pettibon. Pettibon might very well be the man who, straddling the two worlds more so than any artist before him, connected the two forms. I remember the first time I saw a major Pettibon exhibit, at the Berkeley Art Museum, in the early '90s. I was knocked flat.

It had a basis in comics, but also owed a great deal to, say, the sketchbooks of the old masters. It was as if you'd opened Rembrandt's sketchbook (it had that looseness), added text—from offhand gags to literary quotations and allusions—and presented the work within a simple, unaffected way.

After Pettibon, it became increasingly difficult to draw the line between fine art and comics. It seemed arbitrary, even, how one artist would show his work in galleries, and another, working in a very similar way, would xerox his work, staple it, and call it a zine. For example, about ten years

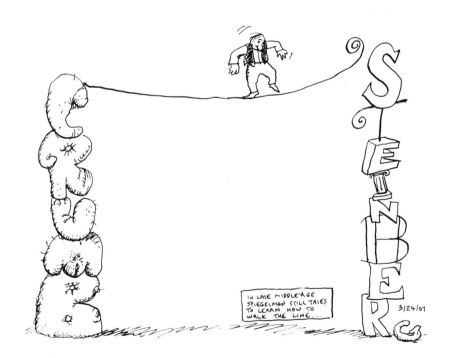

ART SPIEGELMAN, *Sketchbook drawings*, 2007, ink on paper, 5.13 × 8.13"

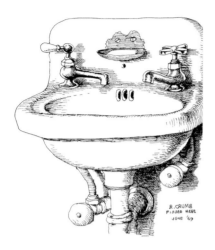

Drawing of a
HOLY SINK

R. CRUMB, *Holy Sink*, 1969, ink on paper

DRAW MORE
YOU ASSHOLE

CHRIS WARE, *Sketchbook drawing*, 1999, ink on paper, 2.33 × 2.5"

ago I discovered the work of David Shrigley, and knew that he had had shows in galleries and had been accepted in at least some portions of the art world. At the same time there was Quenton Miller, who was doing work that in many ways was similar—it was odd, funny, crudely drawn—but his work was seen in handmade chapbooks, not on gallery walls, and it was unclear whether he intended his work for magazines or museums.

So I was following these developments, and asking these questions, when apexart called. Jesse Nathan came on board and right away we decided to set some pretty strict, if strange, guidelines. Because there was a vast world of art that used text—from Bruce Nauman to Barbara Kruger to Roy Lichtenstein— we knew we needed to narrow it down to work that a) was narrative in purpose, that is, the text describes or addresses the image itself; b) is handwritten (ideally), so that it's incorporated into the work itself (as opposed to being a title or caption); and c) that the image and text together result in something funny.

Humor was key. Humor was a primary component of the whole enterprise. In fact, the formula that Jesse and I set up early on was this:

IMAGE

+ TEXT (*usually referring to the image*)

+ HUMOR

———————————————

= GOOD ENOUGH FOR US

Humor was crucial, because worse than narrative art, according to the stodgier edge of the fine-art establishment, is art with a sense of humor. And the humor part of the equation pushed it even further toward comics, and toward that uncharted territory shared by the gallery-artist Pettibon, the stapled-together-self-publisher Quenton Miller, the author-illustrators Kalman and Shel Silverstein, sometime-sketchbookers Chris Ware and Jeffrey Brown, and other-media-specialists/dabblers like Byrne and Cohen and John Lurie.

It made sense, of course, that people from the world of words and the world of images would converge on this highly democratic hybrid genre. The images in this book come from similarly disparate origins of creation. Sometimes an artist might create an image and add offhandedly funny text, maybe in an effort to deflate the seriousness of the notion of fine art. Often the image

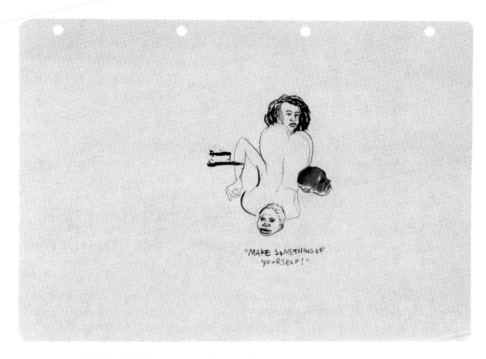

KARA WALKER, *Do You Like Creme in Your Coffee and Chocolate in Your Milk?*, 1997, watercolor, colored pencil, and graphite on paper, 11.63 × 8.19"

is simply an illustration accompanying a good caption. And just as often, it's clear that the art and words were conceived together. For no good reason at all, I've included a few of my forays into the style, which I've been doing since I was in high school. These two, on the next page, show one

way of going about the process. For the masturbating-man drawing, I first found a photo, from the 1930s, of a butler. I drew a version of the man, but couldn't get his hands right. Being surrounded by paper-fragments, I grabbed one, and taped it over the poorly-drawn hands. Then, because it

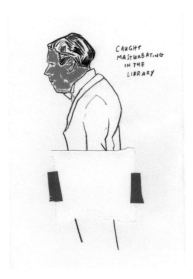

DAVE EGGERS, *Caught Masturbating in the Library*,
2009, mixed media on paper, 10 × 16"

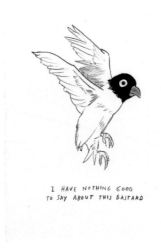

DAVE EGGERS, *I Have Nothing Good to Say About This Bastard*,
2009, oil pastel on paper, 10 × 16"

looked like the man was hiding something under
the paper, I wrote the caption: "Caught mastur-
bating in the library"—partly because the man
looked like a friend of mine, who I'm sure someday
will be caught doing just that. The second image,
of the bird, was similarly executed, in that I did
a drawing just because I saw an interesting parrot
picture, and then, because the bird looked too nice,
I suppose, I wanted to deface it somehow. Thus
the caption.

In both cases, making the work was deeply
pleasurable, and even a bit anarchic. Just as
Duchamp's *L.H.O.O.Q.* was a sendup of the hallowed
Mona Lisa, so the addition of text, and funny text
especially, is an attempt to have fun in a world—
the art world—that is too often no fun at all.
And so in this book we find some very serious
artists, like Goya or the brilliant Kara Walker, playing
fast and loose with text. And given how many artists
from all media dabble in this form, it's self-evident
how therapeutic and liberating the practice is.
Why they converge in these cartoons-cum-image/text
experiments is anyone's guess, and being loath to
draw conclusions about the artists' motivations
or methods—because so many of these people
are dead—I'm instead going to list some
questions that occurred to us and might occur
to you and might help the show blow your mind
completely:

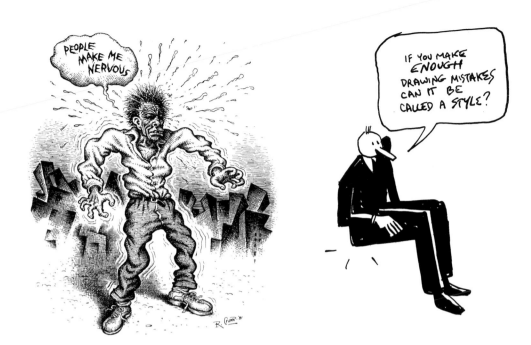

• Why is it that so many of these artists can't spell? And why is it that when they screw up a word, instead of starting over, they just cross the word out and write it again?

• Does it seem, sometimes, that the artist is defacing his or her own work by adding the text? That's partly why we included the Duchamp/ *Mona Lisa* experiment and the Goya—in both cases, the words are a lighthearted comment on a finished image. Sorry; that's not really a question. Moving on:

• Why is it important to some of the artists that the drawings appear casual, even sloppy? Is the loose draftsmanship part of their appeal, in that they seem more intimate and disarming? Is absurdity more appealing when it comes across as humble?

• What is the line between a doodle, a cartoon, a gag, a work of fine art, and will there ever be a time when someone doesn't insist on writing this sort of silly and rhetorical sentence in an art catalog?

• Are you bummed you didn't get to see the whole show (if you didn't)? It was almost as good as this book, and had a massage table and wine.

FUNNY WONT GET US TO THE MOON

ELECT
BONNIE PARNELL
ASSEMBLY DISTRICT 40

INTRODUCTION BY
MICHAEL KIMMELMAN

YOUR VOTE COUNTS

Pd. for by Comm. to Elect Bonnie Parnell

© 1999 DJR

Dave Eggers makes a good point in this book. The "stodgier edge of the fine-art establishment," as he calls it, has historically frowned on mixing narrative and funny. All those crucifixions and martyrs getting roasted on the grill or punctured with arrows certainly weren't meant to be funny, even if two breasts served like a pair of Floating Islands on a dessert platter in a brightly colored Italian fresco can look perversely comic.

When modernism came along, and people started laughing at all-white paintings, and at bunches of scribbles and geometric shapes, the art world insisted only more vehemently that it was perfectly serious. Art galleries became as intimidating and judgmental as confessionals. Newspaper comic strips and other populist expressions of visual lightheartedness fell below the radar of serious consideration. Of course this didn't prevent fine artists like Roy Lichtenstein from pilfering the funny pages, but always while looking down on their sources, like those two boys with scrawny arms and legs and bowling-ball-sized heads in a drawing here by Jeffrey Brown. The boys gaze at a decapitated playmate. Their eyes are big o's, the dead boy's, x's, a tic-tac-toe of cartoon semiotics whose punch line ("Mom is going to be pissed") depends on the image, and vice-versa, as they should.

I mention Lichtenstein because one day when we walked through the Metropolitan Museum of Art he took pains to tell me that a certain Renaissance tapestry he stopped to admire, a work composed of panels with texts just like in a comic book, did not intrigue him for that reason—God forbid, only a goofball would

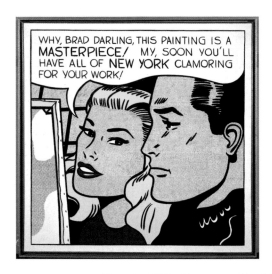

ROY LICHTENSTEIN, *Masterpiece*, 1962, oil on canvas, 54 × 54"

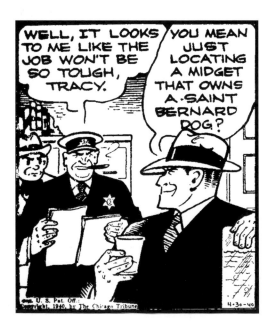

CHESTER GOULD, panel from *Dick Tracy*, 1940

think so, his look of contempt at the suggestion implied. No, he liked it, he said, because different fields of primary color were contained within outlines, or some such explanation of local color. Lichtenstein was a quiet man with a sly sense of humor, but he wasn't kidding. Nor, in general, was his art, whose intended audience was always the fine-art establishment. How he talked about that tapestry now brings to mind the 1969 drawing in this book by Saul Steinberg showing an army of ZZ Tops wearing cowboy hats and dark glasses, marching in lockstep past the National Academy of the Avant-Garde.

Some funny artists, like Yves Klein and the Fluxus gang that revolved around George Maciunas, became princes in the art world, where Duchamp remains king, never mind if, comedically speaking, the air is pretty thin up there where he operates. But a more bumptious provocateur like Peter Saul has only grudgingly been accepted in the manner one accepts a crotchety, conspiracy-theory-obsessed uncle at Thanksgiving who farts and knocks over the fancy china. Saul long ago found a way to redeem toothless surrealism by combining it with *Mad* magazine to produce pictures whose bad taste, hard though it tries, can't entirely disguise an eye-pleasing technique. You will find herein a picture of Fidel Castro wiping his ass with a $5 bill. "I wipe my typhoid infected ass with dollars then my agents spend the money in Miami restaurants, no kidding," reads the bubble

quote, and while the combo of text and image pulls no punches, it's still possible to notice how well El Presidente's head is drawn.

Speaking of *Mad*, comic artists weaned on it clearly influenced a generation or two of youngsters who have since come of age and effectively forced the establishment's hand, so that just the other day, in fact, the Louvre in France announced it was organizing a show about comics. Finally it seems we're all free, in case we didn't already feel so, to look at everything without fretting about status, the art's or ours.

And this has opened many eyes to what was often just lying there on the kitchen table, in plain sight. I'm talking about those same funny pages, like the old *Dick Tracy* strips, the ones in which the aged Chester Gould, who invented Tracy, went kind of gaga and launched his hard-boiled hero into outer space to fight bad guys on the moon in a rocket-powered garbage can. Or the classic *Peanuts* cartoons, for which Charles Schulz invented a kind of graphic minimalism that improbably dovetailed with art-world minimalism. Other comic geniuses like Winsor McCay, George Herriman, Harvey Kurtzman, and Jack Kirby didn't ask the art world to ratify their worth, because they didn't need it, and underground stars like R. Crumb and Art Spiegelman, in any case, viewed the establishment with outspoken and not unjustified contempt and so, for a long time, actively rejected its entreaties after it finally came around to recognizing their talents. They got the last laugh.

These comic artists are behind much of what you'll find here, which is a sampler of smart and smart-ass pictures, in the tradition of all those nerdy kids who drew endlessly in their rooms when other kids wouldn't play with them, dreaming about someday telling the world, "I told you so."

Well, that day has come.

GEORGE HERRIMAN, *Untitled*, ca. 1920, ink on paper

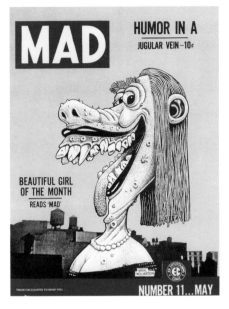

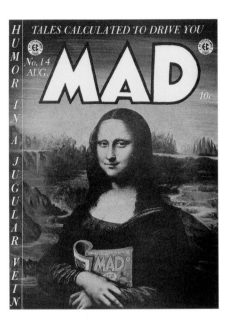

MAD MAGAZINE, founded 1952; issue 11 cover by Harvey Kurtzman (writing) and Basil Wolverton (art); issue 13 cover by Harvey Kurtzman; issue 14 cover by Harvey Kurtzman, with Leonardo da Vinci

Raymond Pettibon is now a darling of the art world. A rumpled 50-ish fellow with the pasty, hangdog expression of a man nursing a perpetual hangover, he was raised in the surfing hamlet of Hermosa Beach, California, and until recently still lived with his mother on a street of bungalows in a tumbledown split-level designed by his father, a frustrated artist and writer, who stuffed every inch of the house, Collyer-brothers-style, with thousands upon thousands of dog-eared paperbacks, back issues of *Show* and *Detective Story Monthly*, old *Playboy* magazines, his own thrift-store-like paintings of pinups, back issues of *American Heritage* and *Crimes and Punishment*, horror and classic comics, not to mention bags of moldering sporting goods and broken gadgets, all of which became fodder for Raymond's art.

His drawings bear deadpan or incantatory texts culled from Mickey Spillane, Walter Pater, St. Augustine, or wherever. When he comes across a line that strikes his fancy, Raymond clips it and stuffs the clipping into one of various messy manila folders, which he'll

mix and match with pictures he has also accumulated. A man in a skull cap with his back turned to us, leather collar up, stands before a full moon facing a skyline. "A Certain Donald Trump," is written above the image, with "the first real gentleman I'd met in years," below. Like everything Pettibon does, it skirts specific meaning to find the mercurial edge of clear thought, where poetry tends to happen. In another drawing, of a chimp in silhouette with a cigarette dangling from his mouth, Pettibon includes the line: "The monkeys have the bomb—they will use it." Even as you

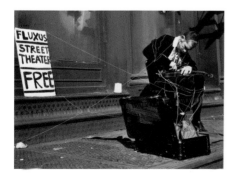

FLUXUS, Ben Vautier performing on Canal Street, New York, May 23, 1964.

grasp the humor, you also wonder if you haven't heard that line before, in the way that all of Pettibon's work seems to rummage through the attic of our memory, naggingly.

The noodling manner in which he draws, like so many works by other artists here, is deceptive. It's now a virtual house style in art schools, shorthand for immediacy, humility, and crafty craft. Tucker Nichols's *Almost Canadian*, for example, consists of a single imperfect line, a one-liner, cunningly drawn just above those two words to imply a border, with the rest of the page left blank as if to imply a vast, snowy, Great White North. The emptiness also acts like a pregnant pause in the manner of the classic "your money or your life" routine by Jack Benny, the old master of stand up.

Quenton Miller's *Skier* operates according to roughly the same principal. "Pro skier distracted by a fallen log that looks like his ex-wife" partners a chicken scrawl

of a twisted stick figure on skis with what, frankly, doesn't really much resemble a log or an ex-wife. Which is the joke. The work looks as if your six-year-old drew it, in the tradition of so much cunning, childlike modern art. Combined with "ex-wife," this produces the desired comic dissonance.

I'm suddenly sounding like my late aunt Molly, the psychoanalyst, who when I was ten overheard me joking with my beloved piano teacher about his age and launched into a lecture about the Oedipal complex. Were she to have seen Shel Silverstein's drawing in this book of a woman with the world's longest nose, no doubt she'd have diagnosed acrofacial dysostosis. She wouldn't have noticed that the face resembles a Calloway driver.

Then again, that drawing, like all true comic art, is open to interpretation. That's the funny thing about art.

Michael Kimmelman is chief art critic for the New York Times.

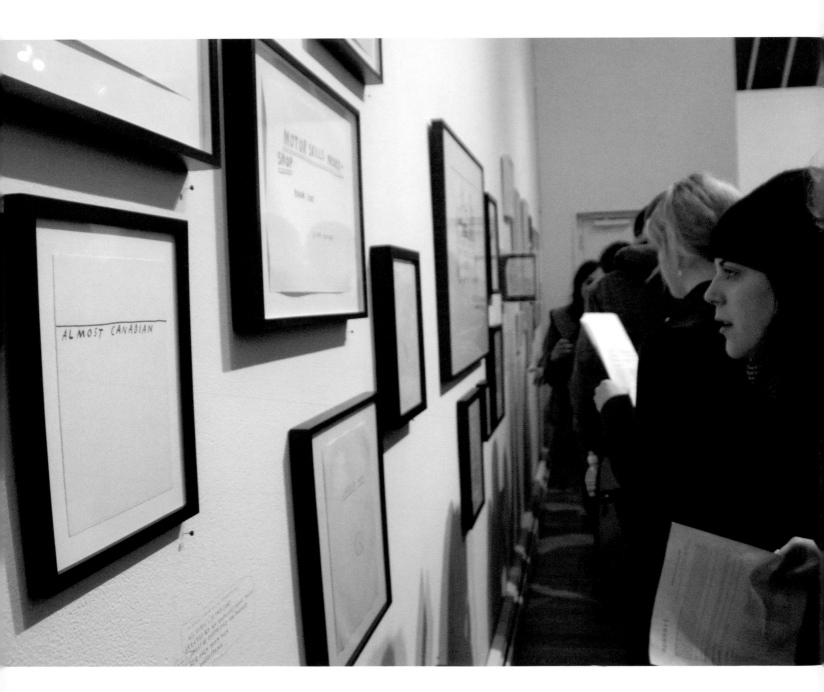

HOW IT CAME TO THIS

BY JESSE NATHAN

When Dave Eggers started the process of curating the show at apexart, he called me into the operation. I'd just finished an internship at McSweeney's and Dave knew of my interest in fine art and poetry, and so around Halloween a couple years ago, he hired me to help him put together the exhibit.

He had about ten people he knew he wanted in the show—Pettibon, Shrigley, Kalman, Nichols, Mamet, and Byrne among them—and after giving me that list, he basically said, "Go forth and find anyone else who might fit this category."

It was like I'd put on some fantastic pair of goggles. I was seeing the form—image plus hand-written text plus humor—everywhere. I hit up Printed Matter in New York and the Walker Art Center in Minneapolis. I checked out a bad airport exhibit in Phoenix and a string of badass shows on Valencia Street in San Francisco. I sifted through maze-like websites and old British publications and out-of-print monographs on obscure painters. I lusted after artists' sketchbooks. The hunt for the secret doodlings of legendary men and women was in full swing. FedExes came in from Bulgaria, Nashville, and Scotland. I took calls from Long Island, Germany, and Amsterdam. I mailed inquiries to the reclusive executors of artists' estates.

And just about every artist we found led us to another.

When Tucker Nichols, for instance, dropped off drawings for the book one afternoon months ago, he mentioned the work of Porous Walker. Told me it was crazy stuff, and very funny, and that I just had to see it to understand. I emailed Porous. The next day I had a sheaf of obscene, and obscenely funny, drawings from him. Similarly, I paid Jack Hanley a visit at his gallery (a charmingly understated hole-in-the-wall) on Valencia. He'd had a Pettibon show years ago and I wanted a copy of the poster. I got the poster, and I also stumbled into an exhibit by former

MARCEL DUCHAMP, *L.H.O.O.Q.* (*"There is Fire Down Below"*), 1919, pencil on color reproduction, 24.2 × 19.5"
In a 1966 interview Duchamp said of this painting: "I really like this kind of game, because I find that you can do a lot of them. By simply reading the letters in French, even in any language, some astonishing things happen." When read rapidly in French, "L.H.O.O.Q." sounds like "She has a hot ass." A few years before he died, Duchamp offered a looser translation of L.H.O.O.Q.: "There is fire down below."

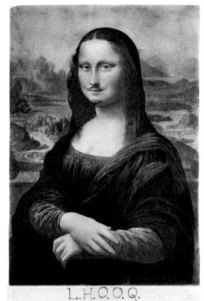

SALVADOR DALÍ, *Picasso* (*"Picasso is communist and neither am I"*), 1970, charcoal drawing
Dalí admired Picasso. The source of this drawing is a lecture Dalí gave in Madrid in 1951 in which he said: "Picasso is Spanish, so am I. Picasso is a genius, so am I. Picasso is a communist, neither am I."

GEORGES BRAQUE, *Untitled* (*"I laugh marvelously with you. That is my unique good fortune"*), 1963, seven-color lithograph from *Letter Amorosa*
For Braque, and for many of the artists included in this book, work containing funny texts are at the fringe of the oeuvre. In the Braque book where we found this image, it was the only word-inclusive work.

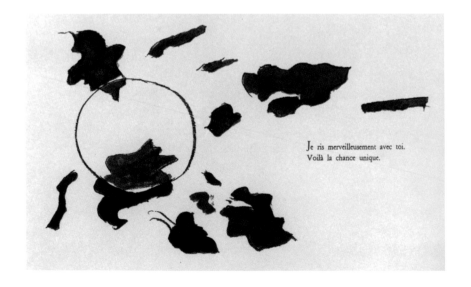

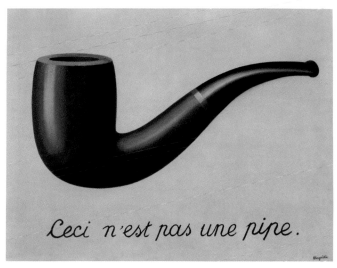

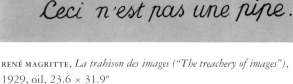

RENÉ MAGRITTE, *La trahison des images ("The treachery of images")*, 1929, oil, 23.6 × 31.9"

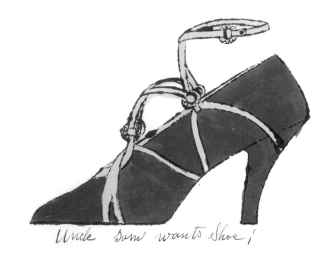

ANDY WARHOL, *Untitled*, 1955, hand-colored print, 9.25 × 13.5"

San Franciscan Chris Johanson— all dumpster-dived wood, portraits drawn on crinkly brown paper, and a brilliant unreality of colors in his paintings. Johanson's work also had text in it, and it was funny, and Jack helped me get in touch with Johanson.

Nichols, who lives near San Francisco, and Quenton Miller, who lives in Australia, independently suggested I look at the work of the doodling Zen master Gibbon Sengai. Sengai worked in the early 1800s. At the same time on the other side of the globe, Francisco Goya was crafting "Disasters of War" and "Los Caprichos," collections of snappy, satirical drawings that inspired the contemporary artist who told me to look at them, Enrique Chagoya. As I trawled history, I met famous examples of the form by Marcel Duchamp (his *Mona Lisa* spoof) and René Magritte (his not-pipe). Less famous were the funny, text-filled drawings by Salvador Dalí I found while researching a poem I'd been making about the Spaniard. I found drawings of shoes by Andy Warhol in a book I pulled off the dusty shelves of a mostly empty mansion in the Hollywood Hills owned by my recently deceased

JEAN-MICHEL BASQUIAT, *Untitled drawings*, 1981, ink, crayon, and acrylic on paper, each 30 × 22"
Most of Basquiat's work incorporates hand-scrawled text. though it's often stinging and philosophical. rather than funny.

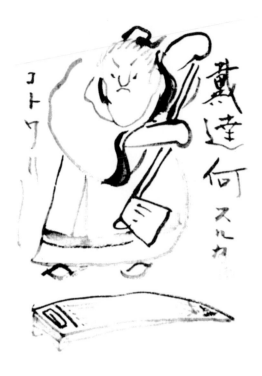

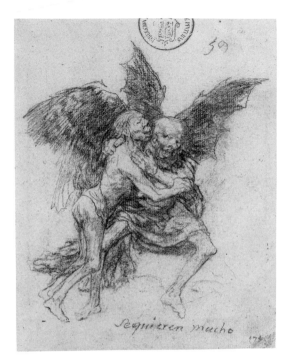

great uncle. At the beginning of his career, I read, Warhol drew shoe advertisements for a living. Turns out he also made some for kicks. It was thrilling, too, to find that contemporary artists working in fields like music were making funny word art also. I had no idea, for instance, that singer songwriter Leonard Cohen drew or that musician John Lurie painted.

Fine art cartoonists like William Steig, Saul Steinberg, and Edward Gorey—themselves stepping often on the shoulders of people like Goya and George Cruikshank—made me think, oddly, of Shel Silverstein, a cartoonist and children's poet rarely accused of being a fine artist. I was writing an article on Silverstein's early career and

I'd just interviewed Hugh Hefner, who first published Silverstein's work. Hefner said Silverstein was constantly cranking out doodles. On a hunch I asked Mitch Myers, Silverstein's nephew and the keeper of the Silverstein archive, if I could take a look at any unpublished artwork Silverstein might have left behind. He said sure—and then

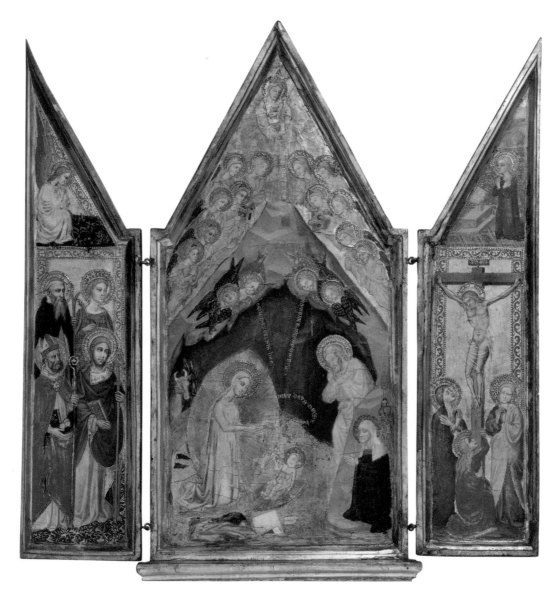

NICCOLO DI TOMMASO, *Triptych: Saint Bridget's Vision of the Nativity*, 1377, tempera and tooled gold on panel with vertical grain, 21.38 × 25 × 1.63"

The words emanating from God read: "This is my beloved son." From the seraphs on the left come the words, "Glory to God in the highest." The seraphs on the right speak the words, "And on earth peace to men of good will." Mary says, "Come my God, my Lord, my Son." Except for the Virgin's line, these are quotes from the biblical book of Luke.

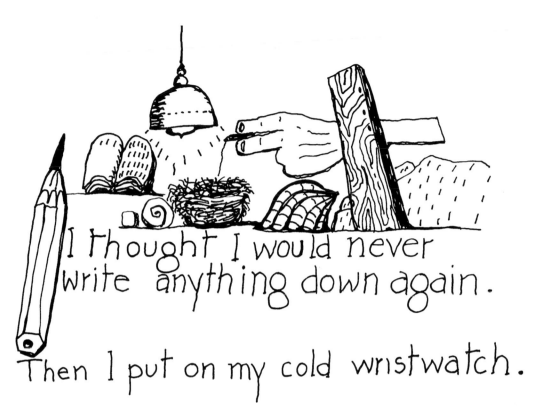

I thought I would never write anything down again.

Then I put on my cold wristwatch.

PHILIP GUSTON & MUSA MCKIM GUSTON,
I Thought I Would Never, 1975,
ink on paper, 19.125 × 24"

he put me up for a couple nights and drove me to the archive, a tidy top-floor of a warehouse in Chicago. The archive, complete with a kitchen and a stereo system, was filled wall-to-wall with Silverstein's books, records, videos, notes, photographs, and a cache of unpublished sketches and doodles. Many of these drawings, I soon discovered, were single-panel cartoons in the vein of Steig and Steinberg. In other words, perfect for our purposes. To my delight, Myers was happy to help us bring a couple of these drawings to light.

Chicago was fruitful in other ways. There was the Quimby's find. On my way to the airport after digging around in the Silverstein archive, I was perusing that bookstore's self-published rack. I fished out a collection of a dozen or so drawings by a Mr. Luis Campos called *My Nothing*. The drawings cracked me up, but when I tried Campos's e-mail, listed on the back of the book, I got an error message: it had

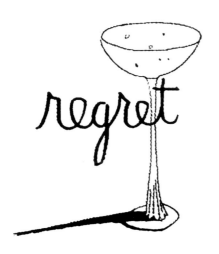

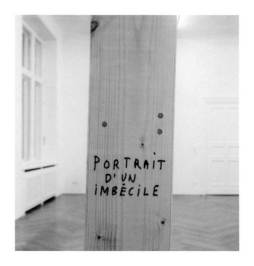

MAN RAY, *Regret* and *Bothered,* date unknown, ink on paper
During our interview with Leanne Shapton, she told us she'd had a series of Man Ray drawings taped to
her wall for years. "They achieve a perfect floating point between reading and looking," she said.

HENRIK OLESEN, *Portrait d'un imbécile (10)*, 2008,
wooden laths and felt pen, 12.7' × 3.7" × 2.2"

bounced. I scratched my head. The book's short bio said Campos was a construction worker in Asheville, North Carolina. I paid a detective service to compile and send me all the phone numbers (listed and otherwise) for "Campos" within a thirty-mile radius of Asheville. I called them, one by one, the Sunday before Thanksgiving. Some were disconnected, some led to strange automated messages, and one connected me with a jolly bank teller in suburban North Carolina. No dice. After Thanksgiving, I called Quimby's. They thought they might have, buried somewhere, a different e-mail for Campos. They promised to pass along my urgent message if they did. I'd barely put down the phone when it rang. It was Luis calling from Asheville. One of the messages I'd left on one of the machines had found its way to the man behind *My Nothing*. He was astounded I'd found him, and so was I. Luis and I talked for five minutes. Half an hour later he sent me high-resolution scans of his drawings.

On top of this, there was the marvelous happenstance of finding Amy Jean Porter. One day I was phoning the Yale University Art Gallery. They'd done a show

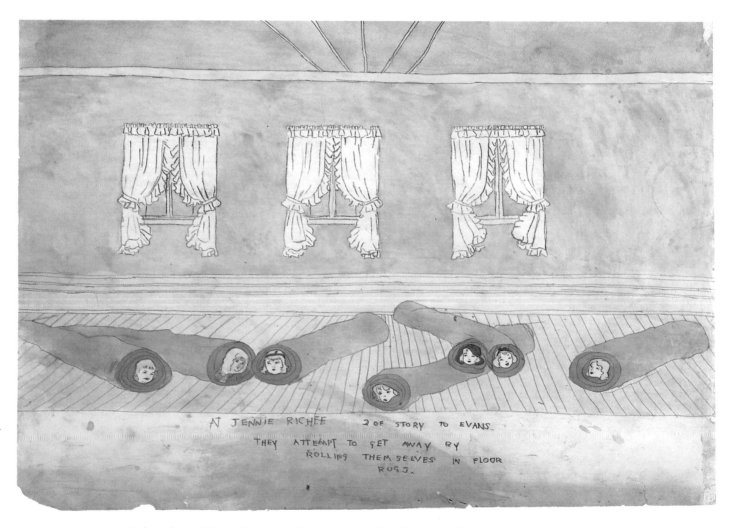

HENRY DARGER, *At Jennie Richee 2 of Story To Evans They Attempt To Get Away By Rolling Themselves In Floor Rugs*, date unknown, carbon tracing, pencil and watercolor on paper, 19 × 24"

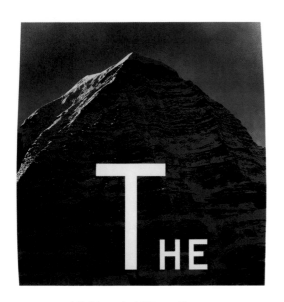

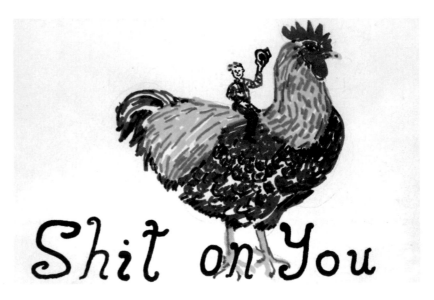

ED RUSCHA, *The Mountain*, 1998, acrylic on shaped canvas, 76 × 72"

RON PADGETT & GEORGE SCHNEEMAN, *Shit on You*, early 1970s, ink on illustration board, 3.75 × 6"

of canonical drawings by artists like Guercino and Degas, and I wanted to check out the catalog. A woman answered the phone, and when I told her about the exhibit I was working on (in order to score a catalog), she mentioned that her name was Amy Jean Porter, and that she might have a drawing or two herself that fit. She did. And she had another, and another, and she filled my inbox

with them. The Yale exhibit, by the way, had great drawings, too, and one or two with text, but none that were funny.

Which brings me to an important note. I came across lots of work that *almost* fit our three standards. Work that had images and words, for instance, but wasn't funny. History is littered with examples. There were the tempera paintings of

Niccolo di Tommaso that Dave saw in Florence. Words spill in a straight line from the mouths of people and deities, almost like cartoon talk-bubbles. Apparently for a brief period in Florence in the late 1300s, Renaissance painters like di Tommaso made words visible in their art when painting the annunciation—the moment the angels bring Mary the news of whose son she's bearing.

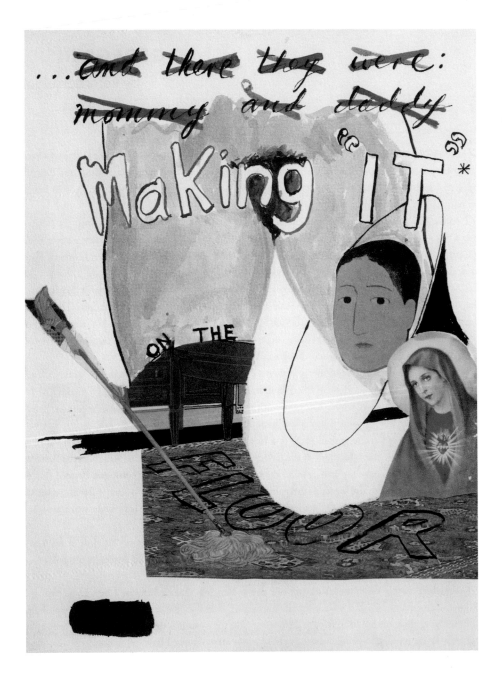

GEORGE SCHNEEMAN & PETER SCHJELDAHL,
Making "It," 1968 or 1969, mixed media on
paper, 12 × 9"
*The work George Schneeman made with poets is filled
with light-hearted text. A year before he died in
January 2009, I spoke to Schneeman on the phone,
and later talked at length with Ron Padgett about
the experience of collaborating with Schneeman.
I asked, "So George just calls you up sometimes
and says, 'Hi, Ron, you wanna come over and make
some things?'" Ron replied, "Every once in a while
George will say to me, 'Let's do some collaborations,'
and I answer, 'How about Saturday?'" So then
I asked Ron, "What do you guys say to yourselves
when you're finished?" "Time for lunch," said Ron.*

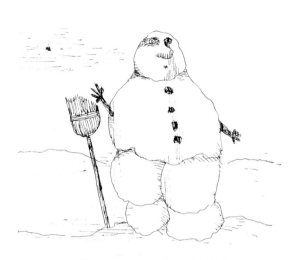

The snowman realizes who he is

WILLIAM STEIG, *The snowman...*, date unknown, ink on paper

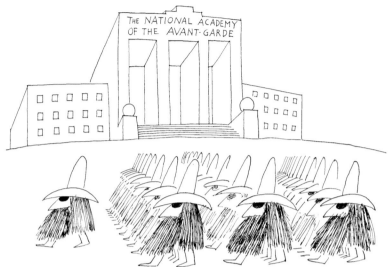

SAUL STEINBERG, *The National Academy of the Avant-Garde*, 1969, ink on paper

A couple hundred years later in France, Jacques Callot began experimenting with captions on prints. But his captions are usually earnest observations or frank statements. Sometimes they're satirical, but they're never outright funny. (Francisco Goya, by the way, was among those influenced by Callot.) Meanwhile, I looked at the stunning but not outright-funny word art of Jenny Holzer and Bruce Nauman. And there was art that came even closer to fitting, almost-funny works by Philip Guston, Man Ray, Jean-Michel Basquiat, Henrik Olesen, Henry Darger, and Ed Ruscha, among others.

And then finally, after months of gathering and selecting, there was the show in New York.

The night before it opened I was riding in a taxi, heading back to Chelsea from a cousin's place in Newark. The driver was a hard man who spewed hate and anxiety with every story-from-the-streets-of-Newark he told. I got to talking about the show. He seemed interested, so I went on. I finished explaining and trailed off. Silence. The driver rolled down his window and spat. It was 3 a.m. "I like art," he said, face forward, voice casual. "It relaxes me."

Jesse Nathan is a writer, editor at McSweeney's Publishing, and the managing editor of this book.

ACTUAL
THINGS
LIKE
THIS

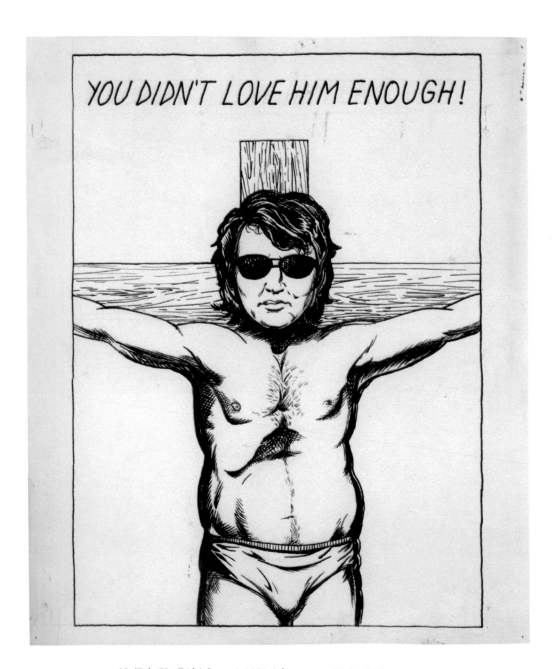

RAYMOND PETTIBON, *No Title (You Didn't Love...)*, 1981, ink on paper, 10.5 × 8.5"

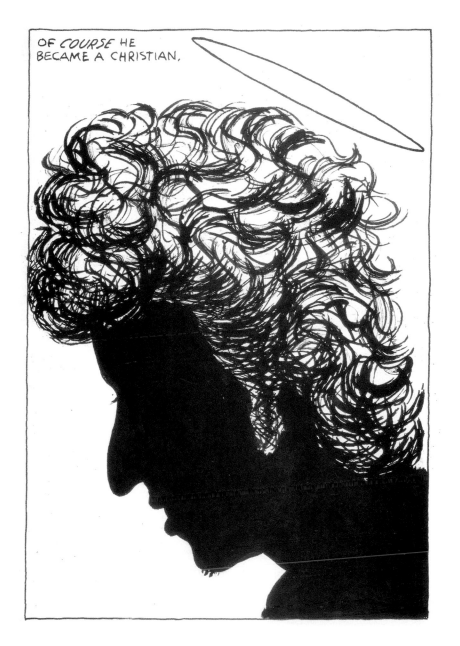

RAYMOND PETTIBON, *No Title (Of Course He…)*, 1982, ink on paper, 12 × 8.5"

RAYMOND PETTIBON, *No Title (Forget the Meaning.)*, 1986, ink on paper, 11 × 8.5"

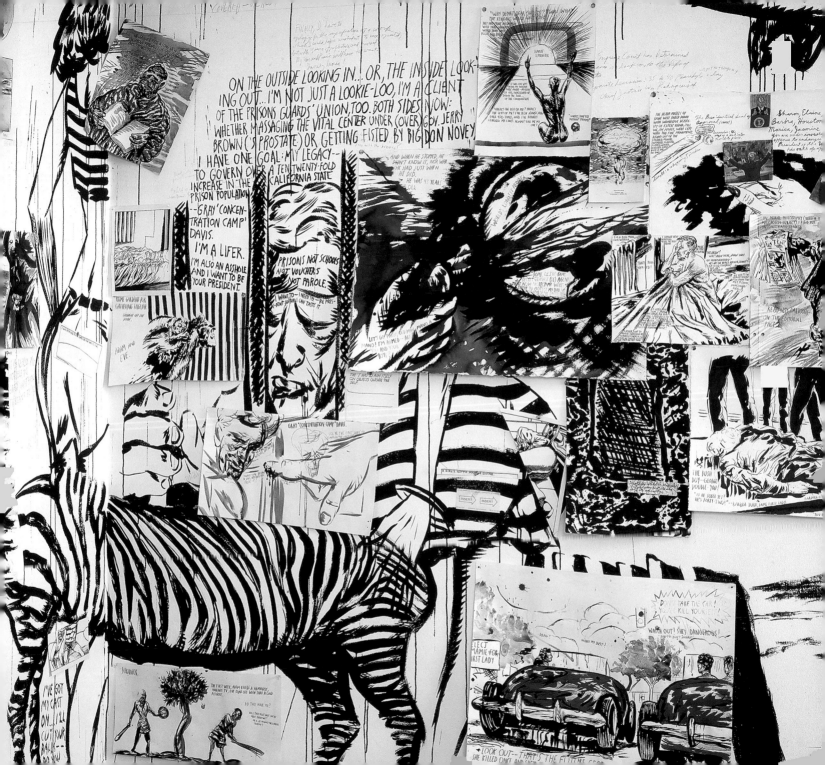

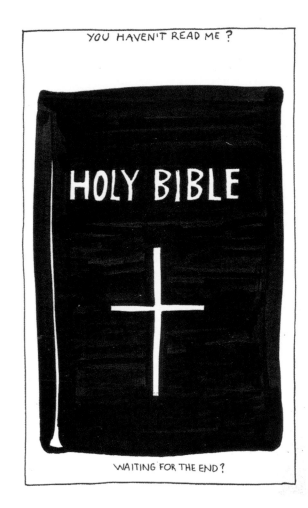

RAYMOND PETTIBON, *No Title (You haven't read)*, 1986, ink on paper, 25.5 × 19"

"Very rarely do I get by without words."
An interview with Raymond Pettibon

Raymond Pettibon was educated at the University of California, Los Angeles, and, these days, lives and works in Hermosa Beach, California. His work has been shown at museums and galleries around the world, including Regen Projects in Los Angeles and the Contemporary Gallery of Fine Arts in Berlin.

JESSE NATHAN: What do you like to look at?

RAYMOND PETTIBON: Anything. It can come out of left field. When I go to see a show or read a book or see something on paper or on the wall or whatever, I'm always wanting to see something great. I'm always wanting to be open to that. I'm not looking for something, for certain kinds of work. I'm open to any influence—for my work or just as someone who likes to look at work, an admirer.

JN: But what catches your eye?

RP: I don't know. I have a very bad visual memory. There are things that hit me sometimes that are sort of revelatory experiences. I think on one's deathbed whatever flashes back, if you could put that on film, it would be an associative mishmash for whomever was willing to sit through it, but to one's self it would make sense.

JN: Is being funny important to you?

RP: In my work and in the rest of life, I would say yes. But you'd have to ask other people if they get the joke or not. With my drawings, people sometimes ask, "Is humor intended? Is it proper to laugh?" To me, hardly ever is humor wrong or inappropriate. Humor and seriousness—one is not weighed against the other, it's not zero sum, it's not like you get humor and that detracts from the seriousness of things.

JN: Do you find your work funny?

RP: Laughing at one's own jokes—that's a brief stroke toward schizophrenia.

JN: Do you make good art when you're feeling surly?

RP: Actually my emotions don't matter in the process that way. Some of my recent work is more political. It's been described as angry, as if something's been weighing on me, as if I'm mad at injustice and so forth, and, sure, there are a lot of things to be upset about and angry at in life, in one's personal life and in the whole world situation, and so on, but the work, it's more coldblooded than that, it's not therapeutic. It's not getting things off one's chest. I can't paint in such generalities, especially about other people's work, but it seems like the most ineffective work is when it's just coming out of some pure emotion. My work is much less personal than most people tend to think. When you're just trying to express feelings, unarticulated emotions, that's admirable. To have empathy for one's fellow humans is admirable, I think. But as a communicative act on paper or film, or whatever the medium is, it doesn't work that well. We've all been in the position of feeling someone's raw pain right in front of us. But there's more to making art than that.

JN: Which one comes to you first, the text or the image?

RP: It's hard to explain how the mind works between visual imagery and language. Sometimes it's hard to say whether it happens relatively simultaneously or not. Often I start with a drawing or an image and it's almost like a challenge then to make some kind of a narrative, make some coherent statement—the words. It can go either way, really. One or the other, or perhaps almost both at the same time.

JN: Do you prefer to use certain sources for your words, or do you make it up?

RP: Both. I borrow sometimes. It depends. There are sources that, for whatever reason, I seem to have an affinity for. On the other hand, it can come from anywhere, just about. Rarely from a conversation, though.

JN: Do you do lots of drafts of drawings?

RP: To this day, I've never used white-out for any reason. Editing and crossing out are always directly on the work. At one point I did start editing and changing quite a bit, especially the writing. It amounts to drafts, I guess. Nowadays there tends to be quite a bit of rewriting and editing, so I guess you could say that I do drafts.

JN: Is the handwriting in your drawings your actual everyday handwriting?

RP: Well, no, because I use a pen with a steel tip or a quill. Some of the handwriting in the drawings is cursive, but even with that, the look isn't my regular type of writing. The look is dictated a lot by what I'm drawing, by what I'm doing. Or sometimes the brush as well. Sometimes the more primitive or awkward-looking the better.

JN: How do you decide something's finished?

RP: When there's nothing left to be said, really. My drawings have elements of cartoons and comics and that sort of thing, but there's not normally a conclusion in my work, not a punchline of sorts. There's no

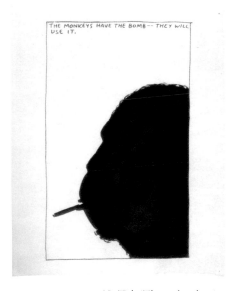

RAYMOND PETTIBON, *No Title (The monkeys have)*, 1986, ink on paper, 14 × 10"

RAYMOND PETTIBON, *No Title (Which is America's)*, 1984, ink on paper, 10.5 × 14"

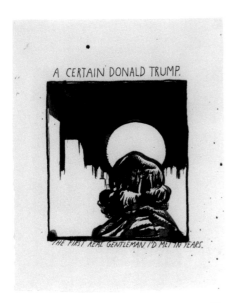

A CERTAIN DONALD TRUMP.

THE FIRST REAL GENTLEMAN I'D MET IN YEARS.

RAYMOND PETTIBON, *Untitled (A Certain Donald Trump)*, 1986, ink on paper, 13.8 × 11"

easy way to describe it, especially because, in my case, I have hundreds of works in my studio that are in an unfinished state. I wish there were some easy way to decide. I guess it comes down to my actual working state. Process is more important than anything, than completing something. Once I know what's going to happen, it just becomes a chore to spell it out, to do it. That does become a concern when you have to make work. Practically speaking, getting bored like that is not good for making work.

JN: Do you work fast?

RP: In a sense I work fast, but I do a lot of actual writing and drawing first. It tends to become complicated. It's never easy nowadays: there's one digression after another. What starts out relatively simple can become very complex. It's good to have some sort of methodology for time management, for having to deal with the art world and galleries. I can communicate best this way, through making art. It's better than telepathy.

JN: You keep saying "nowadays." What do you mean?

RP: At one point in my life I wrote directly with ink. Also, I would normally work on one drawing at a time, or no more than a handful—whatever—but now there's so much at hand. There's so much now that it would take more lifetimes than I have to get it all finished.

JN: Does it matter to you how people classify your drawings? As comics, or fine art, or whatever?

RP: Personally, no. Doesn't really matter to me. I'd rather have that take care of itself. I don't have any professional or emotional concern with how it's categorized. I've pretty much just always done the work and not prefaced it or announced it by where it's supposed to be accepted or consumed. The fact is, it's found its audience—not in comics and cartoons. Even when I analyze it, that doesn't work, doesn't fit. Doesn't quite describe what I do. That's not to take anything away from comics or cartoons. In a way it kind of saddens me, because the cartoon and the comic form are such great forms in and of themselves and there has been and there will be great work done in those forms. But my work doesn't generate a blip in the world of cartoons and comics. It's completely unknown, as far as I know. Of course, my work owes a lot to cartoons, the language of them, and I do come from roots in political cartoons (some of my more recent work goes back to that), and political cartoons are kind of a sadly dying form. Not to say there aren't good people working in that form. Some of my later work was kind of pointedly designed to prove that something could be done in that form. In a way these barriers between gallery world and editorial page—or comics page or cartoons—are fading. There rarely is a barrier to entry that's useful for any purpose other than guarding one's own turf.

JN: Are there things that belong in art galleries that aren't there?

RP: If you asked me that twenty years ago, my answer would be different. My answer would have been yes. Now there's been a

lot more openness. The art world is not as forbidding as it once was. But I'm not really in that position, in a curatorial role. Though, naturally, artists can have a big influence on that sort of thing, that's usually where it starts. I owe a lot to other artists for bringing out work that should be seen, work that's opened things for me.

JN: What does drawing well mean to you?

RP: Well, that's assuming a lot.

JN: What do you mean?

RP: That I draw well. That I know what good drawing is. There's so much time and effort, with no guarantees, of course, for any rewards. It's not like you go through this program and then you get an automatic payoff. In terms of drawing well, there's something in it beyond monetary payoffs. It's not a vocation that you decide to get into in order to get to whatever else you want. I don't want to say something dumb and obvious, but one writes well or draws well for…its own sake. When I do a drawing and it comes out well and I think there's no one else in the world who could have done this this way, and at the same time it doesn't hurt anyone—there's a lot of stuff out there hurting people—that's pretty good, I think. Of course, that's kind of admitting, well, let's be honest, art doesn't have much effect on things. Not all artists are great people so it's probably for the better that art doesn't have much effect on things.

JN: It's faddish and seductive, especially in writing, I think, to talk about finding one's voice. That's supposed to be a big milestone. Did you find your voice as a draftsman? How did that happen?

RP: Yeah, there's a tendency to want to speak in those terms in visual art, too. But I don't know, finding one's own voice— that tends to take care of itself. You just make the work and make more work, and over time it happens. Your voice or style or whatever you want to call it comes about. But it was there all along. It's like a thumbprint.

JN: How do you stave off getting bored during the more drudge-filled parts of making work?

RP: To me, boredom usually sets in when I've got an idea but I haven't made the piece yet. I know the end of the story. There's no surprise anymore. I have to fight this.

JN: Your work has a narrative component to it. Are you trying, in part anyway, to tell stories with these drawings?

RP: Yeah. I would think it's inevitable, because with text and image that's the way these two work. It makes drawings like frames from a film.

JN: And the frames sometimes make a sequence. And sequences are the bones of narrative.

RP: It's a kind of shorthand for me. I make pieces of the story. Other people put them together in their heads how they want to. I give just enough context to spark interest. I've done narrative work with my videos, too.

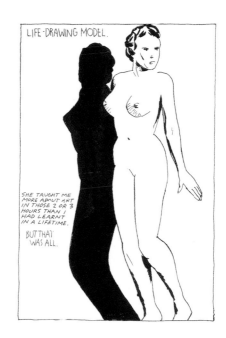

RAYMOND PETTIBON, *No Title (Life Drawing Model)*, 1985, ink on paper, 14 × 10"

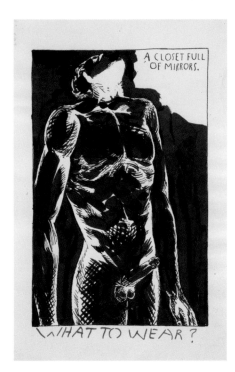

RAYMOND PETTIBON, *No Title (A closet full)*, 1992, ink on paper, 12.38 × 8″

JN: Have you ever wanted to be a writer?

RP: What I do with writing and images but purely with writing, without the drawings? Yeah. I could have done that. But that's basically what I do. My father wrote. I've always written, since I was a child. Somehow the form of what I'm doing now seems to work; it's best for me. But it's not like I planned it that way. The evolution of one's life, it can be more made for you than any conscious decision to do this or that.

JN: What about the relationship between text and image in your drawings—how would you characterize it?

RP: I don't know if I could do well explaining that much. Very rarely do I get by without words. Neither do the words fit on their own without the drawings. Sometimes the person who's doing it is not the best person to talk to; they're too close to it to analyze it. That may be the case here.

JN: Do you make much use of titles?

RP: Well, with my work the text is so much a part of, embedded in, the drawing that it wouldn't make any sense to distance it with a title. Like how would you add a title to it? That would just become part of the rest of the text. So as a matter of classifying them, the way the gallery does it, to make order out of them, their method is to take the first few words or the first line. In poetry it's done that way if they don't have titles. I love titles. I love titling my books. But with a drawing you'd have to isolate that text from the rest of the text in the drawing. Otherwise it would just become part of the drawing.

JN: Once you have an idea, do you like to get it down on paper quickly?

RP: Yes. Like I said, once you have an idea, you want to make it happen or it kind of withers. You lose it. Of course sometimes I sit on things for ages.

JN: What's your favorite kind of paper to draw on?

RP: I just use whatever's available. I don't have specific preferences that seem to always work. If it's rough or smooth, it can affect the drawing—so it matters—but I don't have a style that's that consistent anyway. I've used a million different papers—well, maybe not that many, but I'm working on it.

JN: What do you mean, you don't have a style that's that consistent?

RP: The minute you make one mark, it's recognizable. It's inescapable. But that's another case where one can be too close to what's really going on to comment on it. With a lot of artists, they arrive at some skill, or something that works, and they spend, well, the rest of their working lives replicating that, with a few variations. I don't have that. I tend to complicate things, and it's almost like starting over each time. It's like cooking dinner—it can come out good or bad. With me, the most likely thing is it will be inedible. For me, making art is like finding one's way without a map. I usually end up in some maze. You only know the work that's out there, in public, or on the wall, or in books—and those tend to be the more successful ones, the ones that worked out.

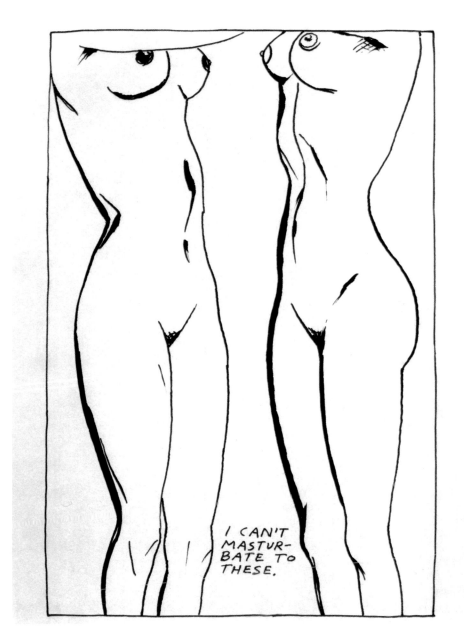

RAYMOND PETTIBON, *No Title (I Can't Masturbate)*, 1985, ink on paper, 12 × 9"

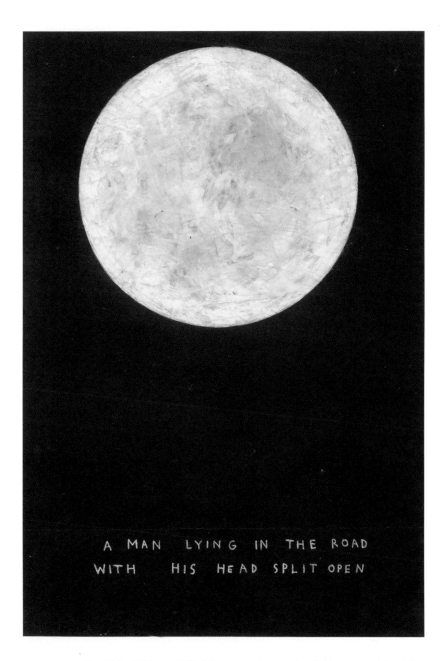

SIMON EVANS, *New Urban Whimsey*, 2005, ink, tape, and correction fluid on paper, 11 × 1 /"

SIDE A

1. CIGARETTES GO WELL
WITH LAMPS.
2. COMMUNITY COLLEGE.
3. RUSSIAN RIVER.
4. DRUGS BRING FRIENDS
TOGETHER SOMETIMES.

SIDE B

1. SO MUCH FOR
OUR MIX TAPES
(SAD REVOLUTION)
2. SUICIDE IS
SELFISH REPAIR.
3. ANOTHER VAGUE
SONG ABOUT HISTORY.

OLD TIME DRINKERS
IN THEIR EARLY THIRTIES
AT THE SILVER JEWS
CONCERT.

SIMON EVANS, *One Hundred Mix CDs for New York* (detail), 2008, mixed media, 84 × 58"

Jaguar

"Man, you've got good-looking handwriting."

AMY JEAN PORTER, *Jaguar*, from "North American Mammals Speak the Truth and Often Flatter You Unnecessarily," 2003, gouache and ink on paper, 7 × 10″

Douglas's Squirrel

"Your wit greatly enhances all of our efforts in forging through the sexual morass."

AMY JEAN PORTER, *Douglas's Squirrel*, from "North American Mammals Speak the Truth and Often Flatter You Unnecessarily," 2003, gouache and ink on paper, 7 × 10"

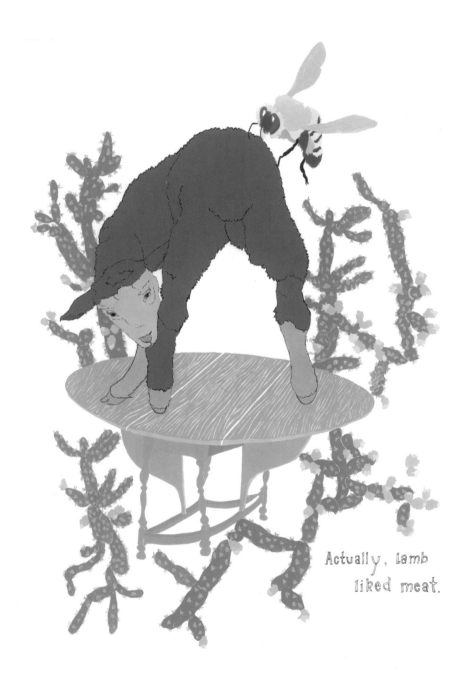

Actually, lamb
liked meat.

AMY JEAN PORTER & MATTHEA HARVEY, *Of Lamb #102*, from "Of Lamb," 2008, gouache and ink on paper, 10 × 7"

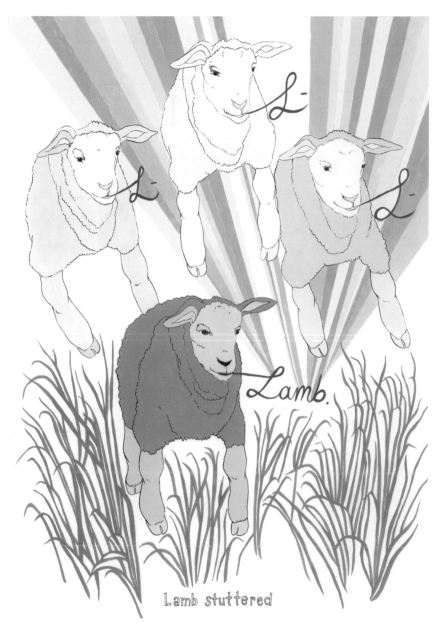

AMY JEAN PORTER & MATTHEA HARVEY, *Of Lamb #32*, from "Of Lamb," 2008, gouache and ink on paper, 10 × 7"

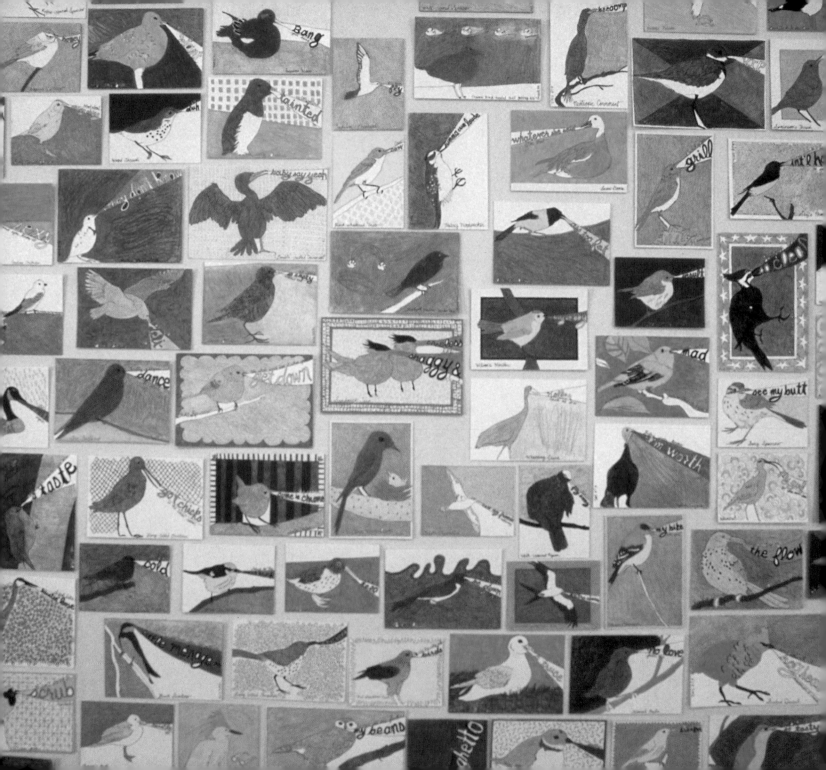

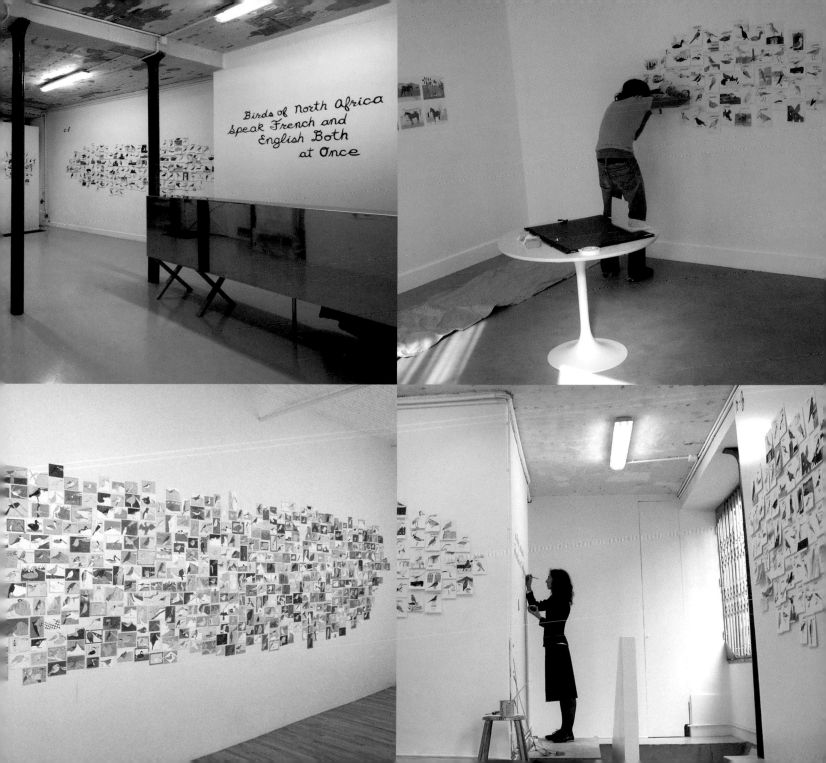

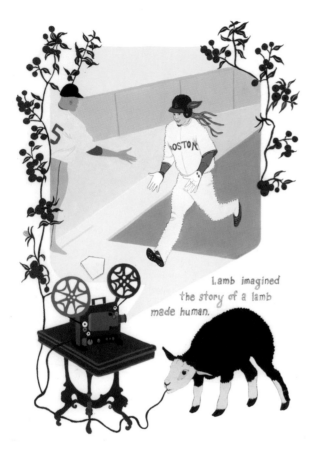

Lamb imagined
the story of a lamb
made human.

AMY JEAN PORTER & MATTHEA HARVEY, *Of Lamb* #79, from
"Of Lamb," 2008, gouache and ink on paper, 10 × 7"

Birds on pages 39 and 40 are from the 2002 series "Birds of North
America Misquote Hip Hop and Sometimes Pause for Reflection."

"I'm more inspired in tedium than in quickness."
An interview with Amy Jean Porter

*Amy Jean Porter grew up in Oklahoma and Arizona and now lives in New
Haven, Connecticut. Porter has drawn over one thousand species of animals for
her ongoing project "All Species, All the Time." Her drawings have appeared
in* Cabinet, Flaunt, jubilat, *and* McSweeney's, *and exhibited in galleries
across the U.S. and Europe. Her work is represented by G-Module, in Paris.*

JESSE NATHAN: What do you like to look at?

AMY JEAN PORTER: Lately, I find myself strangely enchanted by the
seasonal planters in strip shopping centers and places like McDonald's.
There's an unintentional inspiration there, a slipshod symmetry that
irks me, and I can't stop looking at the clipped bushes and tiny blooms.
Things that I seek out are illustrations by Charley Harper and Dick
Bruna, wallpaper patterns, and leftover signage from the 1950s. I also
really, really like Hans Holbein.

JN: What do you like about Holbein?

AJP: I saw Holbein's portrait of Erasmus at a museum and couldn't get
enough of it. I'd go and look forever at the face, because of the incred-
ible clarity and detail: individual strands of hair, curve of lip, twinkle in
the eye. Everything is exactly perfect. I always thought it would be nice
to have two sets of eyeballs. One pair you would use for everyday, and
the second you would take out when you wanted to look really closely
at something. Everyday life means ignoring ninety percent of the
details because there's just too much to see. We would get overwhelmed
and throw up. But the details are where all the fun is.

JN: When did you decide that you liked art?

AJP: Maybe around age five. I remember drawing a horse and thinking,
"That horse is mine." That's when I knew I liked making art. Looking
at art is another thing, of course. We had these two very 1980s screen
prints in our living room—two parts corny, one part earnest, with

very bright colors. One depicted the bust of a very pale woman with a bird on her Elizabethan forehead and a mess of hair behind. I would stare at the bird and then the face and then the hair and, even when I think about it now, I still can't figure it out. I always liked looking at things, and maybe that was the first work of "art" that captured my imagination.

JN: Why do you draw?

AJP: A line is like a scalpel that you can take to the world, and, quite simply, I like the operation. I'll use the tiniest liner brush I can find and load it up with ink and make the sharpest, skinniest line I can. The sheet of paper is all yours to divide up into parts and dips and valleys. When I'm in my most obsessive mode, I can see the depth of the ink or gouache on the paper and be delicate about how the colors come up against each other and touch. At different points in my life, I've also found drawing to be a great way to be socially antisocial. I used to take a sketchbook to bars and drink beer with friends and just draw. I can feel more at ease with lines than I can with conversation.

JN: Is being funny important to you?

AJP: I don't really know how to be funny on purpose, except for one joke about a stick. But everything is funny. I come from a long line of people who laugh at anything. My mother is Irish, from Ireland, grew up in the country with a big extended family. So there's something of a Frank McCourt–type story there. But I've spent good chunks of time in rooms with great aunts and grandparents who are splitting their sides in laughter over the brown bread or whatnot.

JN: Colors seem key to what you do, at least some of the time, and you described the 1980s piece on your wall that captivated you early on. Why use color?

AJP: I love bringing together colors that aren't quite right, that make your eyes hurt a little bit but not too much. If you get the combination just right, you can't stop looking, even though it hurts and you want to look away. I like thinking about what's going on in your brain at that moment.

JN: Yours isn't a DIY aesthetic. You are meticulous and very careful. Do you ever try to draw sloppily intentionally?

AJP: Oh, of course. Sloppy is fun. Sometimes I'll get something juicy coming out of the side of my head. I'm particularly good at making sloppy portraits. But I'm more inspired in tedium than in quickness. I'd rather be doing the same thing over and over again, and with a very tiny brush.

JN: What is it about doing the same thing over and over that's inspiring to you?

AJP: There's a rhythm that lets you shut off your brain, and that's when something interesting can happen. Otherwise your thoughts and intentions manhandle your lines and you can end up with something stiff and flat.

JN: How does text come into your work?

AJP: On most days, we toss language about like an old overcoat. I look for throwaway phrases and try to give them some attention.

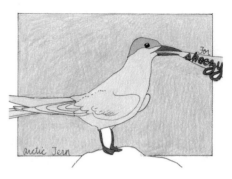

AMY JEAN PORTER, *Arctic Tern*, 2002, colored pencil and ink on paper, 4 × 6"

AMY JEAN PORTER, *Bird with Macaroni*, 2002, colored pencil and ink on paper, 4 × 6"

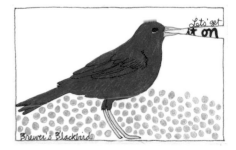

AMY JEAN PORTER, *Brewer's Blackbird*, 2002, colored pencil and ink on paper, 4 × 6"

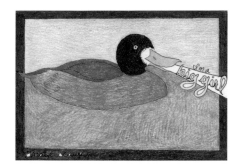

AMY JEAN PORTER, *Greater Scaup*, 2002,
colored pencil and ink on paper, 4 × 6"

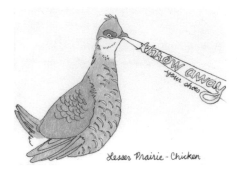

AMY JEAN PORTER, *Lesser Prairie Chicken*, 2002,
colored pencil and ink on paper, 4 × 6"

AMY JEAN PORTER, *Spruce Grouse*, 2002,
colored pencil and ink on paper, 4 × 6"

For the series "North American Mammals Speak the Truth and Often Flatter You Unnecessarily," I liked the idea that I was capturing phrases from popular printed material (newspapers, magazines) in the same way someone might stuff an animal and put it on display.

JN: Do you ever make up the text?

AJP: I'm more of a collector or hunter than a writer, though when I'm in a doodling mood I'll play with words.

JN: Do you do lots of drafts of drawings?

AJP: No. I usually try to slam-dunk them. At the beginning of a series, I often make a lot of crappy drawings until I find what I'm looking for. But after that, I try to put down a drawing without looking back and without erasing. When I don't erase much, it means things are going well. When I get to the painting stage, I can't go back on a color or line, and I find that tension exciting. It's important to live dangerously.

JN: Do drawings often turn out the way you expected?

AJP: Never, really. If I try to plan something, it often goes to the graveyard. Instead I usually begin with one thing, something small, like an eyeball, and work from there. In this way, I must constantly react to what's developing on the page.

JN: Things not going how you expected—is this a good thing?

AJP: Absolutely. It's best when I have only a vague idea. Like, if I had directions, it would be "Go towards that mountain," rather than "Turn right at the stoplight, then left, then two blocks over, then look for the house with the yellow door."

JN: How quickly does any given method become stale?

AJP: Thirty, forty years? I don't know. I feel like I'll have dalliances with other kinds of art-making—maybe giant paintings someday—but I feel like I have so much more to learn from the tiny brush. I remember thinking that Dublin was a small city that you could easily figure out in a week or so. But then I ended up living there for nearly three years and realized I hadn't seen any of it. The longer you work with something, the more you realize there's further to go, more to try.

JN: Is the handwriting in your drawings your actual everyday handwriting?

AJP: I forgot about cursive from about second to eleventh grade. Then I think I had to write in cursive for some identification thing when I took the SAT. I remember thinking, "Oh, wow, cursive. This is great stuff. Why did I abandon you?"

JN: Why draw well?

AJP: I think you can learn to "draw well," to follow the rules, to capture a likeness, but still not capture anyone's interest. On the other side, I've seen scribbles that create such perfect balance and/or tension on a page that I'm compelled to keep looking at them. So drawing well might be more like seeing well: being able to see that important line about to come out of your pencil and guiding it to an interesting place where

it will have some exciting adventure in the eyes of a stranger. There's a whole underworld of communication outside of language that we can't put a finger on. I think there is ideally a combination of known and unknown—idea, intention, intensity, plus the lucky gamble. It's good to have a little sloppiness, or breaking of rules.

JN: Is the material autobiographical?

AJP: There are some hips and haws from my life, sure. In the hip-hop bird series, I had been listening a lot to Hot 97 in New York and the lyrics just percolated into some bird drawings I was making. For "Tiny Horses Say What," the habitats are mainly from photographs I had taken that year and from places that meant a lot to me. There are buildings and accoutrements from Oklahoma City, New Orleans, Phoenix, Montauk, Coney Island, Honolulu, etc. The "Birds of North Africa" series was in part a tribute to where my parents met: Tunisia.

JN: Are you trying, in part anyway, to tell stories with these drawings?

AJP: The more elements you throw in, the more the combination suggests some kind of story. It's almost impossible to avoid. In some ways, I like the mammals series because it really screws up any reading of narrative. But I've also been happy to hear the stories that people find in the drawings—things that connect to them personally in some way. Someone recognized their Ikea lamp, for example, in a bird drawing, or saw an African bird saying "thermostat" and remembered how the rabbi called them a thermostat at their bat mitzvah.

JN: What about that relationship between text and image in your drawings?

AJP: I like to think the image fills in what the words can't say and the text takes care of what the drawing doesn't say. They work together, but they also tug at each other and send you in different directions. I always try to be a hair shy of a punchline.

JN: Does humor belong in art?

AJP: I think people can be afraid of humor, which is perhaps why I find it so powerful. Well, maybe *afraid* is too strong a word. It's more like *suspicious*. Before you laugh, I think you always want to be sure the joke's not on you. Sometimes in certain contexts, you can't be sure.

JN: Do you read comics much?

AJP: I'm not a devoted reader, but I love the classics like *Peanuts*— Snoopy will always be my hero. Great comic artists like Chris Ware make my day, all the time.

JN: What is it about animals that you're drawn to?

AJP: Animals are sublime, irreverent, and inscrutable, but we still tend to recognize ourselves in their wild little faces, and this makes them interesting surrogates for thinking about human culture. I'm also earnestly fascinated by how incredible they are and by all the insane adaptations they've developed. When you think of the multitude of animal superpowers—night vision, flight, speed, shooting webs, prehensile tails and toes, their ability to climb tall buildings—it's enough to blow your mind. And it's for real.

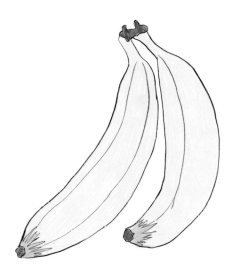

AMY JEAN PORTER, *Your Bananas*, 2008, ink and colored pencil on paper, 10 × 6"

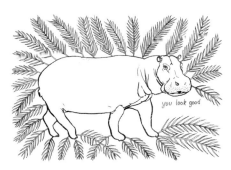

AMY JEAN PORTER, *You Look Good*, 2008, ink on paper, 4 × 6"

TUCKER NICHOLS, *Hey Ladies*, 2003, gouache and acrylic paint pen on paper, 10 × 6.25"

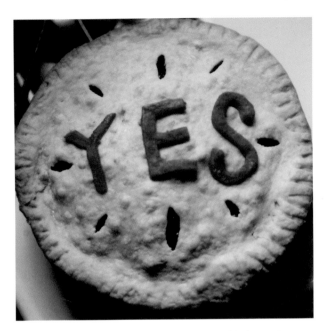

TUCKER NICHOLS (with Jon Nichols), *YES*, 2005, blueberry pie

"Wow, who would write 'WE BEAT THE INTERNET'?"
An interview with Tucker Nichols

Tucker Nichols has had solo shows in America and Europe, as well as a recently completed residency at the de Young Museum in San Francisco. His drawings have been published in numerous books and journals, including Nieves Books and the op-ed pages of the New York Times. Nichols is the artist behind Anonymous Postcard. He is represented by ZieherSmith Gallery, New York.

JESSE NATHAN: What do you like to look at?

TUCKER NICHOLS: As much as I like walking around in nature, I really like when other people have made some effort to put something on view, whether that's in galleries or storefront windows, or any kind of street signs or bulletin boards. There's something about a thing having gone through the filter of human beings. I feel comfortable making rash assumptions about what I'm seeing and how it got to be that way. I generally like looking at things that other people want someone to look at.

JN: Do the things you make tend to come out the way you expected them to, or envisioned them?

TN: Sometimes. I try to shorten the distance between a thought and its execution. I find if things get stretched out too far, if there are too many steps between an idea and its final state, it tends to sort of deaden or I'm not as interested in it by the time it's actually a physical thing in the world. I try to execute right away and then later look back and figure out if there's anything there.

JN: Do you usually have a pretty clear picture in your head of what a drawing's going to look like?

TN: Not necessarily. At the very beginning of a drawing I usually don't know where it's going. But it doesn't take much for me to throw something away, so I feel lucky in that way, especially when I hear from people who make work that's a lot more labor intensive. Having the freedom to cancel what I've been doing is great.

JN: Some people think the amount of time an artist puts into a work of art is a determining factor in how good it is, how successful it is. In other words, if you put a hundred hours into a painting, then that makes it good, automatically.

TN: Right. I face that temptation all the time, of wanting to take credit for spending so many hours doing what I do, but the reality is, that has no bearing on whether something really turned out or not. It's not that I'm interested in trying to make some big point about this, either. It's just that this happens to be the zone I've settled in. This is the itch I have, and it's not... well, I didn't really predict any of this.

JN: Do you do drafts?

TN: I don't redraw drawings exactly. I used to think this was a hard rule that I would never, ever break: if a drawing didn't work out, I could never have another go at it. It seemed like trying it again would be such a mistake, that it never got any better. Now I'm realizing that an idea for a drawing can actually take different forms. It can kind of graduate until it finds its proper mode, particularly the drawings with text. A drawing can start on a small scrap of paper and end up painted across a window. But it's different for me than the person who's painting for ten hours at a time on the same work. It's almost as if I'm shooting bits for a movie and I'm not sure which ones I'm going to use or which are total crap.

JN: It's a very instinctual process, I'm sure.

TN: When I don't have a really clear response to what I'm making or what I'm going to do with it, it's better to just go away for a while. Hope can get in the way there, too. I find the more ruthless I am, the better job I'm doing, typically. And it can be hard to let go of things that felt really good when I was making them and I can't quite understand what's wrong, but I know something's not working. In the wintertime, when we've got a fire going, that selection process is easier 'cause I can burn them. When I throw it in the recycling bin, there's this feeling like *What's it doing in there? Something's still going to happen with that.* You really have to destroy it. That's the only way to go.

JN: Do you think of yourself as telling stories with your work?

TN: Yeah, but I switch around between what stories I think are at play. A lot of times I do have an idea of myself as an obsessed person who just can't stop drawing, almost like the guy in *Close Encounters* who's making mounds out of his mashed potatoes and making mounds out of dirt in his backyard. He doesn't have a choice, he's gotta make the next mound. I think about that guy a lot, about how much I am or am not like that guy. And there's a part of me I can occasionally isolate that thinks, *I am a person obsessed with drawing branches. I don't know what the significance is, or if there's any significance. Like, I can't leave yet, I see there's enough time for me to get off one more branch and then I'll be ready to go.* I don't know where that comes from.

JN: You studied Chinese painting. What kind of work were you studying and how did that influence you?

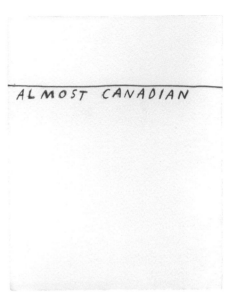

TUCKER NICHOLS, *Almost Canadian*, 2007, colored pencil and pencil on paper, 7.75 × 6"

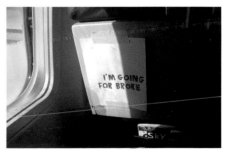

TUCKER NICHOLS, *I'm Going for Broke*, 2006, Digital C-print, 20 × 30"

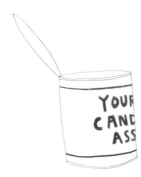

TUCKER NICHOLS, *Your Candy Ass*, 2006, pencil and colored pencil on paper, 9.5 × 12.5"

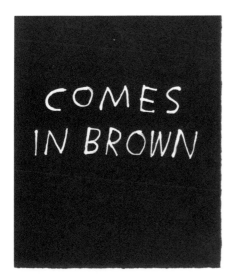

TUCKER NICHOLS, *Comes in Brown*, 2007, correction fluid on paper, 6 × 5"

TN: I was drawn to really simple ink drawings. That was the stuff that got to me. In my first semester of college, I took an art history class where each professor taught their expertise for a week or two. It was like a buffet of art history. And the professor who taught the Chinese section showed slides of some simple paintings, ink drawings that were made five hundred years ago on the other side of the planet, from a culture that I knew nothing about. And yet here they were being projected on a screen in a dark room in Providence, Rhode Island, and I could feel it in my sternum. I needed to understand what that was. I started by studying Chinese and reading and writing papers, and then moving to Taiwan—I took it all pretty seriously— but eventually I realized the only way I could really understand that feeling was by actually drawing. I'm curious if I can recreate that sternum feeling in the *making* of things. Sometimes yes, sometimes no.

JN: What kinds of text are you drawn to?

TN: Advertising especially. The vast majority of the words we see in public are trying to convince us of something. And it's really easy to draw on that tradition. It's everywhere. There are catchphrases, and even just the physical manifestation of the lettering is all a culture we're really familiar with. I can refer to the tradition without doing much.

JN: Do you try to be funny in your work?

TN: No. But I like it when it makes people laugh. I'm less interested in making people laugh than I am in activating something in

them—see if I can't get their brain to move around in a way that's something like the way mine was moving around when I made that drawing, or when I decided to keep it, or when I decided to send it to them, or whatever. I don't really think I know how to be funny. Compared to my friends, I'm not really funny at all. I think it's just by coincidence, honestly, that what I do and what people find funny sometimes overlap.

JN: Where does your text come from?

TN: There are really two different ways: things that I actually see in the world and write down or speak into a little digital recorder in my car, or I make it up. When I find something in the real world, often the impulse is to think, *Wow, who would write, "WE BEAT THE INTERNET"? I could never have come up with that.* It was a sign on a golf supply store advertising cheaper prices. It's such a wonderful phrase. This Internet thing is so perplexing, and the idea of claiming any type of victory over it is just like…good for them! So there are these things that float around, and I think that's very much the way we experience text in the world.

JN: Does the text usually come first?

TN: Well, I've been separating the text out from the images, so they don't actually exist in the same drawing very often anymore. Now it's in the editing process that the text will end up next to something else. Sometimes that'll be another piece of text, sometimes that'll be something abstract but a bit mountain-like, or sometimes it'll be something that looks like a factory. I

want to build just enough of a bridge to encourage people to walk between the two but at the same time not say for sure why those things are together. One of the great things about text, and I think this goes for the apex show as a whole, is that we've forever been trained to believe that the words will save us. When we're exposed to something that's confusing—like, why is there a picture of a giant rock in the local section of the paper?—to see the caption is to see the light. I can read the caption and understand everything and then go on with my day. Caption is the clearest example of where text and image meet, but also, think of instruction manuals or road signs—there are so many places where those two things go together, and they're always working to help us understand something. And when you give artists a chance to play with that dynamic, the results get kind of murky. And sometimes it's the ambiguity that makes something come to life.

JN: What about that relationship between text and image in your drawings? How would you characterize it?

TN: To me, text is really just another mode I work in. In my studio I have boxes where drawings get sorted: buildings, rocks, diagrams, text, and so on. Text is only different from the others because it's so potent, like a spice you've been warned about that drowns out all the other flavors. I've found the only way I can work with it is by shaving it down to such a vague state that even I can't be sure where it came from. Like it washed up or got caught in the lint trap. I feel good about a drawing when I don't

know for certain what it means, but I still want to think about it. A rock or a sad building can do that.

JN: Is a lot of what you draw drawn from things that you've experienced directly?

TN: Not really. I'm not trying to tell my own story like someone who paints memories or stages photo shoots to reflect something from their past. I'm often making up vague scenarios in which some fictional character would need to make such a diagram or sign or even a drawing of a rock or a bottle. What presentation could that diagram be for? What kind of person would do something like that? But of course lots of the text and even images come from signs and buildings and trees I see in my daily life, so there's some direct autobiographical stuff there. This is my version of the world. It's not very complete, but it's basically what I take away from living here.

JN: Is a gallery the best place for your work?

TN: Galleries are only one place where my work ends up. The whole picture works better for me if I start by making something and then find the right home for it. Sometimes that's the mail, sometimes that's framed in a gallery, sometimes that's the shredder. The part that makes its way into a gallery feels right there in the same way that it's good to go to an ice cream parlor if you want to eat ice cream. But sometimes ice cream tastes best standing in front of your freezer with a spoon.

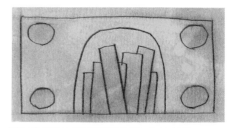
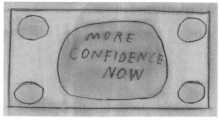

TUCKER NICHOLS, *More Confidence Now* (front and back), 2008, pencil and acrylic on cardboard, 6 × 3"

SORRY ABOUT THE ICE BUCKET

TUCKER NICHOLS, *Sorry About the Ice Bucket*, 2003, ink on paper, 4 × 6"

The Spring Break Hitlers

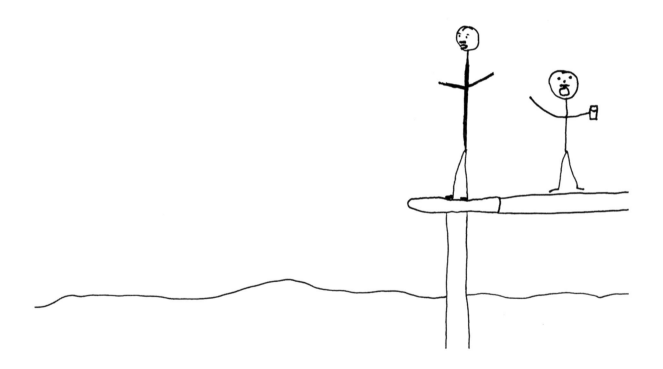

DAVID BERMAN, *Spring Break Hitlers*, 1997, ink on paper, 11 × 8.5"

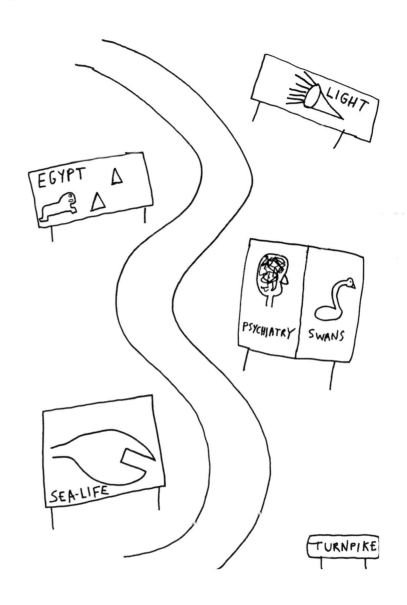

DAVID BERMAN, *Turnpike*, 1994, ink on paper, 8.5 × 11"

DAVID BERMAN, *Look at*, 2001, ink on paper, 8.5 × 11"

Sea-Nerd

DAVID BERMAN, *Sea-Nerd*, 2001, ink on paper, 8.5 × 11"

DAVID BERMAN, *Guardwork*, 2001, ink on paper, 8.5 × 11"

"Specialization just reinforces worldwide loneliness."
An interview with David Berman

David Berman's book of poems is Actual Air, *and he is the avatar of the Silver Jews. He makes poems, songs, cartoons, and other things. Before the Silver Jews, Berman began writing and performing songs (often left on friends' voice message machines) with a band called Ectoslavia. He was born in 1967 in Williamsburg, Virginia, and now lives in Nashville.*

JESSE NATHAN: You're sitting on an airplane. Guy asks what you do for a living. You say—what?

DAVID BERMAN: I say I'm a songwriter. It's a respectable job category in Nashville. In fact I feel like society is almost unfairly kind to songwriters in ways it isn't to other artists. You're encouraged to be eccentric no matter how normal you are. There are other free passes.

JN: Someone asks what your art is about. What do you say?

DB: I would probably blank.

JN: When or how did you decide that you liked art?

DB: I had a friend in college who would just crack up at the drawings I made in notebooks. Whenever he would visit me he'd immediately pick up any notebook of mine and sit down and just laugh for a great amount of time.

JN: Why do you draw?

DB: Sometimes I think it's a way for me to listen to music. I can't listen to music when I'm reading or writing, or when I need to think or feel without interference, which means I hardly ever listen to music anymore except when I'm drawing. Drawing and driving. Something about a police sketch artist in a road rage incident.

JN: Do you dabble in other media or forms?

DB: I plan to try them all at one point or another. I say, Why not?

Specialization just reinforces worldwide loneliness.

JN: What do you like to look at?

{In response to this question, Berman later emailed us the following link and message: http://www.sun-sentinel.com/features/food/ sfl-retro-kid-cereals,0,1195000.ugcphotogallery—Especially, numbers 1, 7, 9, 10, 13, 14, 16, 18, 19, 20, 21, 22, 24, 26, 27, and 28.}

JN: Why is being funny important to you?

DB: Let me rephrase that. Do I expect it of myself? Perhaps. I've never been an out-loud funny person. I actually have a tremendously slow brain.

JN: How does text come into your work?

DB: Sometimes it precedes the drawing. This happens more and more. Hopefully it happens in your head as you're drawing. You start to discover something. Your mind is trying to coax some sweet meaning out of what your hand is doing.

JN: Do you have a typical process?

DB: If the caption doesn't arrive in the same sitting, it often goes into a purgatory file. Further on are the many failures of File C. Very few make it back from File C.

JN: Do you ever get your text from elsewhere, or do you pretty much make it up?

DB: Normally I want everything to be to be mine, mine, mine. I'm testing for Google purity all the time.

JN: How would you characterize the relationship between text and image in your drawings?

DB: Troubled. It is the whole rub. It's difficult, tough. It doesn't seem like it should be, but it is.

JN: Do you ever redo drawings?

DB: Sometimes you come up with one of these image-text pairings, but the image is dented or half-assed. So you make a much sweeter, more together splice on the cleaned-up one.

JN: It seems like getting these drawings and captions down quickly, and in the same sitting, is pretty important to your process. If you think about an idea too long, does it get stale?

DB: Yes, but now I'm putting together a book. I'm at the stage where I am captioning these utterly mute things. I am trying to look at it as one-liner poetry titled by an image. I'm trying to get them to click into focus as a "made thing." Ultimately you can fix your eye on the image as you let an enormous amount of information ticker tape across the space below it.

JN: How do you decide something's finished?

DB: Some movement is completed in the looking at it. I'm trying to lead the potential entertainee across a thought worth crossing.

JN: Do you think of yourself, when you're doing these drawings, as an entertainer?

DB: Yes. I love it when my friend Dan Koretzky goes through a pile of them. From the next room you can hear his laugh

The harpist at the sheraton.

DAVID BERMAN, *The Harpist at the Sheraton*, 2001, ink on paper, 8.5 × 11"

If you were New Wave in cincinatti in 1983, I probably haunted your spare time occasionally.

DAVID BERMAN, *If you were New Wave in Cincinnati*, 2001, ink on paper, 8.5 × 11"

DAVID BERMAN, *Don't Worry It's Just a Phase*, 2004, ink on paper, 8.5 × 11"

DAVID BERMAN, *Mowing the cockfields*, 1997, ink on paper, 8.5 × 11"

rising and falling, rising and falling, in eight-second waves.

JN: Are you a good speller?

DB: Average speller. Clumsy typer.

JN: Is making a mistake fun?

DB: Not for what I do. I try to know what I want and to put it across. Mistakes are the pollutants in the bloodstream of my oeuvre.

JN: But sometimes you cross things out and leave that x-ed-out bit in the final version of the drawing. Based on what you say about not enjoying making "mistakes," this seems to me to mean that these scratched-out things are kind of like stylized mistakes, right?

DB: I'm not intentionally making mistakes, but I'm also not gumming myself up with the fear of making a mistake. Crossing out unwanted text in a rigorous though aesthetically pleasing way is a backdoor back into the origins of this art of pen-and-pad doodling.

JN: Pen-and-pad doodling? Is that how you'd describe what you do?

DB: I guess that all depends on the presentation. It's pen-and-pad doodling when the work is discovered posthumously.

JN: Do you think it matters whether crudeness is natural (unintentional) versus intentional? Wait—is natural versus intentional even a real distinction?

DB: I think the unintentional and the intentional are interlarded throughout the creative process. I also think crudeness is

probably impossible to detect outside of your own era.

JN: Does this kind of artwork play on the viewer's notions of authenticity?

DB: People seem to be terrible judges of authenticity when they're not pre-fed the answers. It's one of those things people imagine they're great judges of, like good character, "just folks," etc. But aren't.

JN: What do you mean?

DB: I think evaluators who claim to know the real deal are too sure of themselves.

JN: A minute ago you mentioned haikus and simplistic comparisons. Do you think your drawings have something in common with haikus?

DB: They are probably more like *The Far Side* by Gary Larson. Just imagine how much more his work would be esteemed if he hadn't gone with the coffee mugs and greeting cards. If he had just let the work collect in distinguishedly bound collections. I do like short forms of all kinds. I have a shot at finding just enough soul to pour into a small vessel. I am starting to like dialogue, because it is a small thing. I had confused it with narrative, which I consider a massive job, beyond my ken. But dialogue is very small and painterly.

JN: What's massive about narrative?

DB: Its purview is infinite in scope. I can't imagine writing fiction, knowing how far below your work is, compared to Dostoevsky. Poetry and simple song-writing and drawing give you the feeling

that any day, you might hit on something in the neighborhood of the quality of your predecessors.

JN: How is making a drawing similar (or not similar) to composing a piece of music?

DB: It's similar in that you spend step one completely lost on a foggy plane. You need to create something to evaluate. You make a move and then either reject that move or, seeing some potential in it, use it as a temporary reference point for a second move.

JN: The drawings in the apex show were fine art of some kind, though they shared affinities with cartoons, graffiti, high modernist painting, even pop art. But, actually, does it matter what we call the form?

DB: Other arts may die out, but I feel certain that what I do will be done for as long as there are office supplies. It's very much a product of the occasion: What did you have—a legal pad?—that day?

JN: What does drawing well mean?

DB: I'd like to be able to. Technique with no fresh idea is inferior to spirited amateurism in our times. Hopefully, enough of us will still be around to draw the singularity when it happens.

JN: Why do you say spirited amateurism is superior?

DB: The mass of the handmade compared to the mass of the mass-produced keeps getting smaller. Ninety-nine percent of the objects in my vicinity are symmetrical products of calculation and design.

JN: Also —before I forget—do you think there will be a place for art when the singularity happens?

DB: I think once that happens, art will be universally regarded as irrational and disruptive to what they'll call "life." It will be eliminated, and any human who so even mentions Mona Lisa will be destroyed.

JN: One of my favorites of yours is *Spring Break Hitlers*. Did you meet someone who inspired the drawing?

DB: For a long time I've played with the idea of a movie called *Spring Break Nuclear War*. The *Spring Break Hitlers* came out of some drawings I was making around the time I was toying with the idea. There is a link the mind might make between *Spring Break Hitlers* and Mel Brooks's *Springtime for Hitler*. Of course, there is a resonance between the mindless, conformist rituals of spring break and those of Nazi Germany from the Dead Kennedy/MDC point of view of the early eighties.

JN: Does a lot of what you draw about happen to you?

DB: I don't think so. Not much happens to me. I try to happen to the paper.

JN: Do you like making titles for drawings?

DB: Yes. Here's one: *Four Christian Hijackers (Matthew, Mark, Luke, and John)*.

JN: I know this is a really general question, but here goes: what is drawing for?

DB: It's the quickest art you can make with the smallest IQ and the simplest materials.

DAVID BERMAN, *2 Floridas and one Duane Allman*, 2001, ink on paper, 8.5 × 11"

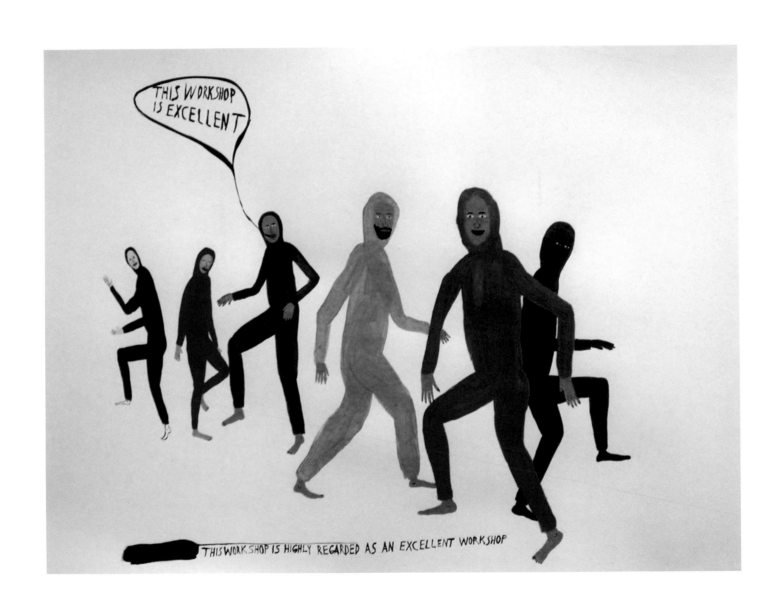

CHRIS JOHANSON, *This workshop is highly regarded as an excellent workshop*, 2002, acrylic on paper, 22.5 × 30"

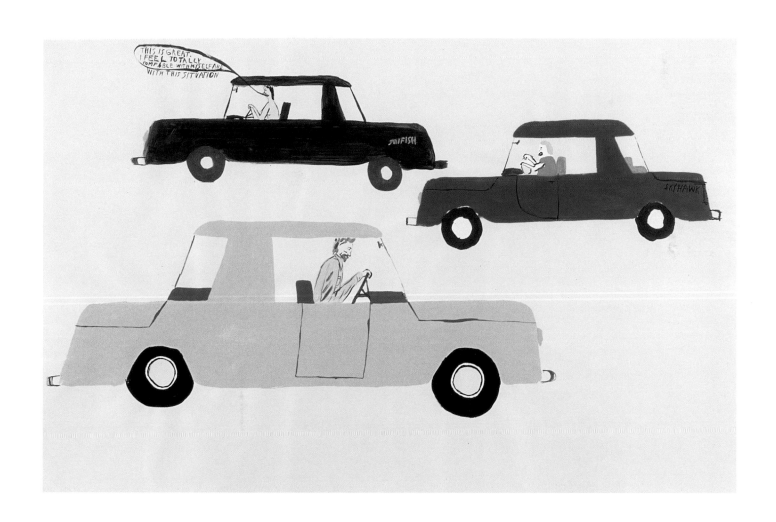

CHRIS JOHANSON, *Untitled (This is great)*, 2001, acrylic on paper, 25 × 38"

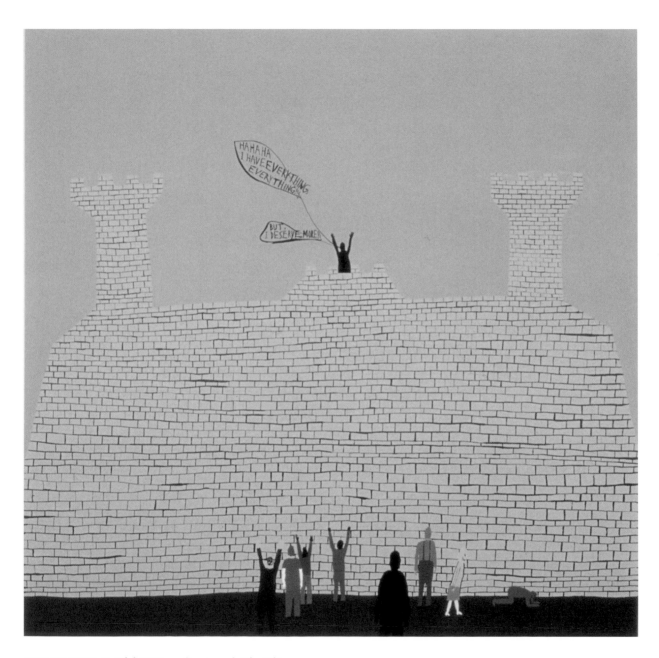

CHRIS JOHANSON, *Untitled*, 2002, acrylic on wood, 36 × 36"

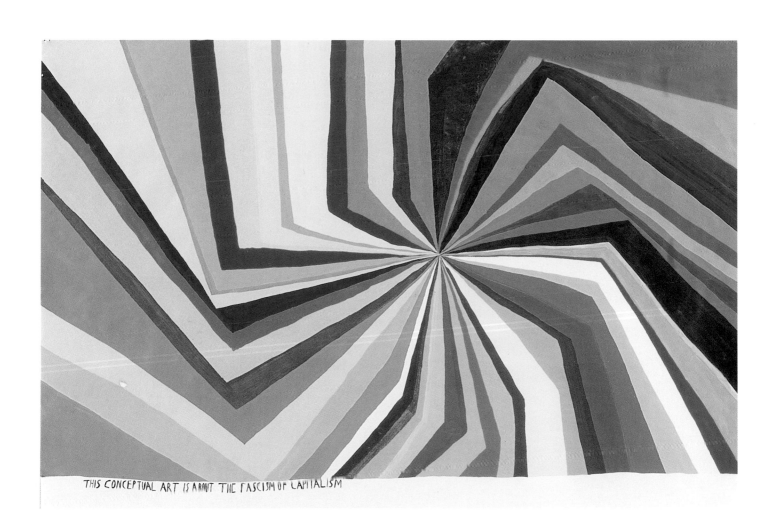

CHRIS JOHANSON, *This conceptual art is about the fascism of capitalism*, 2003, acrylic on paper, 26 × 38"

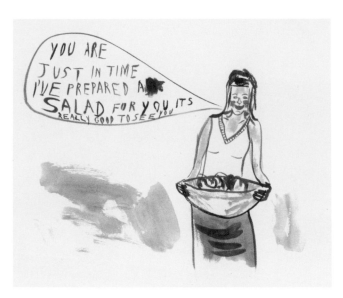

CHRIS JOHANSON, *Untitled*, 1999, acrylic on paper, 10 × 12"

"I've learned humor as a tool to deal with the process of being alive."
An interview with Chris Johanson

Chris Johanson's work appears at galleries around the world, including the Jack Hanley Gallery, Galleri Nicolai Wallner, and the Baronian-Francey Gallery. His films have appeared at the New York Underground Film Festival and the Film Arts Festival of Independent Cinema. He lives in Portland, Oregon.

JESSE NATHAN: What do you like to look at?

CHRIS JOHANSON: I don't know, man. I'm an open book. The things that interest me most at this point in my life are more peaceful. Public sculpture.

JN: What about public sculpture do you like?

CJ: I like those good visuals on a walk. That's what interests me. I like to think public sculpture is like health food for adults and children. Because people are so bombarded now with all this bullshit, advertisements for everything all over the place, and I really like the idea of a minimalist sculpture, or a big sculpture of, like, an animal. It's beautiful. It's like health food.

JN: Is being funny desirable to you in your work? I mean, do you seek it out?

CJ: Yeah. I think humor's a good way to deal with life. I mean, I don't know, I'm kind of existential sometimes. And that part of me can be a little bit of a bummer. So I like that I've found humor. It's a good way to deal with the crises of living, with the heaviness. Living is a burden. Living is great. But being human is harsh in a way. I'm just lucky that I've learned humor as a tool to deal with the process of being alive. I don't know that I'm funny or anything, but I know that humor really helps. So, yeah, I think it's important to have humor in my art. I want to make things that are about life and the seriousness of living and coexisting. To be alive means to affect the world. I think that's pretty

serious. And if I use humor to talk about those things, well, you can talk about serious things and not alienate people. You can kind of take people into this journey of visual information. When I make these big installations, I use humor to help people enter into it.

JN: How does the text in your work come about?

CJ: I make my work in a lot of different ways. I have years of journals now. Some of those drawings started with some text that popped into my head while I was walking down the street. It will show up in a painting years later. Or sometimes it's just like, I'll have been working on a painting for five minutes and it's done and text just comes to me right away. Or sometimes a year'll go by, and I didn't know it was going to have any text and it all just kind of works out. A long time ago my work used to have a whole lot of text, a lot of language. And now, the writing in the drawings and paintings and the work in general is just becoming a lot sparser.

JN: Why is that?

CJ: You just get things too dialed. I can't keep making work the way I used to. I don't like to have things too dialed. My philosophy is not to have everything derailed or chaotic all the time. But with what I'm doing with my paintings I have to mutate, or else it just becomes stale. But language is a good way to communicate, that's for sure. But it's not the way I communicate best. Definitely not with lectures or textbooks, that's not the way I'm

comfortable with. I have to do it my way. I do lectures sometimes, but I don't think I'm a very good communicator that way.

JN: How quickly does a method feel stale?

CJ: I don't know.

JN: There's probably not a general answer to that.

CJ: No, but I often think that my paintings are completely devolving visually. Like, I've become a much worse painter. A better way to say it is: things are becoming more abstracted. It seems like that's a more honest way for me to paint. That's a more honest way for me to talk about issues. And I noticed that I used to paint people in this detailed way. And now when I paint them, it's just a color. It's more like stick figures. It seems like a more respectable way to paint people.

JN: Is the handwriting in your drawings your actual everyday handwriting?

CJ: It is, but it's a little different, because in the nineties I used to draw always with these crayons, these grease pencils, and so that was more exactly my handwriting. But I do all this handwriting now with a paintbrush. So it's really slow and it takes a long time. That affects things, because it's not really fluid. But I like that even more, because it gives me time to meditate on exactly what I'm saying.

JN: How do you pick the colors and materials for your work?

CJ: Well, first, all the wood is dumpster-dived, always. Every single time now. It's

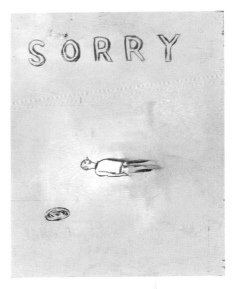

CHRIS JOHANSON, *Sorry*, 1994, acrylic on wood, 20.25 × 16.25"

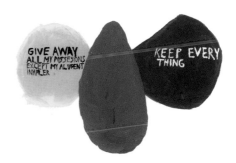

CHRIS JOHANSON, *Untitled*, 2005, acrylic on paper, 12 × 16"

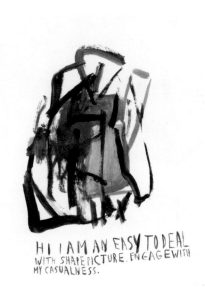

CHRIS JOHANSON, *Untitled*, 1999, acrylic on paper, 5 × 4" (approx.)

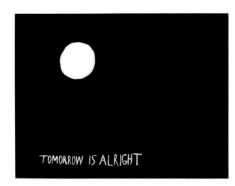

CHRIS JOHANSON, *Untitled*, 2000, acrylic on wood, size unknown

cool, man. At this point that's just the way it is. If I went to a museum and they asked me to do a show, I would say, "You have to help me find wood." They would have to scout it out so that I could find places where there's wood. I'm serious. I won't, I can't, paint on new wood. It's not even worth it. There's no experience that's worth that anymore.

JN: Why not?

CJ: Because there's so much waste and garbage. It seriously makes me sick to my stomach. I would like to say it in a different way. Here: it profoundly bothers me. I find it profoundly upsetting the amount of waste going on in the country and the world. It makes me feel a little more peaceful to find wood that I'm perhaps even giving a third life to. We're talking about wood's beauty, and old wood's beauty. It should be cherished. I have to go into a dumpster and find the wood. Touch the wood.

JN: And what about color? How do you pick the colors out?

CJ: Everything I do, it has to have a reason. There's a reason why I use any color. I have to articulate why I do anything. Everything has an energy. I paint with yellow because it's the sunlight of the spirit. The spirit is the main reason why we exist, and I find yellow to be a hopeful color. To me, yellow's the color of love and goodness. And positive energy. I try to make art that's more positive than negative. More love than hate. Hate's everywhere, but love is, too. Every action, everything you do,

puts energy out into the world. That's for everything, and it goes on forever. What a person does here, it affects everything into the future. Forever. And then with color, I just think about color the same way. When I make an installation I have to make it more positive than negative. If the rationale for my work is more negative than positive, I wouldn't really be doing anything good for myself. But I don't know, man. I don't know how I choose colors exactly. There's a lot of weird magic. And there's a lot of alchemy in art. It's an obsessive-compulsive thing to do. I probably think about the colors an unhealthy amount. Color is good, because color gets into people's minds. And I used to only paint in black and white. For probably, like, ten years I painted with just black and white. And then suddenly something happened. I don't even remember when it happened or why. I just started painting with color.

JN: There are so many crisp, even geometric, lines in your work. Did you like geometry class?

CJ: I don't know. I barely graduated high school. I didn't graduate college. The type of brain I have and the type of brain that schools favor ... they're different. I don't have any criticism for people who went to school. But I have bad things to say about schools. Because they're not for all people. They're for a certain type of person. And that's a shame. That means there are a lot of people on this planet that are considered less-than. I think that's a shame. When I meet younger people now—every once in a while I talk to kids, and my father was a

high school teacher, even—but I just say, education's everywhere. You don't have to be in school to get an education. The goal's to be aware.

JN: While you're painting—during the working process—can making a mistake be fun?

CJ: Yeah. I think it's because it's like, this is what is and it came from here. It's frail. To be frail is to be alive completely. We're very frail. This is process art. I just think it's a better way to communicate. I feel like it's a normal way to communicate. It feels less fascist.

JN: Have you ever wanted to be a writer?

CJ: I did used to write stuff. I've always done lots of different things. I've made some short films and video work. I played in bands. I'm writing more music to the pieces these days. I used to take a lot of photos. I used to write a lot of stories and stuff, but unfortunately I threw a lot of it away. I did a performance where I came out of a spaceship as an alien and then did a spoken-word music piece with Sam. All the words were prerecorded to sound like an alien. I paint all the time, because I find it to be therapeutic. It's when you do things over and over again, it makes you feel good. I find it to be therapeutic to go over issues through paint. And that's why there's a lot of text in my work, because it's just good to get those words out of my brain.

JN: I have a question regarding your painting called *This workshop is highly regarded as an excellent workshop.* Can you take us, from start to finish, from idea to realization?

CJ: I think I was in New York. I still have the original drawing. It's on an envelope. It just came to me. Because I think workshops are excellent. And I think that self-help is excellent. And I think 12-step programs are excellent. And I think riding your bike is excellent, and laughter therapy and anything anyone wants to do. It's all great. Everyone's so ridiculous. And I thought to have all these people in jumpsuits at this men's empowerment-through-dance workshop, it sounded good. It felt right. If it feels good, you should do it.

JN: Does it matter if it takes five seconds, versus five hours, to make a work of art?

CJ: Not at all. I must say that I like the pieces that are so fast to make. It makes me happy that they get done so fast. Really, they take as long to make for me as the piece that took a year and half. In any case, the ones that took five minutes have equal weight to the ones that took a long time. You know, art is such a loaded thing for me. I could not read and write when I was a kid. It was really a drag. Even into college. It took me so many times to get through English 1A. When I got into state school, finally, they told me I had to take those classes again. That was it. See, I have been painting my whole life. My muscles are so fucked up from the tension of constantly painting. It's pretty much all I do. I do it all the time. It gives me great pleasure. I've done it all my life. It's just what I have to do. That's one thing I can't articulate, though... how it's gotten here. But I know it's the way it has to be.

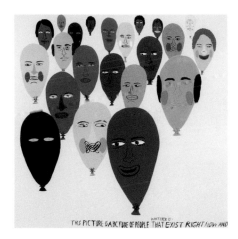

CHRIS JOHANSON, *Untitled (Balloon Heads)*, 2001, acrylic on paper, 26 × 40"

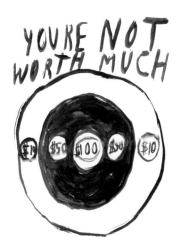

CHRIS JOHANSON, *Untitled*, 1999, acrylic on paper, 10 × 14"

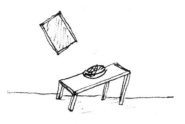

One of the
King's legs
is longer than
the other, and
we must
compensate.

I MEAN —— SOMETHING FABULOUS HAS
HAPPENED THAT I CANNOT
DISCUSS

ACTOR
DOES NOT MOVE BUT
SURROUNDINGS ARE
CARRIED AROUND HIM.

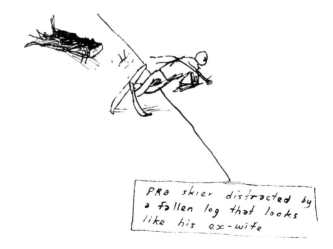

PRo skier distracted by
a fallen log that looks
like his ex-wife

QUENTON MILLER, *One of the king's legs* (top left), ink on paper, 5.9 × 8.3"; *Flags* (top right), *Skier* (lower right), and *Play* (lower left), 2007, mixed media on paper, 5.9 × 8.3"; *Don't kick it down...* (opposite page), 2008, mixed media on paper, 8.3 × 11.8"

Dont kick it down

It was built by a cop

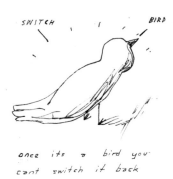

once its a bird you
cant switch it back

QUENTON MILLER, *Bird Button*, 2009, mixed media on paper, 8.3 × 11.8"

"I'm interested in drawing thinking rather than drawing things."
An interview with Quenton Miller

Quenton Miller's work has been exhibited at TCB and published in The Age, The Believer, The Walrus, McSweeney's, *and* Opium, *and in books like* From *and* Max Pageant. *He lives in Melbourne, Australia.*

JESSE NATHAN: When did you learn to draw?

QUENTON MILLER: I've drawn since I was a kid. I would do these panoramas full of friends and enemies and schoolteachers. Some of my happiest memories are of all my friends crowded around a big piece of paper laughing. What I wanted to do was never allowed in art class, though, as I went to a very conservative school in Perth, which I think is the world's most isolated city. Geographically.

JN: Why do you think what you wanted to do wasn't allowed?

QM: I don't know. Once I tried to paint a koala holding a chainsaw and was made to leave the class. I came back eventually and painted a really bad portrait of my teacher in the style of Van Gogh.

JN: So what do you like to look at?

QM: Ancient Greek art, a lot of films, snapshot-y photographers like Jacques Henri Lartigue and Wolfgang Tillmans, the sculptor Stephen Balkenhol, also Willem de Kooning. Lately, when traveling I look for signs that say Danger: Slippery Surface. I've been collecting pictures of people falling over.

JN: When did you realize you liked art?

QM: I began an advertising degree after high school. Halfway through, I won a design prize and the university flew me to London to accept it, and they didn't hear from me again. There was a show at the Tate Modern of the Arte Povera artists, and I remember standing in front of a work by an artist named Giovanni Anselmo thinking, This is it.

Before that I wasn't really aware there was such a thing as conceptual art.

JN: What was the work?

QM: It was a plinth with a cabbage and a slab of granite tied to it, so that if the cabbage got old and wilted, the whole thing would smash itself. So the security guards had to replace the cabbages each day. I have no idea why it moved me so much.

JN: Why do you draw?

QM: It began as a way to record plans for other media. I studied architecture, art, and advertising, and worked entry level jobs in film, publishing, and theater. It seemed like a good way of storing ideas for later.

JN: Do you dabble in other mediums?

QM: I've helped out on films, theater, and magazines in my free time—though it's always been on other people's projects, just observing and learning the ropes.

JN: At some point did drawing become a worthy thing for you in and of itself?

QM: I tried all these different fields, and nothing communicated the way I wanted it to. One morning I was feeling pretty depressed, and I just thought, Screw it, I'm just going to put all my ideas into a book and give them away. It was a sad moment, an admission that I probably wasn't going to actually do any of this stuff. But people's reaction was great, which cheered me up.

JN: Your drawings seem to cheer people up.

QM: When I'm drawing them, I'm always very gleeful.

JN: Why is being funny important to you?

QM: Humor is redemptive in a way. I don't know.

JN: I was about to ask you if it would be good if everyone were laughing all the time, or at least most of the time, and then I realized that sounds like some creepy, insane utopia gone wrong.

QM: Yeah. I've read about laughing workshops, where everyone laughs together for no reason. They scare me. I think unmotivated group-laughing sounds like a technique a dictator would use.

JN: How does the text in your work come about?

QM: It's different in each drawing. As soon as something develops into a methodology, it feels like cheating.

JN: How quickly *does* something develop into a methodology?

QM: After it's done once.

JN: How do you decide a thing is finished?

QM: Yeats described it as "the click of a well-made box."

JN: You're not afraid to make a spelling error or change your mind in the middle of a drawing and just cross out words. Why?

QM: It's pretty basic, generic comedy. You take a mistake and frame it as performance. You also turn it into abstract expressionism when you're scribbling things out.

JN: What's appealing to you about this so-called DIY aesthetic?

QUENTON MILLER, *Time to think…*, 2008, mixed media on paper, 8.3 × 11.8"

QUENTON MILLER, *Thinking of baby names…*, 2008, mixed media on paper, 8.3 × 11.8"

QUENTON MILLER, *Argument staged to...*, 2008, mixed media on paper, 8.3 × 11.8"

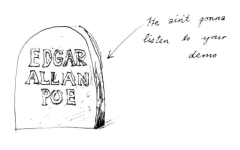

QUENTON MILLER, *Edgar Allan Poe*, 2008, ink, gouache, and correction fluid on paper, 8.3 × 11.8"

QM: That you can often see the process and the personality of whoever made it. With most of my work, no matter how hard I try it ends up as a kind of portrait.

JN: It's a low blow, but people say things about the drawings in the apex show like, "That looks so easy" or, "My kid could do that." For a while Shrigley had an e-mail on his website from a ranter about how insulted she is that his work gets shown in museums. Do you have anything to say to people who get worked up like that?

QM: I don't think the work's easy to make. And there shouldn't be a correlation between the difficulty of making a work and what you get out of it. I mean, do you think "bad," or unskilled, drawing can speak in many comprehensibly different voices, or do you think Bad is a single voice in itself? I really hope that Bad contains all these different voices. That was what I liked most about the apex show: having all these different types of drawings there, it turned crudeness into a genre.

JN: Do you think it matters whether crudeness is natural (unintentional) instead of intentional? Is natural versus intentional even a real distinction?

QM: I can't tell the difference. A lot of what seems accidental or arbitrary isn't.

JN: What do you think is the effect of "Bad" on the viewer? Is it playing on the viewer's notions of authenticity? Does authenticity matter to you? Sorry. That was a barrage of questions, but it seems like they're getting at the same thing.

QM: I think authenticity matters a lot. Also, I'm suspicious of that word, authentic. But I understand what you're saying: People see this stuff as unmediated. And sometimes in some ways, it is. When I was an architecture student, my drawings were full of corrections and they had staircases and walls in the wrong place. Instead of redrawing everything, I used to cut it all up and recollage it, so everything would fit, which turned out to be funny. But I could never consciously re-create that. You just have to be open to whatever happens. Jasper Johns said, "the work is an accumulation of corrections," or something like that.

JN: What does drawing well mean to you?

QM: "Well" for me means there's humanness. The drawing grows, thinks, has a mind of its own, betrays itself, outsmarts me. I'm interested in drawing thinking rather than drawing things.

JN: Interesting. You're trying to visually render the thought process?

QM: My work is very related to thought. Embodied ideas rather than concepts. At one stage I was very influenced by Language poets, and contemporary artists like Ed Ruscha and Lawrence Weiner.

JN: Which one comes to you first, the text or the image?

QM: It changes all the time. Seeing them as separate makes you end up with more traditional cartoons. But you could easily take a *New Yorker* cartoon, describe the image in words, and then draw a picture that expresses the sentiment of the caption.

JN: Wait—what? Sorry, I'm a blockhead.

QM: It would be a reverse cartoon. Of course, it wouldn't work on every cartoon.

JN: Right, right. Ending up with more traditional cartoons. That notion hits on why your work isn't simply a cartoon. These are fine art of some kind. Or, actually, does it matter what we call this form?

QM: Well, for most of the time I've been drawing, I didn't distribute my work. So I didn't really have to define it. My drawings are more like a different medium than a different category. Now they're just defined by where they go. There are things you can do or show in a gallery that you can't do in a newspaper, and vice versa.

JN: I think of the Beat poets, who in truth have a pretty different sensibility than most of the artists in this book, and I don't think of you as having a Beat sensibility, but there is that affinity for the sketch feeling—both in Beat writing and in your drawings. And that's cool. But as you say, it's an illusion. First Thought, Best Thought—yeah right. I mean these guys—Kerouac, Ginsberg, and company—tortured over their writing. Likewise, with your work, even if it feels like a sketch, the sketch aesthetic is, as you said, a show, a put-on. Unrelatedly, do you hunt or ski or stage fake arguments in theaters that then turn into real arguments?

QM: Right. Well, my work is often autobiographical, but never in the way people expect. If it seems like I'm talking about a real event, I'm usually not. It takes about a month for me to show stuff from my life in drawings. And it always turns up accidentally, with all the events slightly different.

JN: Where do you usually draw?

QM: I carry a sketchbook everywhere and try to draw things the second I, or someone else, thinks of them. I also spend a few hours each day working. Mostly at home.

JN: Do you work more intuitively or do you make extensive plans for your drawings?

QM: Both, but never at the same time.

JN: Have you ever wanted to be a writer?

QM: Yeah. Though I always want to branch out into the context in which the words appear. Whether it's film, theatre, or graphic design. Writing seems very pure. My heroes have always been writer-directors like Brecht or writer-designers like the Polish poster maker Henryk Tomaszewski.

JN: Do you see your drawings largely as contexts in which your words can appear?

QM: No, the images aren't subservient to the words. I mean, the words don't come before the images.

JN: Do you make much use of titles?

QM: If there are any words, I usually put them in the picture.

JN: What is drawing for?

QM: Shopping lists. Giving shape to thoughts, maybe. I'm not good at generalizations because my first instinct is to contradict them.

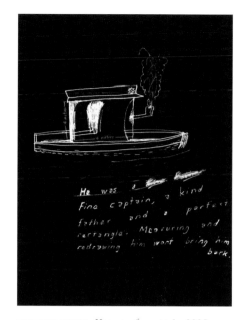

QUENTON MILLER, *He was a fine captain,* 2008, mixed media on paper, 8.3 × 11.8"

QUENTON MILLER, *My hair, in the wind…,* 2008, mixed media on paper, 8.3 × 11.8"

LINDA:

VAST SATISFACTION
OUT OF CANCELLING PLANS

LEANNE SHAPTON, from "Despair," 2001, ink on paper, 8.3 × 11.7"

LUCY:

SUSAN:

TO WHOM CAN
I EXPOSE THE
URGENCY OF
MY OWN PASSION?

A TOUCH
OF ANXIETY
EVERY HOUR
ON THE HOUR

LEANNE SHAPTON, from "Despair," 2001, ink on paper, 8.3 × 11.7"

73

TANYA'S EX-BOYFRIEND MARCEL
ONCE TOLD HER THAT
THE SEX THEY HAD WAS
"UP THERE WITH THE BEST."

LEANNE SHAPTON, *Was She Pretty?* drawings, 2005, ink on paper, 5.5 × 8.5"

PETRA:

ESPECIALLY ANGERED
BY THE DELAY

LEANNE SHAPTON, from "Despair," 2001, ink on paper, 8.3 × 11.7"

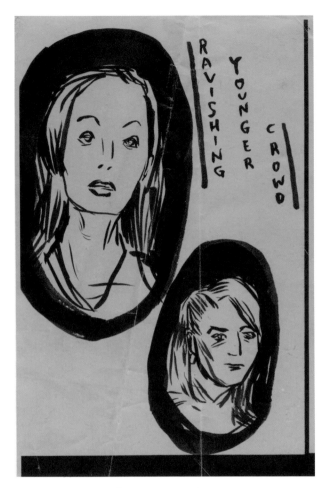

LEANNE SHAPTON, *Ravishing Younger Crowd*, 2002,
ink on paper, 6 × 9″

"I really like drawing from news photographs, the less stylish the better."

An interview with Leanne Shapton

Leanne Shapton is an illustrator, writer, and publisher who was born in Toronto and lives in New York. She is the art director of the New York Times *op-ed page and cofounder of J&L Books, a nonprofit publishing company specializing in new photography, art, and fiction.*

JESSE NATHAN: How would you describe the relationship between text and image in your drawings?

LEANNE SHAPTON: I'd say the drawing is standing alone near the bookcase. Perfectly happy. The text walks up and starts talking, then asks the drawing on a date. At first the drawing is surprised, but is flattered and curious, so accepts.

JN: What do you like to look at?

LS: I like looking at things that are unexpectedly symmetrical, and things that look quiet. Also, dim colors and organic, hand-drawn shapes and lines.

JN: Any particular reason things that look quiet appeal to you?

LS: I think I'm drawn to things that take a minute to sink in. When I say "quiet," I mean possessing a firm, planted feeling, requiring a scan or a read, literally or emotionally. I like looking at Luc Tuymans, Fantin-Latour, Vanessa Bell, Ged Quinn, and Cy Twombly's flowers. Outside of the art world I'm drawn to color and story. Catalogs, samples, random still lifes, things that have come to a rest in some possibly random but appealing configuration.

JN: Have you always drawn?

LS: Yes. Except for a number of years where I swam competitively. Too tired to draw.

JN: Why do you draw?

LS: To focus on what I like or find interesting about something.

JN: Do you seek to be funny in your work?

LS: I try to get the pitch right, and I try to be honest. I think Coco Chanel said "Those who laugh are always right," which makes me hope something that's true makes people laugh.

JN: What do you go for in your texts?

LS: The text is usually emotional and has to do with hauntings or yearnings. I think I try to articulate unspoken feelings.

JN: What is your process—and how do you mix things up to keep from getting bored or complacent?

LS: In terms of the words, I can get fixated on a tone I like. For a while I liked reading a book of translated French idiom for its clear, weird language. It read like English heard through a paper towel tube or something—louder and clearer but distanced. I would try to write like that, with that distance. Or I'd read everything by one author for weeks, like Françoise Sagan, to try to understand the lightness of her sentences. In terms of images, I really like drawing from photographs, usually news photographs, the less stylish the better. I usually draw first, then write. I also like drawing from life, but do it less lately.

JN: Do you have to change your methods up a lot?

LS: I don't have to change things up too much, but I need to have a relatively clear drawing surface and the right ink and paper. The wrong paper can throw everything off course. Things usually change up without my thinking about them; I'll find a new color or perspective or piece of furniture to fixate on, and things will shift from there.

JN: Do you ever get your text from elsewhere, or do you pretty much make it up?

LS: I have done both. I quite like illustrating random found phrases sometimes.

JN: Do you do lots of drafts of drawings?

LS: I will draw something over and over until it feels and looks right. This usually comes as a total surprise.

JN: How do you react to the surprise?

LS: If I'm surprised by the result, it's either, "Sheesh, how could I have made something so lame?"—at which point I will put it aside and do it over—or it's, "Hey, that's not too bad, did I do that?"—at which point I will acquiesce to whatever's happened. I would love to be habitually reliable in my drawings, to know that my hand is trained to deliver something true to me each time. That is a big dream. I have off days where every decision I make is the wrong one. When nothing looks like I made it. But then sometimes months or years later I will look at something I thought was bad and see its charms and be glad I did not rip it up.

JN: When you misspell a word, what do you do?

LS: I usually swear. I stand up and put my hands on my hips and stare at the word,

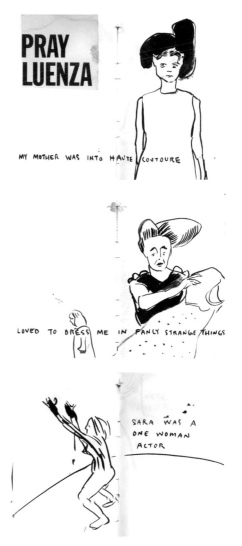

PRAY LUENZA

MY MOTHER WAS INTO HAUTE COUTOURE

LOVED TO DRESS ME IN FANCY STRANGE THINGS

SARA WAS A ONE WOMAN ACTOR

LEANNE SHAPTON, from "Pray Luenza," 1999, ink on paper, 10.5 × 8"

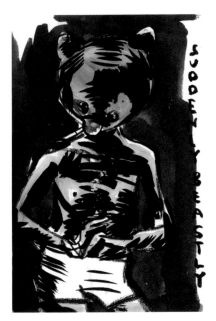

LEANNE SHAPTON, *Suddenly Beastly*, 2001, ink and acrylic on paper, 8 × 10"

then start over, or use my Liquid Paper pen, or rewrite it underneath if I can photoshop it and am delivering a digital file.

JN: Do you differentiate between drawings you want to keep around and someday maybe reconsider versus drawings that you rip up pretty much right away? I mean, do you have different types of trash or something?

LS: The ones I rip up right away are ones that I'm pretty confident are not redeeming in any way. I do save some that—in my head—I will throw away later, but I'd say that was motivated by indecision, not something as positive as reconsidering.

JN: Is the handwriting in your drawings your actual everyday handwriting?

LS: No. The handwriting in my drawings is much more legible.

JN: Did it take you awhile to develop the handwriting you use in your drawings?

LS: I almost always write in all caps—which I also use in my drawings—but using a brush makes me slow down, resulting in much neater letter forms. I avoid serifs on the letters in my drawings, though, I think out of laziness. And I think they look too fancy.

JN: How do you decide something's finished?

LS: If all the information I need to deliver is present. Not too much, not too little. And if the thing feels like it sits on its own.

JN: Do you read the Sunday funnies?

LS: No.

JN: Have traditional comics ever had any draw for you?

LS: I would read the *Toronto Star* comics when I was little, and would save my favorites for last. So I would flip all around the section, reading all the less funny ones first and covering up the ones I liked so I wouldn't see the punch lines. I loved them. My favorites were *For Better or For Worse*, *Peanuts*, *Family Circus*, and *Blondie*. Then I got into *Mad* magazine.

JN: Which comes first usually, the text or the image?

LS: Image always comes first for me. Then I see if it needs text or not.

JN: How crucial to you is technical accuracy in your drawings?

LS: Not important in my own drawings.

JN: What does drawing well mean, in your view?

LS: I don't think drawings have to be drawn well, but in my case I prefer them to have a certain resolvedness about them.

JN: Do you make good art when you're feeling surly?

LS: I feel surliest when I am dancing to New Order! I think I might make better art when I'm feeling rested. I have to be rested to write and draw surly.

JN: Is the material autobiographical? Does a lot of it sort of, or even directly, happen to you?

LS: Much of it is. I'd say about sixty percent, though, is made up. Sometimes after completing a drawing, I know it wants some words in or over or beneath it. And it will just find those words, I'm not sure where they come from sometimes. Like I drew a couple once and then wrote on the man's chest something like, "You are what I'm fighting for," but I have no idea what on earth it means or where it came from.

JN: Are you trying to tell stories with your drawings?

LS: Very much so.

JN: Have you ever wanted to be a writer?

LS: I have always wanted to be a writer. There is this quote that was a favorite of a friend of mine, which goes, "One must apply truth and energy in naming things. It elevates and intensifies life." By Thomas Mann. From *The Magic Mountain*. I've always wanted to call things as clearly as I can.

JN: Does your work belong in a gallery?

LS: I don't know where my work belongs!

JN: Are there things that belong in an art gallery that aren't there?

LS: I see a lot of art I really like through galleries, but I also see a lot I like through books, magazines, the Web, and word of mouth. I do love galleries. They offer a respect and focus to all kinds of work: design, children's wallpaper, found notes, heart-stopping paintings, photography, sculpture, and so on. Which is why thoughtfully and creatively curated gallery shows

are so, so valuable. I think the more galleries are used as an invitation into a world (either the artist's or the curator's) and less as a presentation of a sale, the better. I quite like it when stores sell art. It's so private and matter-of-fact, just between you and the thing, like you could bring it into a changing room for a few minutes to see if it changes you.

JN: Explain the genesis of your book *Was She Pretty?*

LS: *Was She Pretty?* started as a series of drawings I did in the basement apartment of Paul Davis, an ex-boyfriend. He was living in London and I was staying with him for the first time. He'd go off to work and I'd be alone in the flat. He had snapshots of women on shelves and meaningful-seeming mementos lying all around. The only spot free of phantom women was the front room, where I would sit and draw faces from the London papers. I began to draw and write about the most intimidating, attractive, and mysterious aspects of the various "other women" in my past.

JN: What about the drawings that you painted on the wall at apex?

LS: The first of these sorts of drawings were done in that London apartment, too! I called it the "Despair" series. It's a cliché, I know, but the British do tend to construct very dense and brief sentences, with nice little turns of phrase, and going through their weekly newsmagazines and papers I'd sort of pick threads of stories and invent these sad little vignettes. The apex portraits were done from that day's *New York Times*,

LEANNE SHAPTON, cover for *Was She Pretty?*, 2006, 208 pages, 15.2 ounces, 8.4 × 5.8 × 7"

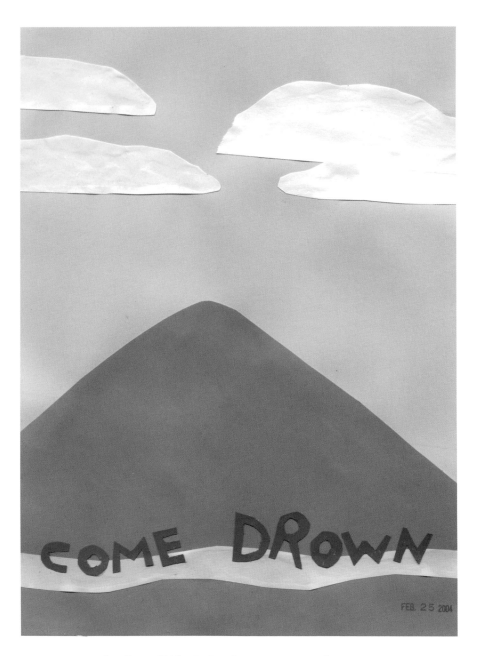

ROYAL ART LODGE, *Come Drown*, 2004, mixed media on paper, 11 × 8.5"

ROYAL ART LODGE, *Poster Making*, 2007, mixed media on panel, 6 × 6"

the invention of skeletons

MARCEL DZAMA, *The Invention of Skeletons*, 1999, ink, watercolor, root beer base, and paper

Count Dracula sends his message of damnation to the people of Canada

MARCEL DZAMA, *Dracula sends his message of damnation to Canada*, 1999, ink, watercolor, root beer base, and paper

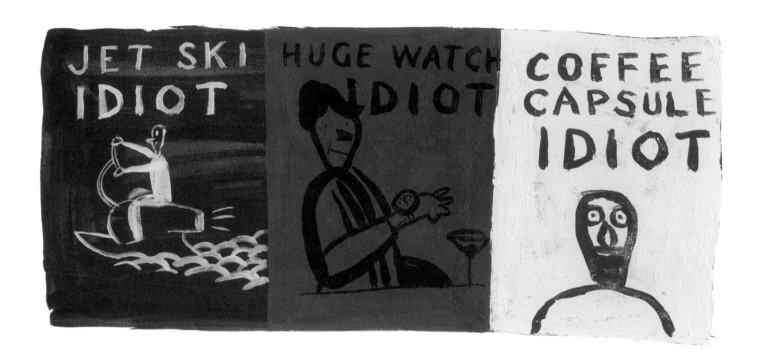

JEFF FISHER, *Opulence*, 2008, acrylic on paper, 4 × 9"

JEFF FISHER, *The Only*, 2008, acrylic on paper, 3.5 × 3"

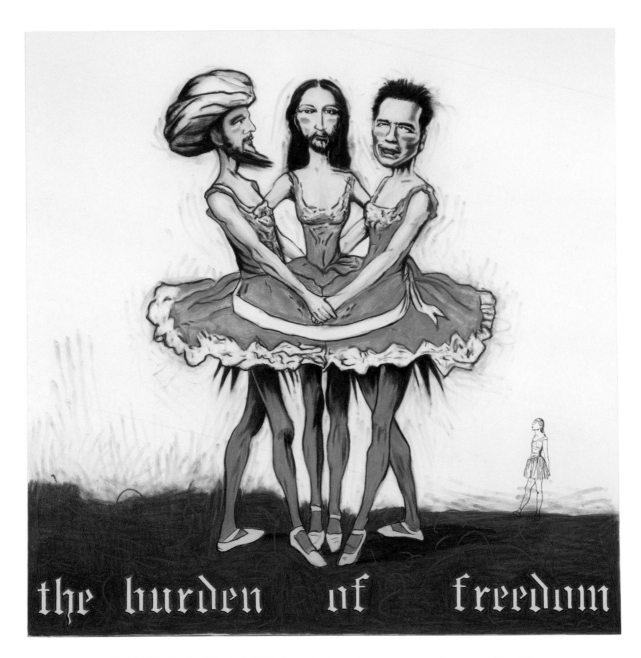

ENRIQUE CHAGOYA, *Untitled (The Burden of Freedom)*, 2006, charcoal and pastel on paper mounted on canvas, 60 × 60"

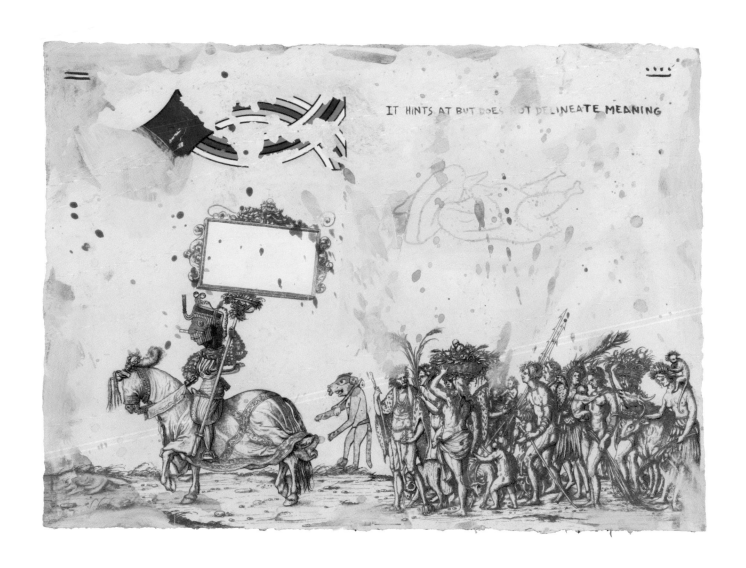

ENRIQUE CHAGOYA, *Illegal Alien's Guide to Philosophical Thinking*, 2006, from mixed-media accordion book, 14 pages, each 8 × 10"

ENRIQUE CHAGOYA, *Untitled (Border Patrol)*, 2006, charcoal on paper mounted on canvas, 60 × 60"

"You have a face so ugly, it looks like a painting by my uncle Enrique."
An interview with Enrique Chagoya

Enrique Chagoya was born and raised in Mexico City. He earned a B.F.A. in printmaking from the San Francisco Art Institute in 1984. He then pursued his M.A. and M.F.A. at the University of California, Berkeley, graduating in 1987. He is a Full Professor in Stanford University's Department of Art and Art History, and his work can be found in public collections all over the world.

JESSE NATHAN: What do you like to look at?

ENRIQUE CHAGOYA: I like to see landscape scenes that are very wide open. This leaves a deep impression in me. I really like the desert. A few months ago, a show of mine opened in Palm Springs, and right next door is Joshua Tree. I'd never been there and it blew my mind. The rocks are huge and out of this world. It left a huge impression. Everywhere around it's like in another world, like on a another planet. I like to look at places that are unfamiliar to me. Especially landscapes. But I like urban landscapes, too. I grew up in Mexico City. I don't know if I could say I liked it, but it leaves a mark in your brain.

JN: Do you consider yourself a painter or a draftsman?

EC: Both. And a printmaker. I like two-dimensional imagery a lot. Since I was a kid. I grew up reading all kinds of comics. Almost any big popular American comic was translated into Spanish. Like Superman or all the DC and Marvel comics—these were all translated into Spanish. But also there were a lot of Mexican comics that were pretty crazy. As a kid, as soon as I had money I used to go to the corner stand and choose from the weekly selection of comics, and then when I read them I used to resell them at my house. There were stairs at my parents' house. I would put them on the stairs and sell them to get money to buy new comics. And that's how I kept going.

JN: Your drawings use recognizable visual symbols—Mickey Mouse,

Jesus, political figures, Francisco Goya... why?

EC: I like to use imagery that is readable as language. For me, popular imagery is a substitute for words. I want to use images that people can read, visually speaking. When I remix them, the groups of pictures on the page become their own sentences. I don't just reappropriate, I rearrange and shuffle. None of us invents the words we are speaking, but we invent the sentences and ways of using those words. The way I use pictures is just like that, like a language. A language hopefully with no phonetics. And I like appropriating European culture from the perspective of an indigenous character. This is the reverse of what happened, of course. But many Europeans did this, worshipped the primitive. Like Picasso with the African masks or architects like Frank Lloyd Wright, who used Mayan architecture for his buildings. So I wanted to do this—and the reverse of what happened with European conquerors. Reverse anthropology. And it becomes some kind of a way of writing, but with visual elements. It's very similar in style to the way ancient books were written. With pictures. It's almost illogical to think you could only have thoughts with words. There are other ways of thinking.

JN: What is it about Goya's work that resonates with you?

EC: His darkness. The way he enlightens us with darkness. It's like a dark light. He has a really dark energy that somehow hasn't changed in history. His "Disasters of War" or the "Caprichos" series, which is a satire on superstition, these are still relevant in our times. Maybe *more* relevant in our times.

JN: And he was one of the first and most prominent to fuse words and images together the way we find artists doing throughout this book.

EC: And he does it with stinging satire. And a playful darkness. He'll draw a demon with funny ears or something.

JN: Is being funny important to you in your work?

EC: Yes. Well... I think so. I have a sense of humor that sometimes offends my own friends. And I'm not going to name any examples. I grew up in a family full of funny, cruel minds. We attacked each other with jokes—not insults, jokes—about weaknesses, and if you didn't strike back with another joke, you would lose. My uncles would make fun of me, and I would have to make fun of them back and... well, I don't know. Here's an example: When my nephew was four or five years old he got in fights of jokes with my brother-in-law. "You have a face so ugly, it looks like a car crash." "Well, you have a face that looks like bacteria." Back and forth. Then my nephew said, "You have a face so ugly, it looks like a painting by my uncle Enrique." And my brother-in-law lost.

JN: That's great.

EC: Yes, you see, in the country I come from, we manage to laugh in the face of tragedy. For two weeks during the big earthquake in Mexico City (I was living in

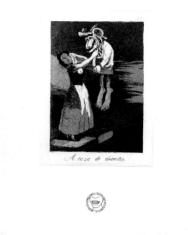

ENRIQUE CHAGOYA, *A caza de Dientes ("Out Hunting for Teeth")*, from "Return to Goya's Caprichos," 1999, ink on paper, 15 × 11"

ENRIQUE CHAGOYA, *Adventures of the Minimalist Cannibal*, 2005, acrylic and water-based oil on Amate paper mounted on canvas, 48 × 96"

89

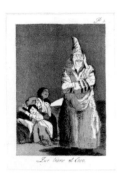

ENRIQUE CHAGOYA, *Que Viene el Coco ("Here comes the Bogey-Man"),* from "Return to Goya's Caprichos," 1999, ink on paper, 15 × 11"

ENRIQUE CHAGOYA, detail from the codex *Illegal Alien's School of Art and Architecture,* 2006, acrylic on Amate paper, 9.5 × 15.5"

Berkeley at the time) I had no contact with my family. The building where the phone operators were had collapsed, and maybe all the operators had died. There were no flights going there. It was a mess. Finally I got a message from my family that they were fine. When I got to talk to my sister the first thing she did was to tell me jokes one after another. They were so funny.

JN: How does the text in your work come about?

EC: The text is usually the last thing I do. Most of the time it doesn't have any illustration connection to the image. I don't want the image illustrating the text, and I don't want the text describing the image. I want it to go like a duet. Like two good friends in a conversation. Like two different statements, connected.

JN: Do you ever get your text from particular sources, or do you make it up?

EC: Both. For *The Burden of Freedom*, I made it up. In other cases I open magazines, like *Artforum, October* magazine—some of those highly theoretical and sometimes incredibly rhetorical magazines. Magazines that aren't very clear, that are neither specific nor concise. Often they don't say much to me. So sometimes when I make a goofy cartoon it just makes sense to me that something in the cartoon should be talking like that, like the way things are said in *Artforum*. Another purpose of satire is making fun of theoretical writing. I like art theory. In my formative years I was really moved by writing about art. But mostly by artists. I was really moved by the Construc-

tivists. Or writings by people like Joseph Beuys, even though he tends toward the rhetorical. Most of the art writing, though, that I read just totally annoys me.

JN: What are you trying not to do when you sit down to make a picture?

EC: My only fear is to do boring art.

JN: Do you do lots of drafts of drawings?

EC: No. Just tiny sketches so I will not forget the idea. But I don't imitate the sketch, I just get the flash of an idea down. I often get these flashes in the middle of the night. I have insomnia, and suddenly when I'm almost asleep I have a flash. I have to get up and go draw it, and then I can go to sleep. That's how many of my ideas are born.

JN: Is the handwriting in your drawings your actual everyday handwriting?

EC: No, not necessarily. Sometimes I try to make something kind of baroque or English Gothic or even German Gothic.

JN: Why?

EC: Especially with the Gothic letters, I want them to look like old illustrations. Making some of my images look like they were done hundreds of years ago rather than today. Especially in the books or the codices. It's just a matter of creating distance, artificially, between the viewer and the work. When you see a work from hundreds of years ago, there's a lot of distance in time. I like to make that distance happen in the viewer's mind. The viewer moves back into that time. But I don't do that with all the works I do. With

codices, though, I try to make them look like they're old. And the same thing with the Goya drawings; they look like they were made a few hundred years ago, but they have familiar faces in them like Jesse Helms, Jerry Falwell, the Teletubbies…

JN: How do you decide something's finished?

EC: Depends on the work. If it's supposed to look like a Goya, once it looks like a Goya, it's done.

JN: Is making a mistake fun?

EC: I somehow manage to use the mistakes as part of the textures in the work and it becomes like a record of changes. I don't necessarily try to cover a mistake, I try to leave it a little obvious. Like leave erase marks in the drawings. Very often the mistakes enhance the final work. Mistakes lead you to things that could not have been planned. That could not have been premeditated. And so they end up enhancing the work. When I make a mistake, if I feel a good initial reaction to it I just leave it alone. If the work's just plain or straight up, I'm not very excited by it.

JN: Do you make extensive plans for your drawings?

EC: I work both ways. Sometimes I just have a general idea or a theme in mind. But I won't have specific images for that theme yet. It's very stressful, because I don't have a lot of time—I usually have at least two solo shows a year. And in between shows I procrastinate a lot. I grade papers. I become a news junkie. I read the *New Yorker*, the *New York Times*, then watch a lot of cartoons on TV like *South Park*. And suddenly I have a month before my opening, and I just jump off my seat. My ideas start popping out in my insomnia and then it's nonstop working every day until I'm ready. And then at the opening I'm totally relaxed, and it's back to procrastinating and watching movies. But it's not a waste, all that time watching movies. That's just how I think about new themes. That's just the way I get updated. School can be very demanding, too, and take up a lot of my energy. Doing this procrastination is actually a very good way for me to think about my work and to rethink my work, if I want to.

JN: Your work sometimes has a narrative component to it. Are you trying, in part, anyway, to tell stories?

EC: Yes and no. They aren't logical stories. They don't follow a sequence. They could be read in many ways. There could be several interpretations about any drawings or comics I have done. Of course some are clearly editorial cartoons. *The Burden of Freedom*—for me, that's like an editorial cartoon. In general, I don't like to convince people of my ideas, though. I'm just basically exercising my freedom of expression and also trying to exorcise my fears, my demons, my anxieties about the contemporary world. And that's maybe another role of humor. Because through humor, and through these images that might not have any specific narrative, the humor gets rid of the anxieties and the nervousness. It makes me relax when I put something funny rather than just tragic in the work.

ENRIQUE CHAGOYA, *Illegal Alien's Guide to Greater America—The Pastoral or Arcadian State*, 2006, multi-plate color lithograph on Amate paper, 25 × 40"

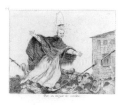

ENRIQUE CHAGOYA, *Que se rompe la Cuerda ("May the Cord Break")*, from "Homage to Goya II: Disasters of War," 1983–2003, ink on paper, 13 × 15"

DOGS MUST BE
HELD ON LEASH.
GUARDIANS MUST
PICK UP AFTER
THEIR DOGS.

Health Code 40(a)(b), Park Code 3.02

9/03 SSC C&C OF S.F. 3M

PROFILE OF A SPHERE

DRAMATIC HAT DANCE

WILLIAM WEGMAN, *Profile of a Sphere* (left), 1974, pencil on paper, 8.5 × 11"; *Dramatic Hat Dance* (top right), 1974, ink on paper, 8.5 × 11";
Home Cooking (bottom right), 1978, ink on paper, 11 × 14"

x Ray of peach in dish

WILLIAM WEGMAN, *X-Ray of Peach in Dish*, 1973, pencil on paper, 8.5 × 11"

RALPH STEADMAN, *Postcard from Bosnia*, 1995, ink on paper, 23.5 × 33"

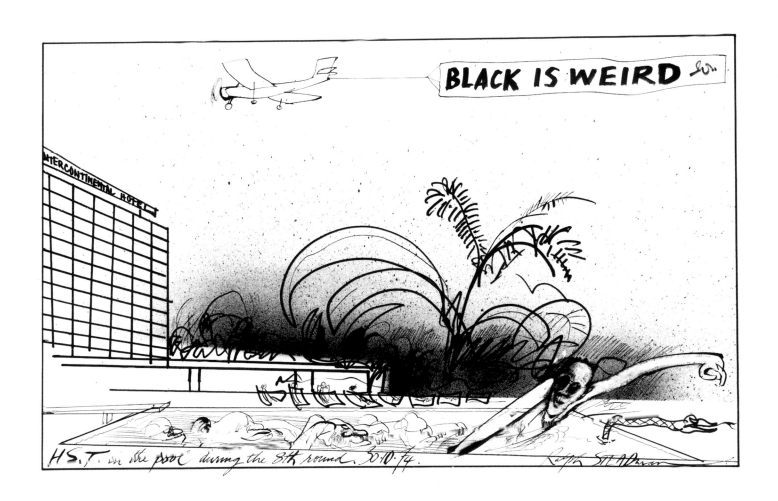

RALPH STEADMAN, *Black is Weird*, 1974, ink on paper, 23.5 × 33"

IF NANCY KNEW WHAT
WEARING GREEN AND YELLOW
ON THURSDAY MEANT.

André Breton at eighteen months, 1897

IF NANCY WAS ANDRÉ BRETON AT
EIGHTEEN MONTHS.

JOE BRAINARD, *If Nancy Knew What Wearing Green and Yellow on Thursday Meant* and *If Nancy Was André Breton At Eighteen Months,* 1972, mixed media on paper, 12 × 9"

IF NANCY WAS A DE KOONING.

IF NANCY WAS A BOY.

JOE BRAINARD, *If Nancy Was a de Kooning* and *If Nancy Was a Boy,* 1972, mixed media on paper, 12 × 9"

UPON MY ~~RED~~ RETURN FROM EXILE
I ENTER THE TOWN
RIDING A GIANT GOOSE

THE GOOSE
WILL PECK THE
FUCK OUT OF
ANY PROTESTORS

DAVID SHRIGLEY, *Untitled*, 2005, ink on paper

WHAT DO YOU FEEL?

I FEEL NOTHING

WHAT DO YOU SEE?

I SEE NOTHING, OR
AT LEAST, NOTHING I
CARE FOR

WHAT DO YOU WANT?

I WANT A MASSAGE

DAVID SHRIGLEY, *Untitled*, 2005, ink on paper

I AM A CRAZY ~~MOTHER~~
~~FUCKER~~

AND
I AM VERY PROUD OF
MY ARTISTIC ACHIEVEMENTS

DAVID SHRIGLEY, *Untitled*, 2005, ink on paper

YOUR CURRENT LOVER

YOUR FORMER LOVER

YOUR DOCTOR

DAVID SHRIGLEY, *Untitled*, 2005, ink on paper

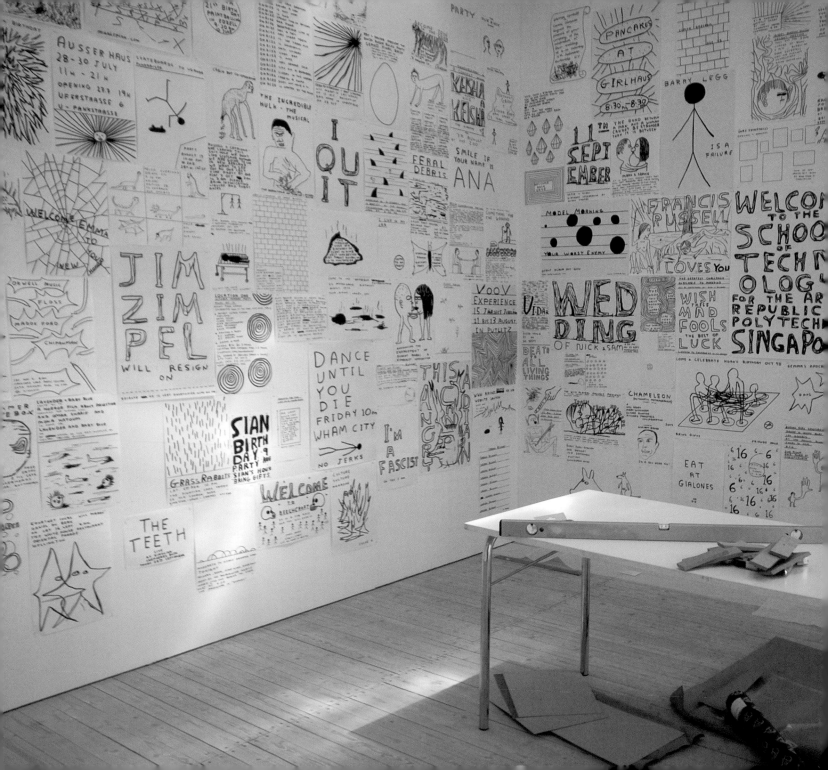

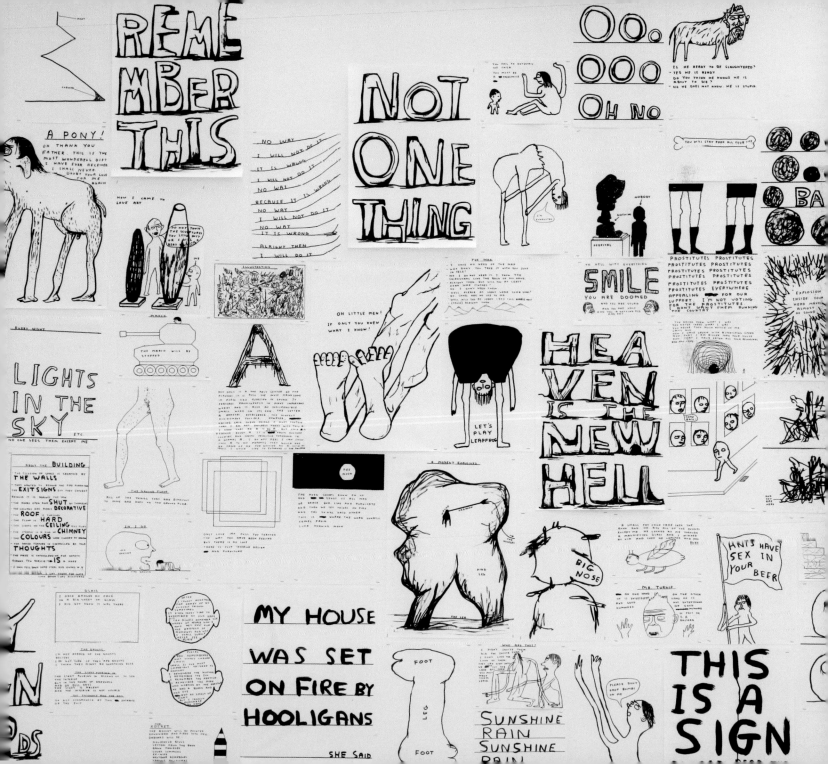

MUSIC HAS LOST IT'S POWER

SO HAS VISUAL ART

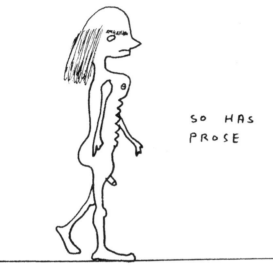

SO HAS PROSE

NOW IT IS THE SOLE RESPONSIBILITY OF THE WRITERS OF ~~LIMERICKS~~ ~~████~~ TO DESCRIBE THE HUMAN CONDITION.

DAVID SHRIGLEY, *Untitled*, 2005, ink on paper

"A drawing doesn't get any better if you do it twice."
An interview with David Shrigley

David Shrigley was born in 1912 and lives in a sixteenth-century castle on the banks of Loch Ness in Scotland. He has been married five times and has accumulated many children, none of whom he sees. After a career as a butcher in Glasgow, he retired in 1975 to pursue his obsession with drawing. Despite his old age he is still a keen badminton player.

JESSE NATHAN: Is it true vandals used to break into your studio and draw on the walls?

DAVID SHRIGLEY: The vandals? Yes, they broke into my studio and wrote stuff on the walls, but it was highly unimaginative stuff, as I remember. Like their names, the names of their favorite soccer team, stuff like that. That's the thing that most annoys me about vandalism. Most of it shows no creativity whatsoever. It's like they have just learned to write and the actual act of writing is still a novelty. If I'm going to be defaced, I want it to be done with flair.

JN: What do you like to look at?

DS: I seem to have been traveling a lot lately and end up watching quite a few in-flight movies. Instead of looking at all the latest movies, I have started watching old black and white ones. They are so much better. On a recent trip from New York City I watched *The Treasure of the Sierra Madre*. I've even started looking at TCM at home.

JN: Why do you draw?

DS: Not drawing would be like not speaking.

JN: Do you dabble in other mediums or forms?

DS: I guess there aren't too many mediums I don't dabble in. I've never expressed myself through dance (that I can remember), but perhaps it's not too late.

JN: Is being funny important to you?

DS: I think being funny is important. Everyone has the capacity to be funny, and everyone should use it.

JN: Do you ever get your text from particular sources, or do you always make it up?

DS: Sometimes I find pieces of text that seem profound when you use them in a different context. It seems sometimes almost any text can appear profound when you think about it: "Remember me on this computer," or, "Why am I being asked for my password?"

JN: Which one comes to you first, the text or the image?

DS: Ideally it alternates for each drawing, but I think it's more often the image. It bothers me a little, so I have been deliberately trying to do the opposite recently.

JN: Can you take us through a moment you conceived of some wisp of an idea to the final product in one specific drawing?

DS: I'll give you two examples. Example one: the phrase "artist eaten by a wolf" came into my mind. Don't know where from. I wrote it down and drew a picture of a wolf above it. Example two: I was sitting in my studio with a blank piece of paper. I looked at the computer. I drew a crappy picture of someone in front of a computer. I checked my e-mails to discover I had none. I wrote that down.

JN: Do you do lots of drafts of drawings?

DS: No drafts. Unless I'm designing a T-shirt or something and they have asked me to remove swearwords.

JN: Why no drafts?

DS: Because a drawing doesn't get any better if you do it twice.

JN: Do your drawings end up where you expected they would?

DS: If you mean the places that my drawings get reproduced, like T-shirts, underwear, the sides of buildings, etc., then yes, I am constantly surprised. If you mean, am I surprised at how the drawings turn out from what I intended when I started each drawing, then, again, the answer is yes, but that's how I work. The method is to try to defeat my expectations.

JN: How quickly does something develop into a tired method?

DS: I suppose a way of working becomes a tired method if you do it more than once. I try to do things that will be different from the last thing I did, which I suppose in itself is a kind of method or strategy.

JN: How do you avoid boredom?

DS: If I'm working, then I'm not bored. I try seeing every group of works I make as a project without an expectation of the result. Often the project is just to use the materials at hand, To use all the paper, clay, wood, whatever. Sometimes I just work for a set amount of time, like eight hours a day. It doesn't matter what I do as long as I work for the set period or use all the materials. Somehow this seems to work.

JN: Do you work quickly?

DS: I think I probably do. It's not something I'm very conscious of. I will have

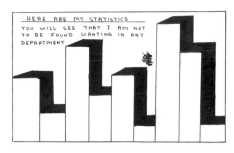

DAVID SHRIGLEY, *Untitled*, 2005, ink on paper

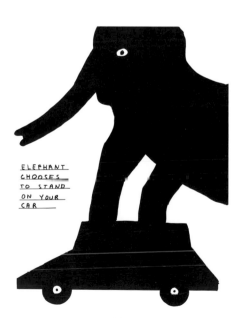

DAVID SHRIGLEY, *Untitled*, 2005, ink on paper

OBSESSIVE COMPULSIVE DISORDER
SAVES LIVES

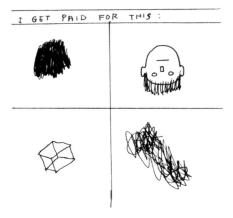

DAVID SHRIGLEY, *Untitled*, 2005, ink on paper

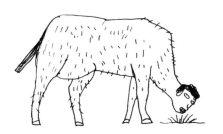

DAVID SHRIGLEY, *Untitled*, 2005, ink on paper

done nine solo exhibitions this year, so I guess that suggests I get a lot done.

JN: Where do you usually draw?

DS: Anywhere I have time, but ideally in my studio, where the furniture is more ergonomic.

JN: Is the handwriting in your drawings your actual everyday handwriting?

DS: Yes.

JN: How do you decide a thing is finished?

DS: I give it time and if I still like it, then it's finished. The actual criteria are obviously highly subjective and perhaps would make no sense to anyone else, but I think it is often to do with whether the drawing in question is significantly different from other drawings I have done. Whether it surprises me or not.

JN: Is making a mistake fun?

DS: It's fun when you're making art but not when you're filling in your tax return.

JN: Why do you say making a mistake is fun when you're making art?

DS: I guess rendering an idea is less fun, where you're essentially copying a picture out of your mind. Mistakes are surprises, so they are fun.

JN: Do you like straight lines?

DS: I love straight lines. I collect rulers.

JN: Really? Where do you store them?

DS: They are stored in a cavernous steel vault miles beneath the earth's surface.

Temperature and humidity are carefully controlled by a computer. The entrance is patrolled by men with guns. Several people have been shot trying to gain unauthorized access.

JN: Are you a good speller?

DS: No. I have been known to spell my own name wrong.

JN: When you misspell a word, you seem to tend to cross it out rather than redraw. Why?

DS: I think I started doing this to show the process. I suppose it must appeal to me aesthetically as well. I'm also a bit obsessive-compulsive, so there is the fear that something bad will happen if I stop.

JN: Why do you gravitate towards showing the process?

DS: Perhaps I am interested in the "performance" of drawing and writing. Each performance is unique and must be performed in real time. Mistakes are part of the performance.

JN: What do you think is the effect of your artwork on the viewer?

DS: I think the responses I would like are laughter, intrigued confusion, disquiet. What my work actually promotes, I am not sure.

JN: Does it play on the viewer's notions of authenticity?

DS: I think notions of authenticity in art are deeply problematic. Suffice to say, when I make drawings I am playing a part. The

voice in my drawings is that of a crazy character who I invented.

JN: Your work does consistently have a narrative component to it. You're trying to tell stories with these drawings?

DS: They are often very abbreviated narratives, but narratives nonetheless. A single sentence is a narrative. It has a beginning and an end. I think all art tells stories. Some long, some short.

JN: Have you ever wanted to be a writer?

DS: Writing is part of what I do, so in a way I'm already a writer. I could perhaps manage some short stories but not a novel.

JN: Do you prefer your work to show up in books or in galleries?

DS: I like both places. Black and white drawings seem to work better in books, but I make sculptures, paintings, and animations as well. There was a time when I wasn't so interested in doing exhibitions, but I've changed my view on that now. I try to treat the gallery in the same way as a blank page and fill it up with stuff, in the same way that I approach drawing. I like doing exhibitions now.

JN: What sorts of creative ways of showing have you tried?

DS: In the last couple of years I have shown my drawings as large collages of ink-jet prints. This is partly practical, as I have all my drawings documented digitally and it negates the need to borrow or make new works. It's also partly an aesthetic decision, as it seems to suit the work to be shown en masse in a non-precious way, particularly if I'm showing in a large space. I show between one hundred and five hundred at a time, stapled to the wall in the manner one might find posters on the wall of a bar or something. I don't know if I'll do this forever, but it seems to work right now.

JN: Do you put them up with pins or nails, or what?

DS: They are put up quite roughly, using a staple gun.

JN: There's something about showing them that way that seems to be nodding towards a sense of haste (even if it's an illusion) or casualness. Do you agree?

DS: It's perhaps more of an acknowledgment that the ink-jet prints themselves are throwaway objects, but also one might suggest that this kind of installation resembles the spirit of the drawing itself: ramshackle, tangential, disordered, and so on.

JN: What does drawing well mean to you?

DS: Drawing well means to convincingly render three-dimensional space. I wouldn't say I drew so well in art school. Neither would my former teachers.

JN: What about now?

DS: When I was a kid, I guess I was relatively good at drawing, but by the time I got to art school I was pretty poor relative to the other students. I think I'm still pretty poor at objective drawing, but nonetheless I'm quite good at making drawings.

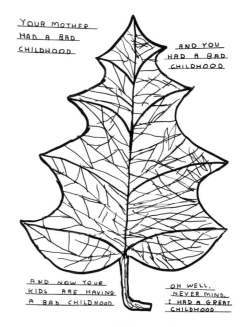

DAVID SHRIGLEY, *Untitled*, 2005, ink on paper

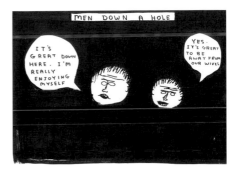

DAVID SHRIGLEY, *Untitled*, 2005, ink on paper

*Domino Intimidated by
a Funnel*

*Grape in Danger of Falling
into Open Drawer*

*Formal Glove Being Shone on
by a Gibbous Moon*

*Pebble Unmanned by
Probability of Anonymity*

EDWARD GOREY, from "Menaced Objects" (above and opposite), 1989, ink on paper, each 4 × 6"

Raisin Cookies Disquieted
by Mysterious Shadow

Stuffed Toy Being Trifled
with by Fire-Tongs

Tray of Calling Cards Threatened
by Quondam Coathanger

Used Chewing Gum Set Upon
by Unsharpened Pencils

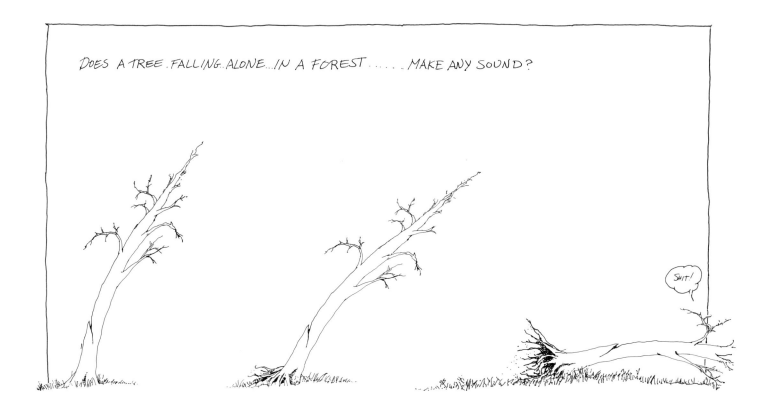

SHEL SILVERSTEIN, "Does a Tree Falling Alone in a Forest Make Any Sound?" from *Different Dances*, 1977, ink on paper, 12.5 × 7"

THE LONGEST NOSE IN THE WORLD, BELONGS TO MISS BETSY BLUE BONNET—WHO LETS ME WRITE THINGS ON IT.

SHEL SILVERSTEIN, "Longest Nose" from *Where The Sidewalk Ends*, 1974, ink on paper, 8 × 5"

SHEL SILVERSTEIN, *Anarchists of the World Unite*, 1958, ink on bristol board, 11.25 × 5.63"; *Huge Clearance Sale*, 1956, ink on bristol board, 13 × 3.5"

PAUL HORNSCHEMEIER, *Dialectic on Preference*, 2004, blue pencil and ink on illustration board, 10.5 × 8″

AIR PLANES

the situation

farting noises

IAN HUEBERT, *Air Planes*, *The Situation*, and *Farting Noises* from "LA LA Land," 2008, mixed media on paper, each 3.2 × 6"

SIGMAR POLKE, *We Are the Cigars,* 1963, ballpoint pen and watercolor, 11.63 × 8.25"; *Ghost with Necktie,* 1965, ballpoint pen, 11.81 × 8.25"

NOW THERE
PRINTS ON
PAP

ARE FINGER
THE GLOSSY
ER

INSTANT

MOST BOOKSTORES
CAN BE TALKED INTO A
10% DISCOUNT

REBATE

KENNETH KOCH, untitled drawing from *The Art of the Possible*, 1992, ink on paper

KENNETH KOCH, untitled drawing from *The Art of the Possible*, 1992, ink on paper

KENNETH KOCH, untitled drawing from *The Art of the Possible*, 1992, ink on paper

STOPPING OFF FOR PASTRY IN ATLANTIC CITY

| HEY! | YEAH? | CAN WE GET SOME PASTRY? | WHY, SURE! |

STOPPING OFF FOR HAM IN ATLANTA

| WANT → ATLANTA → | SOME HAM? | NO | THANKS! |

STOPPING OFF FOR OUZO IN ATHENS OHIO

SHOULD WE GET SOME OUZO?

THIS IS ATHENS OHIO, NOT ATHENS GREECE!

OH

SHIT!

KENNETH KOCH, untitled drawing from *The Art of the Possible*, 1992, ink on paper

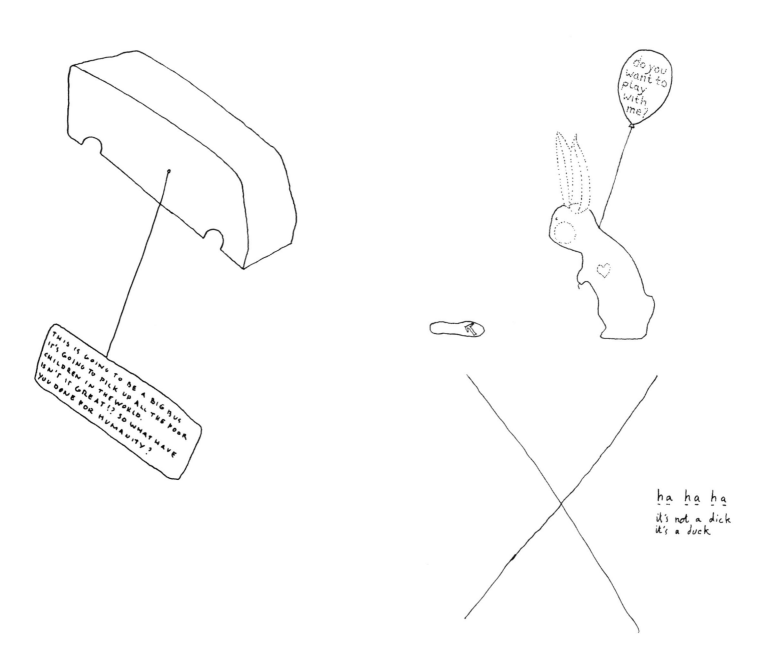

THIS IS GOING TO BE A BIG BUS IT'S GOING TO PICK UP ALL THE POOR CHILDREN IN THE WORLD. ISN'T IT GREAT!? SO WHAT HAVE YOU DONE FOR HUMANITY?

do you want to play with me?

ha ha ha
it's not a dick
it's a duck

OLGA SCHOLTEN, *This is going to be*, 2004, ink on paper, 11.7 × 8.3"; *Do you want to play*, 2004, ink on paper, 16.5 × 11.7"

NOTHING IS FORGOTTEN IT IS MERELY PUT ASIDE IF WRONG MAKE IT RIGHT

GET AWAY FROM ME BEFORE I STUFF YOUR BALLS DOWN YOUR FUNNY LITTLE THROAT

goddamned / ~~~~ doctor Phil !!

OLGA SCHOLTEN, *Nothing is forgotten*, 2004, ink on paper, 11.7 × 8.3"; *Goddamned*, 2008, ink and colored pencil on paper, 16.5 × 11.7"

HEE-HAW! HEE-HAW!
I CANNOT DRAW!
NOW THAT THIS IS SAID AND DONE
LET US MAKE ANOTHER ONE
HEE-HAW! HEE-HAW!
I CANNOT DRAW!
LET US SING ALONG
EVERYTHING IS WRONG!

OLGA SCHOLTEN, *Hee-haw!*, 2004, ink on paper, 11.7 × 8.3"

"I have many papers with only beer bellies on them."
An interview with Olga Scholten

Olga Scholten was born in the Netherlands in 1972. She has published an untitled book containing drawings and text, taught graphic design at the Royal Art Academy in 's-Hertogenbosch, and put on a performance of live drawings at the Centraal Museum in Utrecht. She started her own studio in 1999.

JESSE NATHAN: When did you decide that you liked art?

OLGA SCHOLTEN: When I discovered that making a drawing is the best way to express myself and therefore an excellent medium to communicate. I think I was four. Later on, I discovered that this is not true.

JN: What do you mean?

OS: Images trigger different things for each person. So, saying clearly what you want is actually more effective as a means to communicate. If you want to be sure to get your point across. When I was young I thought by drawing something everybody could look into my heart.

JN: Are you more jaded now, less idealistic about what drawing can accomplish?

OS: I was four when I thought that by drawing something a person could look into my heart. It's just not the way I look at it anymore. So there is no universal use for my drawings—that's okay, though. Everybody reacts differently to what I draw and I like that. When I make something I don't feel restrained, but it's a scary process because I don't know what I will draw. That makes it strange, sometimes funny, sometimes scary. My heart still has a lot to do with that, but I don't have the intention of letting people look into my heart anymore.

JN: Why do you draw?

OS: Max Kisman said, "A drawing a day keeps the doctor away."

JN: Do you dip into other mediums or forms?

OS: I am a graphic designer, so yes.

JN: Is being funny important to you?

OS: No, I'd rather be intelligent.

JN: Are being funny and being intelligent pretty separate things in your mind?

OS: I think being funny is a result of something, a result of being creative, of knowing who you are. So I'd rather be intelligent, and then funny comes along with that, if you are lucky. Think about kids. They never know when they are funny. The adults are always the ones laughing and then the kids think, Oh, I'm funny.

JN: Interesting. Kids are funny accidentally. Or just unselfconsciously. The intention is what's important, you're saying.

OS: The kid doesn't know it yet. If you are funny unintentionally when you draw something then it's funny too, but that's not how it works for me. To be funny with intention is important, because then you show that you know how to use it. Anyway, I feel that being intelligent is more important, and that what makes you funny is the way you think. Intelligence is the first and most important step though. Am I weird?

JN: No. I don't know. Yes?

OS: Thanks.

JN: Sure. What kind of pens and paper do you use?

OS: I like to use the thinnest pen possible, so I don't have to draw on a bigger paper than A4. Huge paper scares me.

JN: How does the text in your work come about?

OS: When I have made a drawing, I feel the words popping up. So: Very easily. When I write without a drawing, that is very difficult, more than drawing something. My English is not one hundred percent, so I struggle with everything, but I love doing it. The reason why I use another language than my mother tongue is because of the distance I have with it. Writing in Dutch is very naked and open. When I write in English I can write words I usually don't use. Also, writing in English feels more like drawing for me, also because of the distance I have with it. Entiendes?

JN: Sort of. Say more.

OS: In English I can say the stuff I want to say. It feels not like words but more like images, if you will. Because it's not as familiar as Dutch.

JN: Do you ever steal phrases?

OS: Of course, everybody does.

JN: What about images?

OS: You can't avoid it. You draw something and the next day you see something that resembles it. Did they steal it from you or did you steal it from them? Did you recognize something in the image, therefore you think you have stolen it? Or is it original? Does it matter? Is whether you stole it the most important thing? I don't think so.

JN: Do you ever get your text from elsewhere or do you pretty much make it up?

OS: I pretty much make it up. It pops into my head. Sometimes it pops into my head and then I think, I have heard that before.

OLGA SCHOLTEN, *Go ahead*, 2004, ink on paper, 11.7 × 8.3"

HA HA HA !
IT IS STARTING TO LOOK LIKE
THE HIDDEN AGENDA OF THE INSANE !

OLGA SCHOLTEN, *Ha ha ha!*, 2004, ink on paper,
11.7 × 8.3"

JN: Then what? Do you discard the text?

OS: I use the text, but I am more critical about it. If I remember the context, and the context was shallow I don't use it.

JN: Do you do lots of drafts of drawings?

OS: Sometimes I can freak out. Especially with man torsos. I have many papers with only beer bellies on them. Don't ask me why.

JN: How do you decide something's finished?

OS: It just is. I don't know. It's a feeling. Sometimes I work on it for months, adding little things. I have a thing about adding too much, though, so I usually just take out a fresh piece of paper if I think I want to add something, and therefore I end up making a new drawing.

JN: Does making a mistake lead you to interesting places in your work, or is it just annoying?

OS: Yes. I make "mistakes," but I leave them there. Sometimes I take a big black pen and "erase" it. So it's like a big black spot on the paper. It's not annoying, but sometimes you fuck up and then you just start over.

JN: Where do you usually draw?

OS: At home at the kitchen table.

JN: What's a good day of work for you?

OS: Working hard, making interesting things, letting yourself be surprised, and laughing a lot. And a good lunch. And answering your questions. Like everybody you look for surprises and undiscovered things. When you see that there is more to explore in a text or a drawing that you made, that is success. When you dream about it. When it makes you laugh. Did I say that already? And when I finally conquered the difficult technique of drawing hands, that was a good day of work.

JN: Do you make good art when you're angry or mad or grumpy?

OS: No, it has to be quiet in my head and around me.

JN: How quickly does something become another tired method?

OS: Not very quickly. That's because I do it to develop myself and I will not cheat.

JN: When a method does get boring, though, what happens?

OS: I make the thing very ugly.

JN: What do you do to remedy the situation?

OS: I just stop. But usually it doesn't get that way, because I "prepare" myself if I am going to draw.

JN: How do you prepare yourself?

OS: I have a fixed day in the week where I stay home from my studio. I do a little bit of cleaning in the house. I clean my table, take my sketches out of a box and look at them for a while. Then I make some coffee and start drawing.

JN: Is your material autobiographical?

OS: Yes, it is. A lot of autobiographical stuff. But never directly. It's usually vaguely connected to my life.

JN: How did the bus drawing (the one shown at apexart) come about? If you could take us through from idea to realization of idea that would be neat...

OS: It's about a news report some fifteen years ago. I saw a BBC reporter showing us what a chinese orphanage looks like. It was terrible. The reporter was crying. I was choked up. I still think about it sometimes. So I imagined a bus picking up the kids. "Imagined" because in the end I didn't do anything. That's why the bus is not finished in form. The text came about while I drew the bus. I was very happy with the drawing. I showed it to people, but they weren't as happy as I was. They would have liked to see the bus finished. Some people didn't say too much because there is a question in my text and I think they were asking it of themselves.

JN: Have you ever wanted to be a writer?

OS: Yes, all my life. But I don't have the talent for it.

JN: These drawings are fine art of some kind, though they share affinities with cartoons, graffiti, high modernist painting, even pop art. But does it matter what we call the form shown in the apex exhibition?

OS: No! You just used a lot of words for something that has always been there and I think needs no interpretation.

JN: The apex show had a very concrete set of criteria. Did you like that about it?

OS: Yes, of course. It made it more digestible. And left more for the viewer to wonder and explore as far as interpretations. And I liked that it wasn't about the technique, it was about the first moment of an idea—fresh, young, not thought about.

JN: Does your work belong in an art gallery?

OS: No. Some people think it does, but if it's there you have people asking you questions, about the why and how. No, I don't think my work belongs there. I don't know about the why and how; especially when they think it's art, then you get arty questions or answers. With the book I made, it was totally different. Then people don't think it's art and are more comfortable to say what they really think. As a graphic designer it is weird to notice the big difference of interpretations when you walk into an art gallery as an artist or as a designer. I prefer the designer.

JN: What is the different view, in your opinion, that people generally have of a designer versus a gallery artist?

OS: With a designer they are more inclined to say what they think of it—if they like it and why. They are not so much afraid of saying something personal. If it's art, the arty people talk art language and the not-arty people make up art language or don't say anything. It creates a distance when it becomes art. Not many people know that it's just a drawing anymore. When it is presented as art, people are hesitant to say something. When it is presented as fun, people are freer.

since i have lost my love
I have been collecting tupperware

OLGA SCHOLTEN, *Since I have lost*, 2004, ink on paper, 11.7 × 8.3"

two famous writers in the Chelsea hotel
they remember it well

OLGA SCHOLTEN, *Two famous writers*, 2008, ink on paper, 11.7 × 8.3"

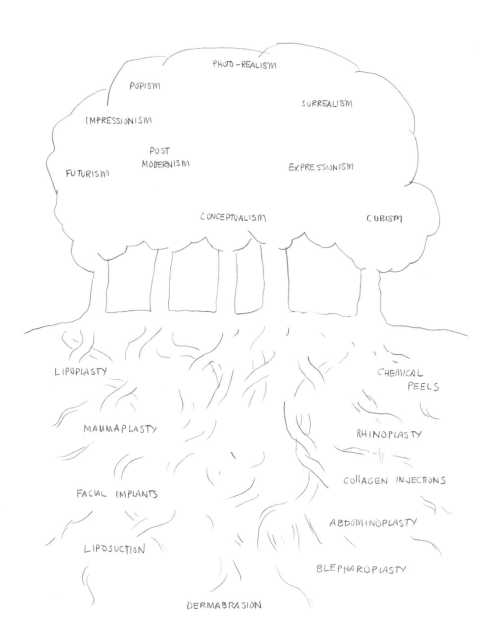

DAVID BYRNE, *Morphological Transformations*, 2003, pencil on paper, 14 × 17"

INVOCATIONS

CHANTS PROMISES

INCANTATIONS SONGS

TEARS WISHES

UNDERWEAR PRAYERS

 JEWELRY

PANTIES

 SOCKS

NYLONS

 CONDOMS

HAVING SEX MAKING LOVE

 GOIN' AT IT

 GETTIN' SOME

SHAGGIN'

 HUMPIN'

 DOIN' IT

 SCREWING

DAVID BYRNE, *Becoming Immaterial*, 2002, pencil on paper, 14 × 17"

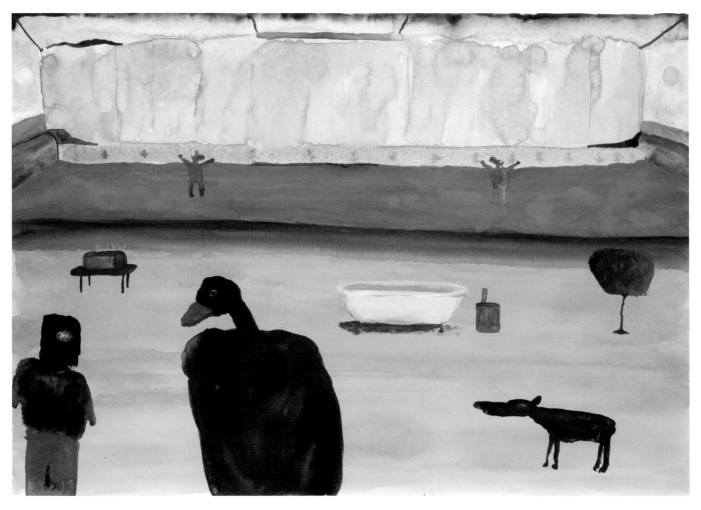

SOME ANIMALS NOAH ONLY HAD ONE OF. THE ONES THAT HAD COME BY TWO PUT ON A MUSICAL, WHICH LIKE MOST MUSICALS WAS BAD.

JOHN LURIE, *Some Animals Noah Only Had One Of. The Ones That Had Come by Two Put on a Musical, Which Like Most Musicals Was Bad,* 2004, watercolor, oil, and pencil on paper, 14 × 20"

IF YOU MARRY ME
WE CAN LIVE HERE

JOHN LURIE, *If You Marry Me We Can Live Here*, 2005, watercolor on paper, 14 × 20"

DAVEY CROCKETT
HAS LOST HIS FUCKING
MIND

BIRD HAS ABSOLUTELY NO FACE

JOHN LURIE, *Davey Crockett* (opposite page), 2004, watercolor on paper, 10.25 × 14";
Bird Has Absolutely No Face, 2006, watercolor and ink on paper, 18 × 24"

About 12 years ago I bought
Steel wool in bulk, and I still
have too much steel wool, would
you like to buy some steel
wool in bulk?

Home plate is ~~looking~~ STARING
at me.

why with these hands I could ADVERTISE PIANOS

LE DERNIER CRI

THE LIVE COBRA HAT

A MAN OF IMMENSE CHARM & STAGGERING GOOD LOOKS

TOO MUCH FONDUE WITH THE CHORUS GIRLS

STEPHANIE VON REISWITZ, *Piano Hands, Live Cobra Hat, A Man of Intense Charm,* and *Fondue with the Chorus Girls,* 2007, ink on paper, 5.71 × 7.87"

BRENT CUNNINGHAM, *Diagram #10 (Regulations for Inflight Snake Storage)*, 2006, colored pencil and ink on paper, 8.5 × 11";
Diagram #12 (Proposal for a U.S.-Mexico Border Fence and Citizen Tunnel) (opposite page), 2006, colored pencil and ink on paper, 11 × 16"

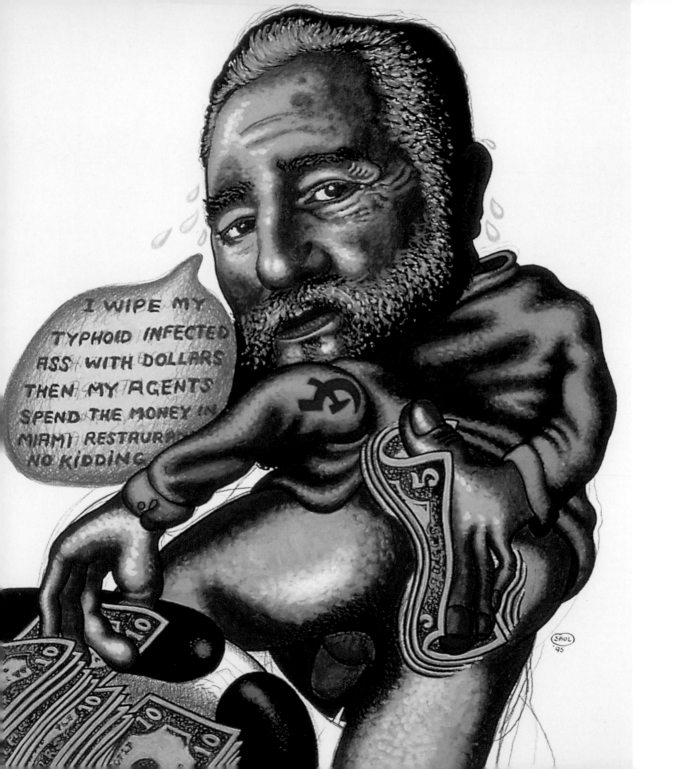

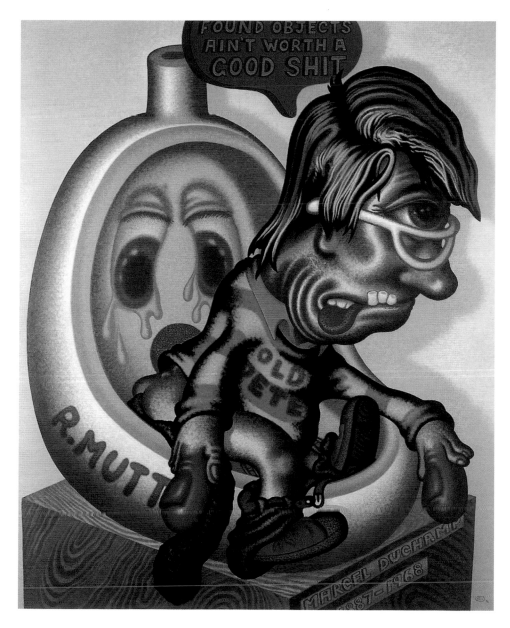

PETER SAUL, *Castro Wipes Ass* (opposite page), 1995, india ink, colored pencil, and acrylic on paper, 29 × 23";
Poopin on Duchamp (above), 1996, acrylic and oil on canvas, 59 × 43.33"

PETER SAUL, *Madame Softwatch*, 1996, oil and acrylic on canvas, 55 × 67"; *Hitler's Brain is Alive* (opposite page), 2006, mixed media on paper, 49.5 × 41.25"

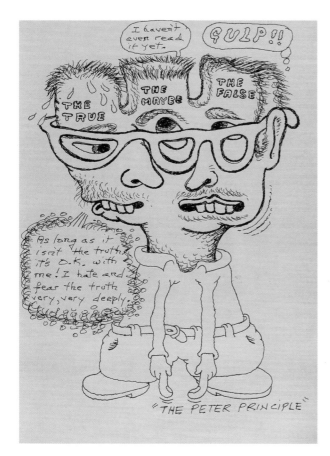

PETER SAUL, *The Peter Principle*, 1998, ink on paper, 10 × 15"

"For some reason my paintings never embarrass me."
An interview with Peter Saul

Peter Saul was born in 1934 in San Francisco. His work has been exhibited widely in the United States and in Europe, and appears in the collections of the Museum of Modern Art, the Whitney Museum of American Art, and the Centre Pompidou, among many others. He lives in upstate New York.

JESSE NATHAN: What do you like to look at?

PETER SAUL: I look at nature. I look at views. That simple question nonplusses me a little bit. I don't see a lot of movies because I don't have time. I just read the reviews and pretend I've seen them. We saw *Wall-E* and *Jane Austen*. I look at all the strange people in strange shapes. And the woodchucks on the lawn—they're getting tame. They eat the grass and they let us get to within three feet of them.

JN: When did you notice that you liked art?

PS: Kindergarten. There was one day for art. This was age five, in 1939—before World War II. The teacher said to make one picture before recess. Most people made a picture with, you know, one line or something. And I stayed. First I made a boat and seagull. And I kept drawing and skipped recess. My teacher phoned my parents and said, "This is unusual. This kid should get art classes. He's very unusual."

JN: Why do you paint?

PS: It allows me to escape the facts of life, which is having a job and getting bossed around, or having things happen to you in an unpleasant way. All I have to do is make stuff and hand it in.

JN: Have you experimented in other styles?

PS: Instead of changing the situation, like by becoming an abstract artist, I've always found that it's best to keep the situation the same. To just make it more my own. So I haven't gone on any technical journey over the years. I've just gotten better. I'm really amazed at how I've gotten better.

JN: Is being funny important to you?

PS: No. It comes naturally. Accidentally. I thought I was not funny. I thought I was a follower of Francis Bacon, all gloom and Ingmar Bergman. But then I saw people laughing at my pictures at my first show in Paris, in 1961. I thought I had to get with it—and I like it now. I saw *Psycho* in France in a small movie theater on the Left Bank. It had been dubbed in French. The audience laughed at all the gory parts. And they laughed at my paintings. And they laughed at Hitchcock's pretension, and since then I've got with it. I don't think about being funny, but if I think it's funny, I think that's good.

JN: Have you always made paintings with text?

PS: Yes. There's been text in them since 1962. At the very start it was just bits of text like "Wow," or "Hello," or "Die," or "Kill." The text in the Castro picture, that was one of the longest in any of my paintings. I can only think of maybe ten paintings with that much text over the years. Usually it's just one word or phrase.

JN: How does the text in your work come about?

PS: Just pops into my head. All my text pops into my head. And often what I do is write it down on a little piece of paper and put it in my wallet. Sometimes my daughter helps me out. She has good ideas for text.

JN: In your wallet? Do you look at it?

PS: Eventually. Within a couple years. Sometimes I forget about it. My wallet's thick with paper. Eventually I put the slips of paper in the studio in a special place, under a teacup.

JN: Do you generally like to let your ideas for paintings percolate?

PS: Yes. I think it's better if I make two or three preparatory drawings over a period of two or three weeks. That's to get a better result. If I have to start right away for whatever reason, then that'll probably be my worst picture. I like to take my time. I think the hardest thing is to make a sketch. I'm doing Cleopatra right now. I've made three sketches already, and the one I'm going to do right now will be it, you know?

JN: How do you know?

PS: I've got everything right except the angle. She's on her golden barge, but the angle's wrong. It's too tipped. I've got the woman in the right place in the boat, the crocodiles in the right place, but the viewer has to look down too much. She's older, based on how she appears in a poem by Shakespeare. She's got a snake in her hair. She's in the water with crocodiles. She doesn't care. She's friends with these terrifying creatures. This is just one painting. We'll see how it all turns out. I like history paintings a lot. I like to paint scenes from history.

JN: Why?

PS: I don't know. There's a reason to look at them in the first place. Of course, eighty-nine percent of the population doesn't

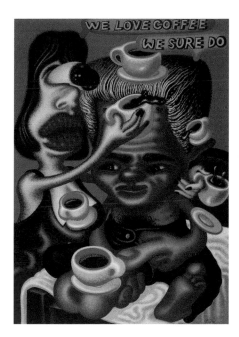

PETER SAUL, *We Love Coffee*, 1998, oil and acrylic on canvas, 47.5 × 36"

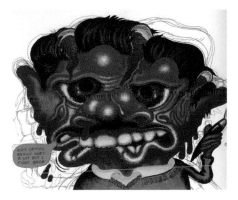

PETER SAUL, *Art Critics Really Hurt,* 1997, mixed media on paper, 23 × 29"

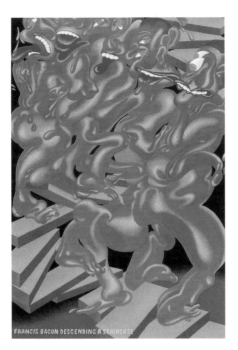

PETER SAUL, *Francis Bacon Descending a Staircase*, 1979, acrylic on paper, 60 × 40"

know who Cleopatra is. Eighty-nine percent of the population thinks she's a rock star or something.

JN: A lot of the text and imagery of your work is political.

PS: I love politics. But it's just another subject. I don't feel it should be specially singled out. I like to use politics and see what I come up with.

JN: Lots of artists won't touch overtly political material.

PS: There's nothing to be afraid of. Within twenty years I'll be dead of old age. I've got nothing to be afraid of.

JN: Have you caught flak from the so-called art world for combining text and painting the way you do?

PS: I think I have. Whatever flak I've gotten, though, is really about my style. My style seems too vulgar. Too easily understood. Too obvious. Outside that, nothing's caused me to suffer. I don't know why. I get on well with art dealers. But people who work in museums I hardly ever meet. They seem frightened of me. When I visit schools—I travel about—if I get a complaint, that will be it: "Your work is too obvious," "Everyone can understand it," "There's nothing to deconstruct."

JN: And what do you say?

PS: I think up an answer. I don't know what I say. Most of the time I get on well with people in the art world. I think I've suffered most from being extremely isolated. I'm sure I've met fewer people in the art world

than anyone else my age. I have room in my brain for knowing only twenty-five people. Ten of those are art dealers. Ten would be people I taught with at the University of Texas at Austin. That leaves only five slots for someone I might meet.

JN: Is your use of color intuitive, or do you plan this out extensively?

PS: I don't plan it at all. All I think about is the subject and what's going on when I'm making my sketches. Then I approach color, and I want it to be beautiful and surprising and dramatic—like nature. When I was in art school in the 1950s, I was painting like everyone else. I was painting these dreary little oil paintings. It occurred to me that it could be different one time when I was reading *National Geographic*. Painting could be beautiful blue skies and bright colors. I've been painting that way ever since.

JN: Your lines are so curvy and cartoonlike. Do you read cartoons?

PS: Yeah, sure. If there are any around, I read them. If not, I don't miss them. But I grew up on cartoons and I have a big stack of undergrounders from the 1960s. I think about them a lot. I've been thinking about this: every year at Christmas I read *Little Orphan Annie*. And also *Trailer Trash* by Roy Tompkins. And I think it's all to somehow give me a sense of what it's like to be young and on your own. I was sent away to boarding school, by the way, when I was young. So that takes care of eight or nine months of the year. During the other months of the year, I had no friends. I just hung out with my parents. So I was lonely. I would

only talk with my parents. We talked about philosophy and painting in the dining room, but I didn't know how to meet any girls. Nothing was possible. I was lost. It gave me the feeling that I didn't get to live those years. So now I like to live those years. To read these things, this raunchy undergrounder stuff I never got to experience when I was actually young.

JN: Which one comes to you first, text or image?

PS: The picture pops into my head and I think the text might, too, but very often I find my text is not good halfway through, so then I have to rethink it.

JN: Does that happen with drawing?

PS: Text is volatile and difficult. I'm not as good at text as I am at painting. I'm much more likely to make a mistake. More likely to have a sudden feeling of contempt for the text even if the painting is beautiful. From now on, I'm going to leave a blank space for the text. I'm going to be a little apprehensive about it. I'm going to leave a speech bubble. The text is the more difficult part.

JN: What would you say your art's about?

PS: I try to make it about the subject matter that I've chosen. I put myself in the background when I paint. I don't deny the truth. My pictures are riddled with truth I wasn't seeking. For some reason my paintings never embarrass me. I've never been embarrassed by my paintings. Most people are mortified if their painting isn't liked or if it casts an unhappy light on them. Not

true for me. For some reason, I have, since the beginning, separated myself from the paintings.

JN: Is the material autobiographical?

PS: Probably not. My life is devoid of events, to a great extent. I've been married twice. That's the extent, though, of the excitement in my life. I've lived in several houses and I've had a teaching job for years. The main event of my life is painting the pictures. A few things have happened, but I can't really connect them to my paintings.

JN: Are you trying to tell stories?

PS: I had that idea first in 1961 or 1963. I had a few paintings divided into two or three squares. Like a comic. But for some unknown reason, I didn't continue. I may yet. It would be kind of refreshing. I have one that's a murder mystery. The crime is committed in three squares.

JN: About that relationship between text and image in your drawings, how would you characterize it?

PS: The job of the text is to explain the picture. To give it the tone. I think the painting is pretty helpless unless you're able to read the imagery. I've come to the unhappy conclusion that a large number of people don't read imagery. They only read text. So if you don't have text with the imagery, it's hard to read. You're at the mercy of art critics. When I feel insecure I tend to use more text. I think most people get their knowledge from text. People don't get information from images. They don't trust images, even though they're everywhere.

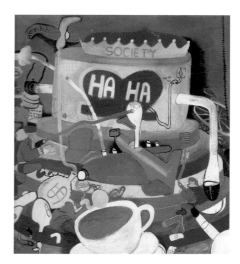

PETER SAUL, *Society*, 1964, oil on canvas, 78.5 × 74.75"

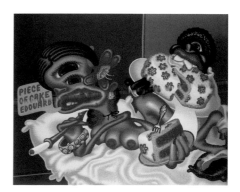

PETER SAUL, *Piece of Cake Edouard*, 1998, oil and acrylic on canvas, 50 × 66"

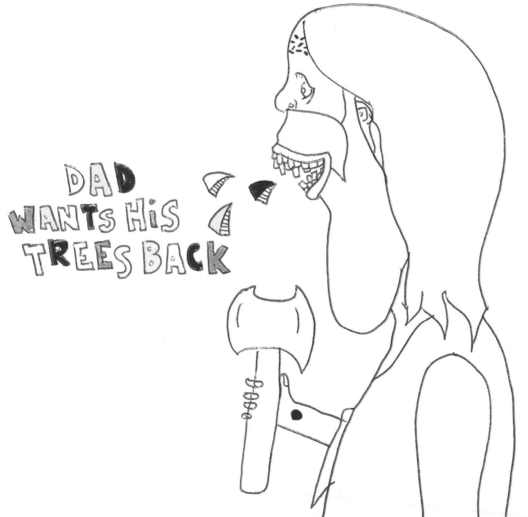

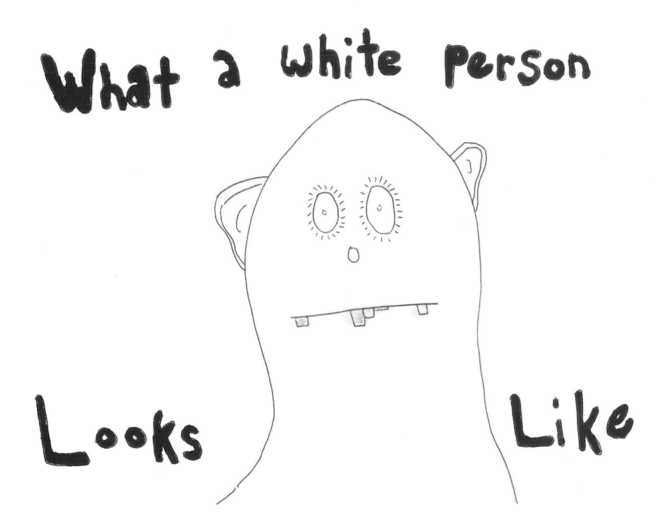

What a white person Looks Like

POROUS WALKER, *Dad wants his trees back* (opposite page), 2005, ink on paper, 8.8 × 11.1"; *Whitey* (above), 2006, ink on paper, 8.8 × 11.1"

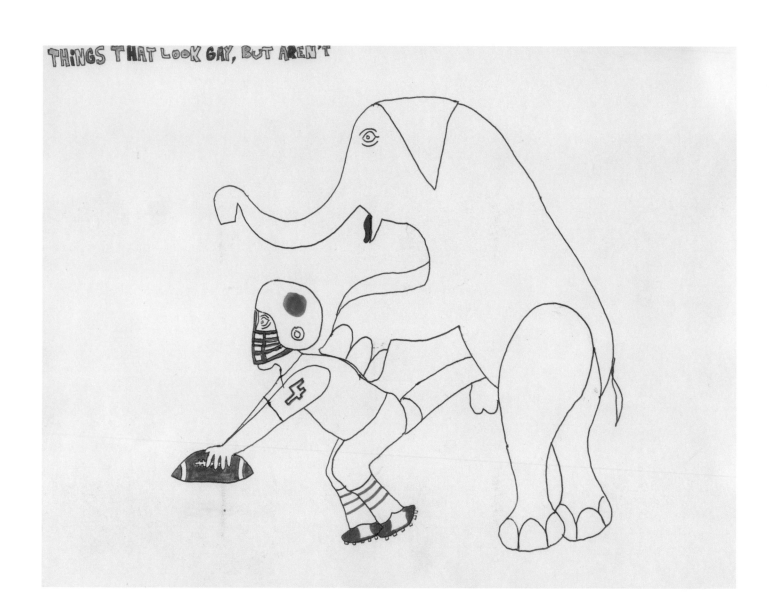

THINGS THAT LOOK GAY, BUT AREN'T

POROUS WALKER, *Things That Look Gay butt Aren't*, 2005, ink on paper, 8.8 × 11.1"

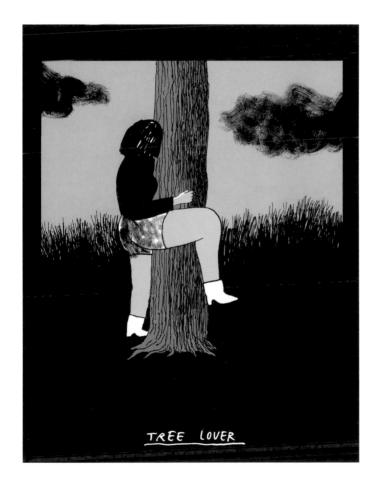

TREE LOVER

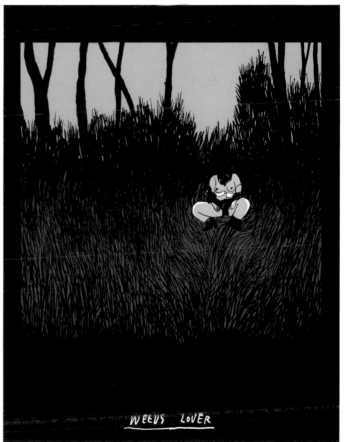

WEEDS LOVER

TYMEK JEZIERSKI, *Nature Lovers*, 2008, ink on paper, 7 × 9.8"

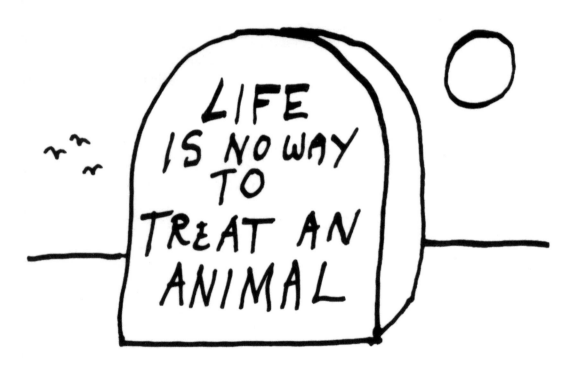

KURT VONNEGUT, *Trout's Tomb*, 2004, silkscreen on paper, 8 × 5"

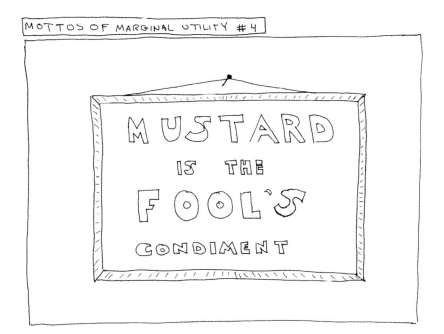

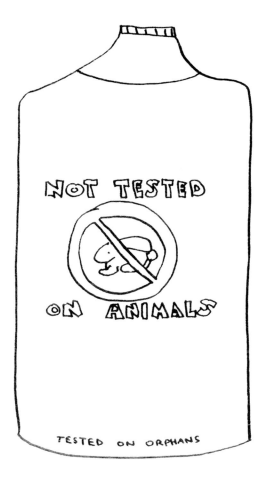

DAVID MAMET, untitled drawings from *Tested on Orphans*, 2006, ink on paper, 11 × 8.5"

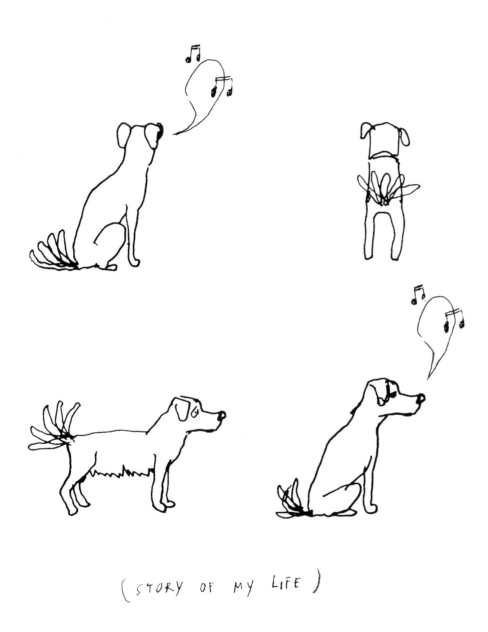

(STORY OF MY LIFE)

PAUL FAASSEN, "Story of My Life," from *Niets meer aan doen*, 2003, ink on paper, 7.8 × 10.5"

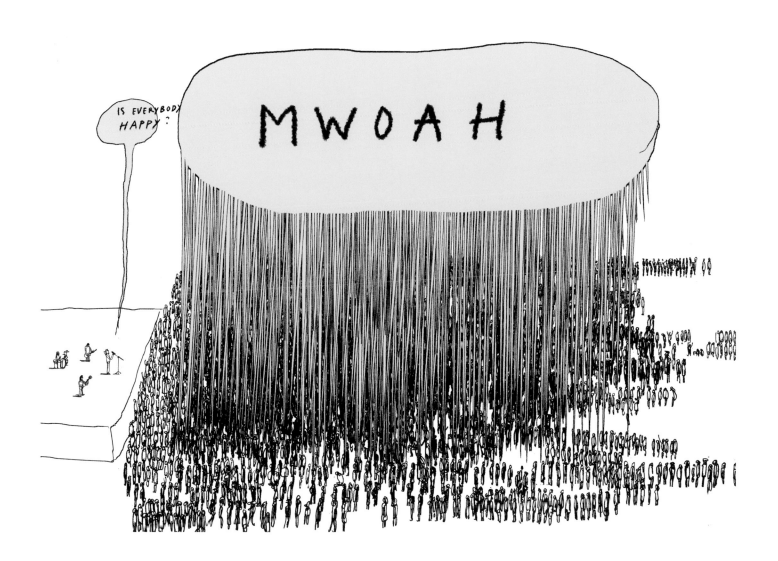

PAUL FAASSEN, *Mwoah* (above), 2008, pencil on paper, 16.5 × 11.8"
PAUL DAVIS, *Failure* and *Nonsense* (next two pages), 2008, ink on paper, 8.5 × 11"

WHO DID IT

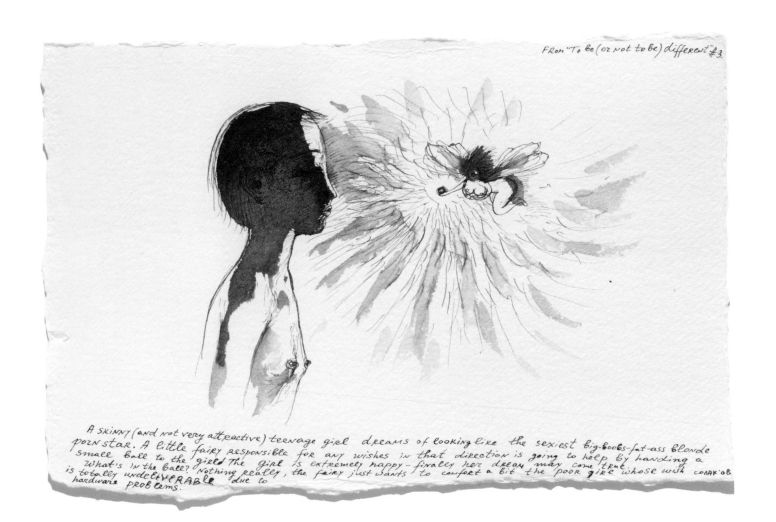

A SKINNY (and not very attractive) teenage girl dreams of looking like the sexiest big-boobs-fat-ass blonde PORN STAR. A little fairy responsible for any wishes in that direction is going to help by handing a small ball to the girl. The girl is extremely happy — finally her dream may come true. What's in the ball? Nothing really, the fairy just wants to comfort a bit the poor girl whose wish соляк'ов is totally UNDELIVERABLE due to hardware PROBLEMS.

NEDKO SOLAKOV, *To be (or not to be) Different # 3 of 12*, 2008, sepia, black, and white ink and wash on paper, 7.5 × 11"

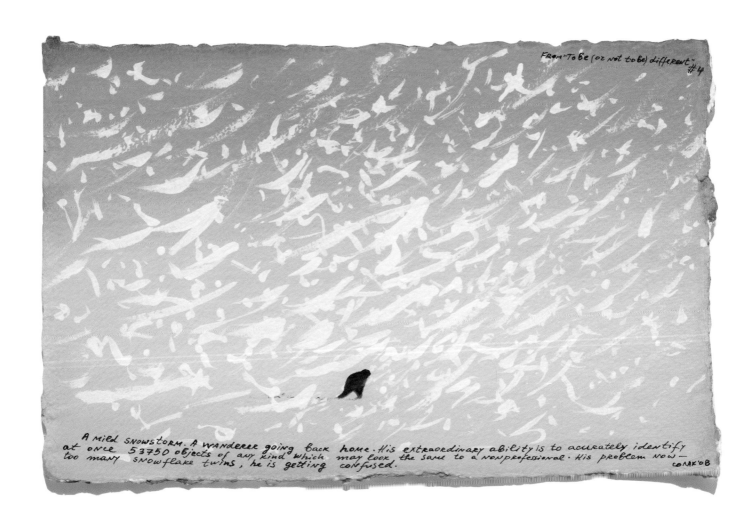

NEDKO SOLAKOV, *To be (or not to be) Different # 4 of 12*, 2008, sepia, black, and white ink and wash on paper, 7.5 × 11"

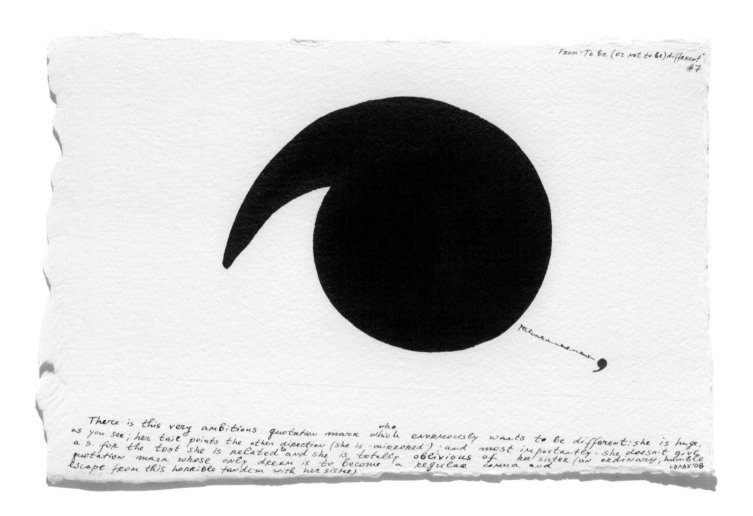

There is this very ambitious quotation mark who enormously wants to be different: she is huge, as you see; her tail points the other direction (she is "mirrored"); and most importantly - she doesn't give a s. for the text she is related to and she is totally oblivious of her sister (an ordinary, humble quotation mark whose only dream is to become a regular comma and escape from this horrible tandem with her sister).

SOLAK'08

NEDKO SOLAKOV, *To be (or not to be) Different # 7 of 12*, 2008, sepia, black, and white ink and wash on paper, 7.5 × 11"

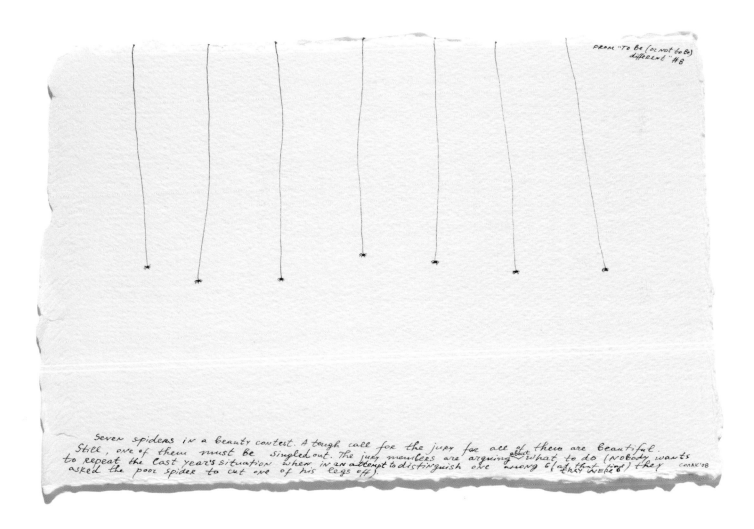

From "To be (or not to be) different" #8

Seven spiders in a beauty contest. A tough call for the jury for all of them are beautiful. Still, one of them must be singled out. The jury members are arguing about what to do (nobody wants to repeat the last year's situation when, in an attempt to distinguish one among 6 (as that time they were) they asked the poor spider to cut one of his legs off). conk'08

NEDKO SOLAKOV, *To be (or not to be) Different # 8 of 12,* 2008, sepia, black, and white ink and wash on paper, 7.5 × 11"

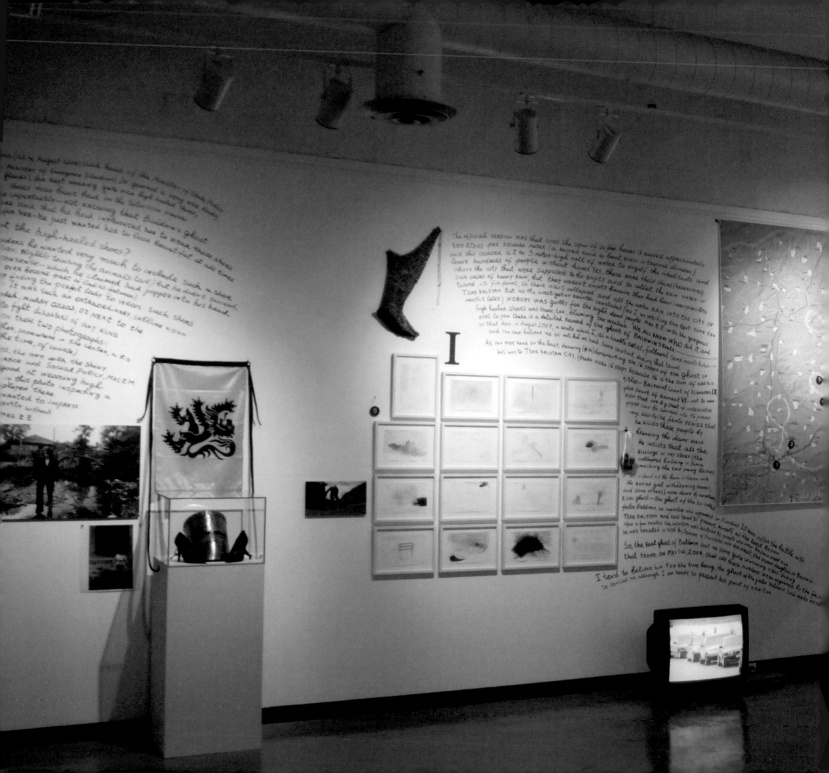

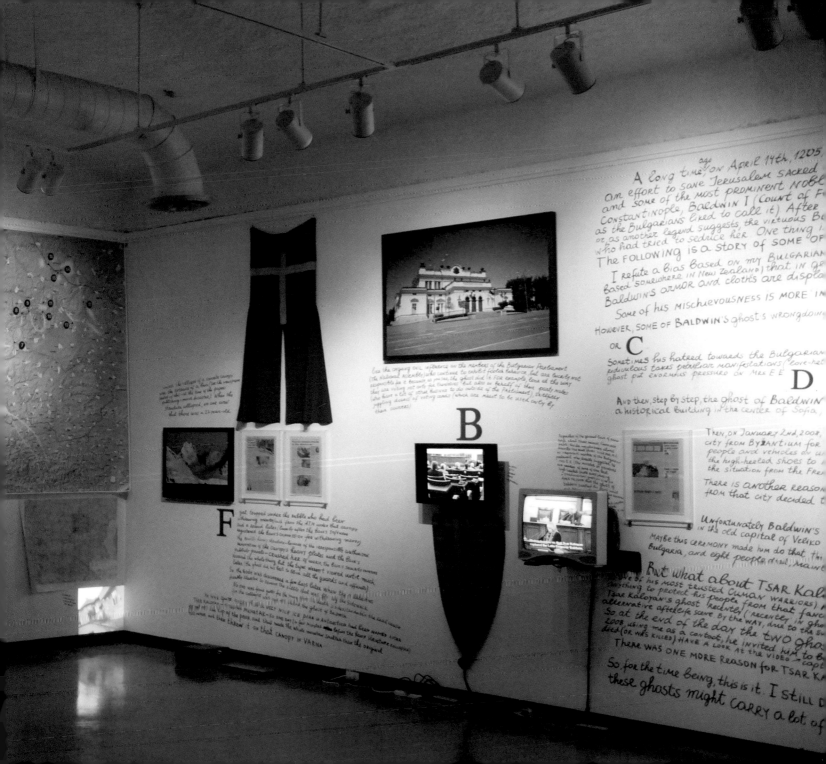

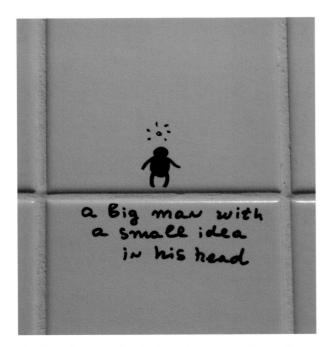

a big man with
a small idea
in his head

The photo above, as well as the three photos on page 167, are from "Toilettes," 2006, felt pen, handwritten texts on various surfaces in the toilets of Les Abattoirs Museum, dimensions variable. Broken Lines/Printemps de septembre, Toulouse, 2006, courtesy the artist. The photos on pages 168 and 169 are from "A Pass-Controlled Story," 2008, felt-tip pen, discreet texts and drawings on all passport control counters at the Zurich airport (the following day all removed by the authorities).

"The funny part of my work is very often on the top of a pretty sad one."
An interview with Nedko Solakov

Since the beginning of the 1990s, Nedko Solakov (born in 1957, Tcherven Briag, Bulgaria) has exhibited extensively in Europe and the United States. He lives in Sofia. His drawings and installations have been shown in Aperto '93 (Venice Biennial); the 48th, 49th, 50th and 52nd Venice Biennial; 16th Sydney Biennial, and Prospect 1, New Orleans Biennial. Recently he had solo shows at CCA Kitakyushu, Japan, and the Israel Museum, Jerusalem.

JESSE NATHAN: What do you like to look at?

NEDKO SOLAKOV: Movies.

JN: Why movies?

NS: I don't know, I just love movies. This is my best way to rest—watching a movie during the week, or a day performance. When everybody works, I am alone in a cinema hall.

JN: Have you always drawn?

NS: Almost. Since childhood, even though my drawings from that time are not really spectacular. As most children's drawings are. So I have been making drawings since childhood. Later it became a constant activity.

JN: Why do you draw?

NS: It's very tempting to say "Because this is my way to think." But this is too cheap. I just love making drawings with stories.

JN: How long does it take you usually to finish a drawing?

NS: It depends. Sometimes a few minutes, sometimes a few weeks—but I don't work only on that drawing.

JN: Which usually comes to you first, the text or the image?

NS: First is the image, at least the beginning of it. Then the text. And then the image gets rendered better, and so on.

JN: Why is being funny important to you?

NS: It seems it is, although I am not doing this as a conscious strategy. It goes by itself.

JN: Do you make good art when you're feeling surly?

NS: It may become a very passionate art, which doesn't mean it is a good one.

JN: How does the text in your work come about?

NS: There are different types of text. In the drawing-stories, the ones you know, the text comes slightly later than the image. I start drawing not really knowing what the story will be. Then comes a vague idea. Then, as soon as I start writing in that little two centimeter space at the bottom of the nineteen by twenty-eight centimeter sheet, the story unfolds itself. I know that sounds like a mediocre writer telling teenager audiences how he writes, using a cheap cliché, but it is true—it goes by itself. For the big installations there is much more work with the text. And a lot of editing.

JN: Do you only edit text of the big installations, or do you edit other texts too?

NS: Sometimes I do. When a series is finished, I am calling a chap with whom I go through all the texts. If necessary, I change things. Whiten the wrongs and rewrite on top. I never, ever write aside a drawing's text, it is always on the paper, inventing it at the moment.

JN: Your text is often small, almost quiet in presence. Do you prefer quieter things?

NS: Not necessarily. Sometimes things have to shout. But there should be a reason for that visually and content-wise.

JN: So do you prefer very small hand writing?

NS: In the drawings, yes. There are limits of the space. I like to mix it up, too. I am on the eve of doing a lot of writing on the wall for my "Emotions" show, due to open next Friday.

JN: How regularly does a methodology become tired and stale?

NS: I don't really have a methodology. Although, saying this, I realize it contradicts itself. My practice, luckily or unluckily, is very rich. The ways to tell story are so diverse that I don't have such problem— to be trapped in a conceptual let's-not-change-a-winning-formula trap.

JN: Why do you like drawing on the walls?

NS: It is one of the best ways to communicate to people, and it is very exciting to work in a space. To tell a story in a space, knowing that you may be able to take people by the hand like little children and bring them to that corner or to that part of the wall, and so on. As I say this—in Copenhagen—I have to go to do, today and tomorrow, such work. The feeling is nice.

JN: You studied mural art right? And murals are often narrative-inclined, among other things. Is what you do on walls like making a mural?

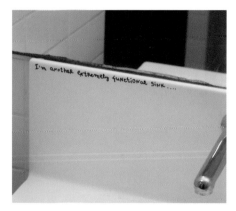

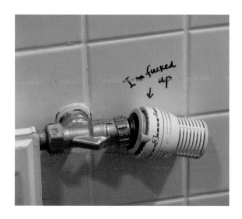

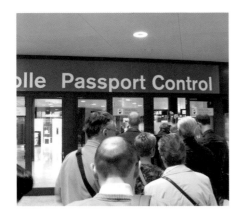

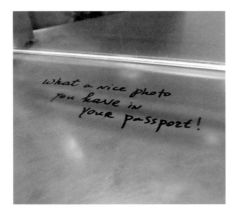

NS: Yes, they might be considered as murals, although most of them disappear after the show, which is not the purpose of a let's-stay-forever-and-glorify-whatever-cause classical or contemporary mural. This slight difference makes a big difference.

JN: Does let's-stay-forever-and-glorify-whatever-cause art bother you?

NS: It is fine, but a huge amount of the recent art production fits into this profile, which is not so good.

JN: Do you ever get your text from elsewhere, or do you pretty much make it up?

NS: All is made up! Don't insult me.

JN: Do you do lots of drafts of drawings?

NS: Never. I just make drawings, with no drafts.

JN: Is the handwriting in your drawings your actual everyday handwriting?

NS: Unfortunately not. My daily handwriting is not really readable.

JN: Did it take a while to home in on a handwriting that you wanted to use for your drawings?

NS: A few years.

JN: Do you ever change that drawing handwriting, or does it pretty much stay the same?

NS: It stays the same basically.

JN: How do you decide something's finished?

NS: I just feel it.

JN: Do you enjoy titling your drawings?

NS: Always the title is an essential part of the work. The title and the media description. I am very sensitive about it.

JN: Is making a mistake ever fun?

NS: It is. With my way of working, theoretically and practically, I can make the biggest shit ever and label it in my way on the wall right next to it saying, with small letters and an arrow, "A mistake."

JN: What appeals to you about that?

NS: It's trying to be more secure about the future. It's inventing a scheme for in case I start producing boring shit. Write "how to be a winner again," and then write "a very bad work" with an arrow pointing at it.

JN: Are you drawn to funny art?

NS: I am open to a lot of things. I love artists from Peter Brueghel to Gelitin. Sometimes people may get confused with the funniness in my work and start thinking that this is it, there is nothing more. The funny part of my work is very often on the top of a pretty sad one. My stories are funnysad and sadfunny.

JN: Who or what influences you?

NS: Art. Classical art. Clever art. Peter Brueghel is my favorite. The absurd situation in Bulgaria helps my stories, too.

JN: What is the absurd situation in Bulgaria?

NS: It is a very long one.

JN: Do you like straight lines?

NS: Not really.

JN: Where do you usually draw?

NS: On the table of my studio.

JN: What's your favorite kind of paper to draw on?

NS: The drawings you know are done on 850 gram Arches watercolor paper. Plus Pelikan drawing ink.

JN: If someone asks you what your art is about, what do you say to that impossible question?

NS: I usually say I am telling stories.

JN: A *Frieze* article quoted you saying that you aren't "brave." What do you mean?

NS: Tomorrow I have to fly again, to Zurich, and the week after to Milano, and the week after—the horror—to New Orleans, and I am really scared of flying. Am I brave?

JN: How did the drawings on the airplane wing come about?

NS: I just got the idea. I am really scared of flying, though. Really. So for me it was also a bit of a self-therapy or something. It took Casino Luxembourg six months to obtain the permission to do it. It was fun. Some people think this is my best project.

JN: Any passenger feedback?

NS: It seems they liked it. One pilot said, "But people are supposed to fly, not read!"

JN: Can you explain your exhibit at the Israel Museum?

JN: It was called Alien Auras. There were twelve areas in the Judaica section in the museum where I "placed" twelve auras. Each one was indicated by those little plexi-numbers for museum exhibits, and the people got a map where they can read the stories of the auras, connected to some of the objects there or other little things.

JN: What was the reaction to that work?

NS: I don't really know, but perhaps they liked it because the "intervention" was extended in time. You know, the Orthodox ones which may be offended by my play, they never go to such museums.

JN: Are there other nontraditional locations where you're work's been displayed?

NS: In a Protestant church, discreet texts. In a museum toilet. At all passport control counters at the Zurich airport. Those were removed in four hours.

JN: In the case of, say, the "Fears" drawings—do you, in your head, invent a whole backstory that no one ever knows about?

NS: If I am trying to tell a story, then I have to have such backstories.

JN: What about that relationship between text and image in your drawings, how would you characterize it?

NS: They ideally are one unit. The text is not an explanation or caption of the image, nor is the image an illustration of the text.

JN: Do you plan your drawings?

NS: Never, ever do I make any plans. I just start to draw.

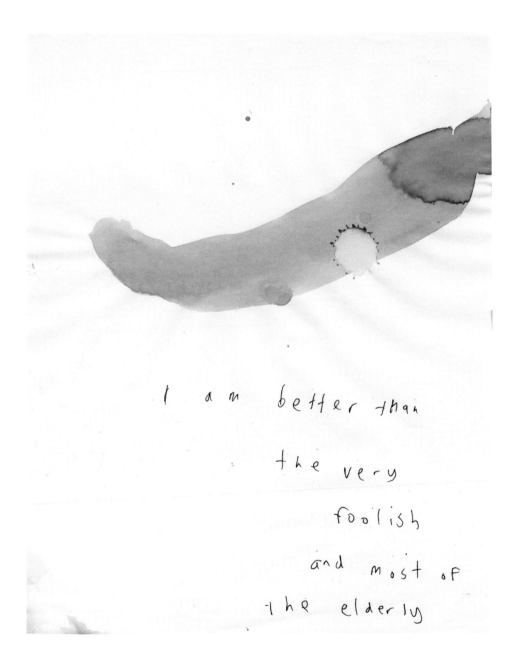

I am better than
the very
foolish
and most of
the elderly

JASON LOGAN, *I Am Better...*, 2005, ink on paper, 5.9 × 7.9"

ATTENTION HIPPIES

DO

NOT GO

AND POINT

YOUR

GOD-DAMNED

CRYSTALS

AT

ME

JASON LOGAN, *Attention*, 2002, ink on paper, 5.1 × 7.5"

THE NIGHT STALKER
IS COMING AND I'M
NOT WEARING PANTIES

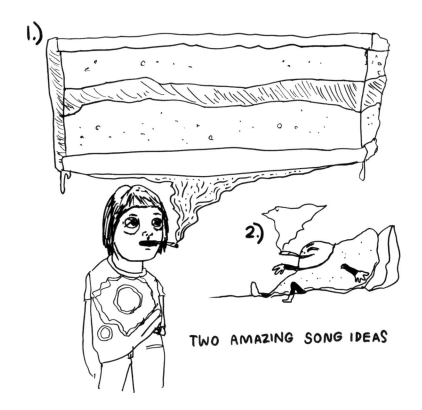

MAYA MILLER, *Night Stalker* and *Two Amazing Ideas*, 2008, ink on paper, 9 × 12"

YOSHITOMO NARA, *Shitty Old Milk*, 1997, crayon and paint on paper, 11 × 8.5"

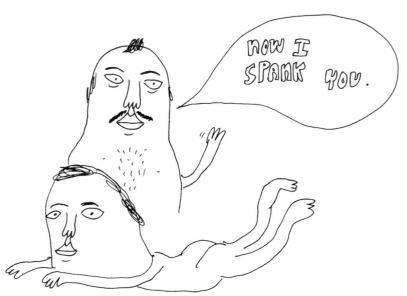

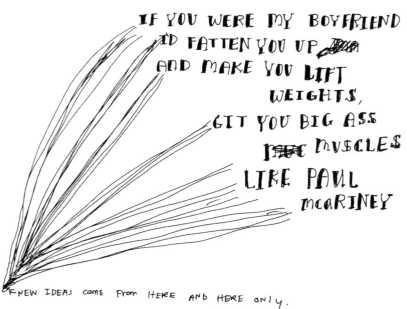

JAY HOWELL, *Now I Spank You* and *If you were my boyfriend...*, 2002–03, ink on paper, 8.5 × 11"

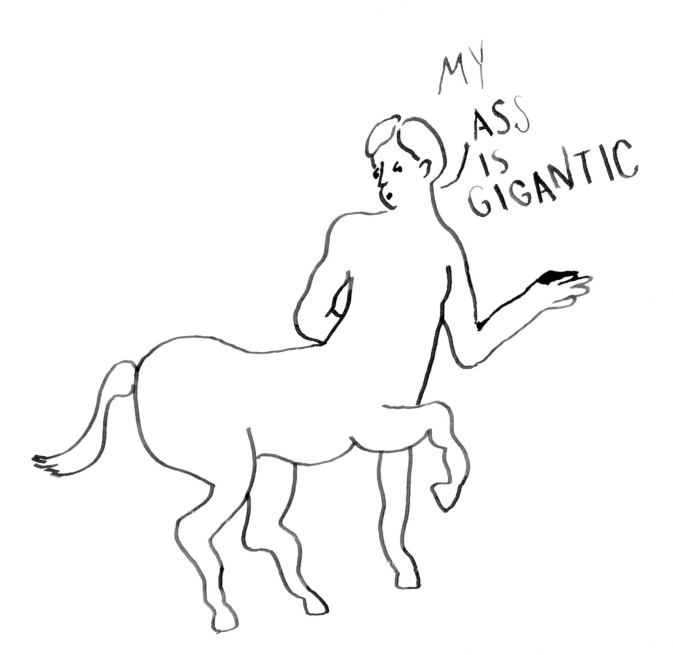

TAMARA SHOPSIN, *Centaur*, 2007, ink on paper, 5.25 × 5.25"

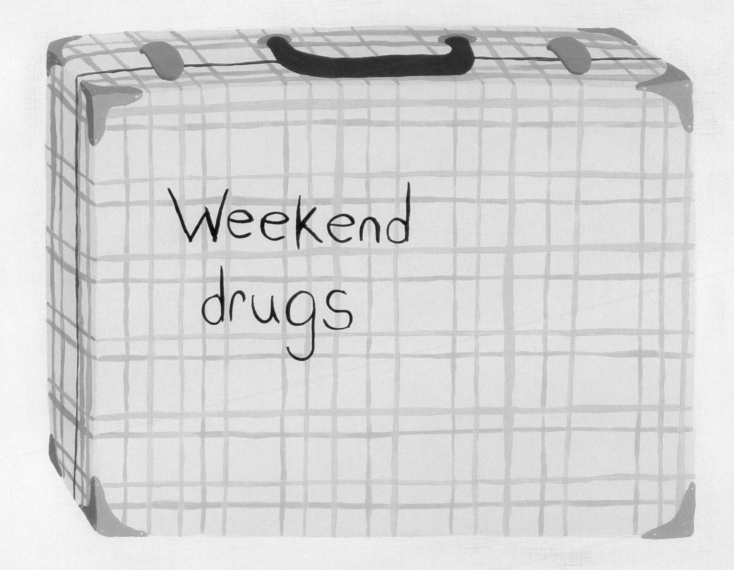

Hey, look what we made. We heard there was a shortage of these.

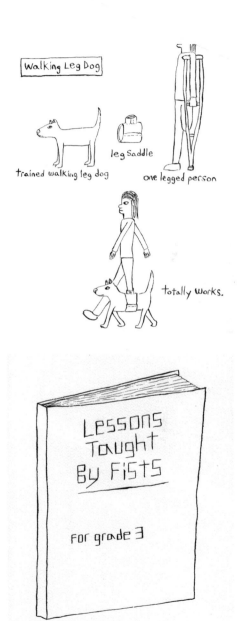

Walking Leg Dog

leg saddle

trained walking leg dog one legged person

totally works.

Lessons Taught By Fists

For grade 3

ANDREW JEFFREY WRIGHT, *Weekend Drugs* (opposite page), 2006, mixed media on masonite panel, 20 × 16"; *Look What We Made* (left), 2004, silkscreen on paper, 5.5 × 7"; *Walking Leg Dog* (top right), 2009, ink on paper, 5.5 × 7"; *Lessons Taught by Fists* (lower right), 2008, silkscreen on paper, 8.5 × 11"

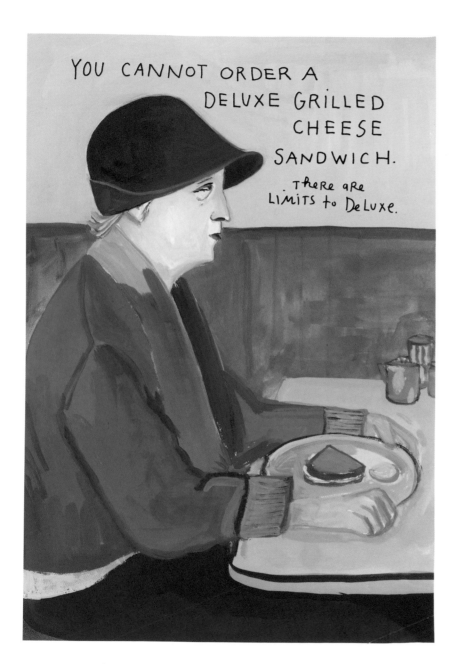

MAIRA KALMAN, *There Are Limits to Deluxe*, 2007, gouache on paper

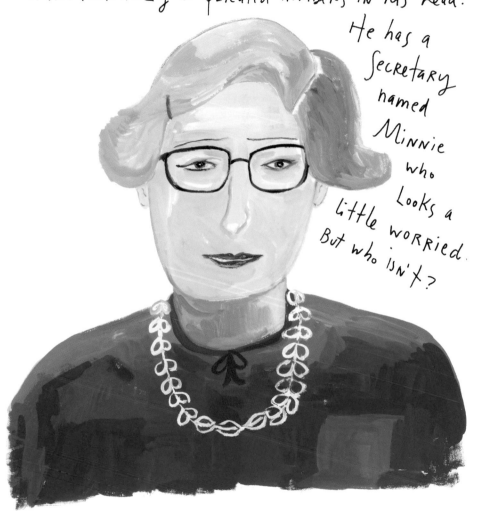

Carol is married to Professor Norman Weiss, a mathematician who collects nothing but extraordinarily complicated numbers in his head. He has a secretary named Minnie who looks a little worried. But who isn't?

MAIRA KALMAN, *Carol*, 2007, gouache on paper

179

The silent sink in the Corbusier house that speaks the truth.

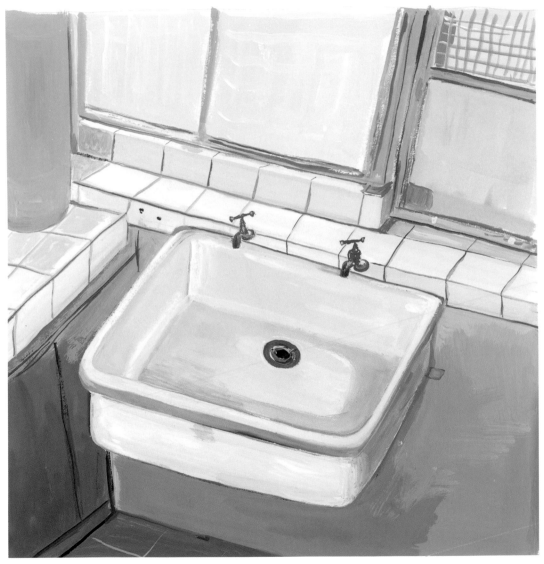

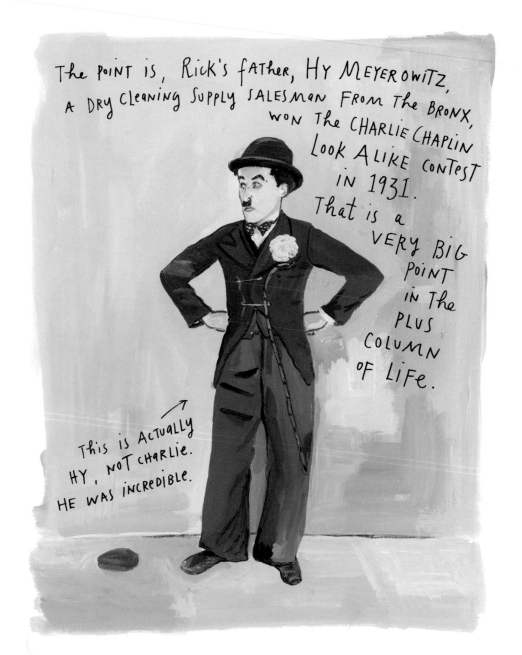

The point is, Rick's father, Hy Meyerowitz, a dry cleaning supply salesman from the Bronx, won the Charlie Chaplin Look Alike Contest in 1931. That is a VERY BIG POINT IN THE PLUS COLUMN OF LIFE.

This is actually Hy, not Charlie. He was incredible.

MAIRA KALMAN, *Hy Meyerowitz*, 2007, gouache on paper

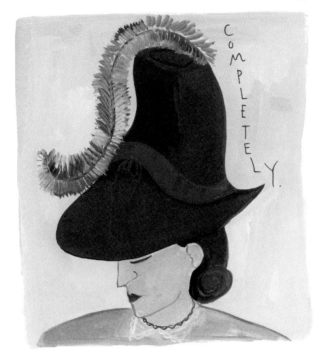

And someone will remember that I did buy a completely sensational hat.

MAIRA KALMAN, *A Completely Sensational Hat*, 2007, gouache on paper

"I want to tell you the understory. The not-story."
An interview with Maira Kalman

Maira Kalman is the illustrator of The Elements of Style, *by William Strunk Jr. and E.B. White, and the author-illustrator of numerous children's books. Her latest is* The Principles of Uncertainty. *She lives in New York.*

JESSE NATHAN: What do you like to look at?

MAIRA KALMAN: The people walking by. The buildings. The trees. Things thrown away on the street, especially chairs and sofas.

JN: Why do you make art?

MK: It is a desire to tell a story. Telling a story makes sense to me. It allows for a benevolent relationship to the world.

JN: When did you start liking art?

MK: I probably always liked art. Just didn't know it. I would go on trips from the Bronx down to Manhattan when I was thirteen. We would go to Ripley's Believe it or Not, the Museum of Modern Art and then to Lord & Taylor for shopping and a snack at the Birdcage restaurant, which was very sophisticated for us. It is all mixed up in my mind. Strange things and art and shopping and food. Not bad.

JN: How does the text in your work come to you?

MK: Painfully. I don't want to tell the story that I seem to be telling. I want to tell you the understory. The not-story. So I get confused. Sad. But something happens in the end. A patched up sort of thing.

JN: Which one comes to you first, the text or the image?

MK: They both come first. Sentences and thoughts and images and considerations and then paintings and photographing things and jotting down ideas and fragments.

JN: Why do you use text?

MK: I am neither an artist nor a writer: some combination of the two.

The narrative story is one that I feel good with. It belongs in a book.

JN: Do you ever get your text from elsewhere, or do you pretty much make it up?

MK: The text in my children's books is mine. If I use a quote in my adult work, I reference it. And I have used Goethe, Dante, Flaubert...

JN: Do you make lots of drafts of your drawings?

MK: Many drafts. I write too much. Then edit it down to much, much less. Then it still seems like too much. I draw too much. Or not right. Then I try to find the images that feel as if they are true, or true-ish.

JN: Are you dissatisfied with how things turn out often?

MK: Often things are not what you see in your mind's eye or heart or wherever it is that you see something. It cannot fully express some deeper feeling.

JN: Is being funny important to you?

MK: I did not know that you knew I was funny. Wait a minute! Well, I think in my family a sense of humor was the most important aspect of being and of conversation. Especially for the women. My cousins are very funny. So, yes, being funny is important. But the nice thing about that is you can also be sad and serious, and that is part of it, too, of course.

JN: Do you try to be funny? Or does that kind of ruin it, to try so directly for something—an affect, a mood, a joke?

MK: If I try to be funny in my writing, I get depressed. Confused. Then I have to rewrite many times. But I suppose I do always try to be funny in some way. Okay: In every way. But not necessarily. Also, I try to be poignant. Sadly poignant. Funnily sadly poignantly confusedly clear.

JN: Do you change up your methods regularly, or do you find a specific way of doing this or that and use it for a long time?

MK: Maybe the inside of me changes. Maybe I understand the nuances of the process as being more real to who I am. But from the outside it may look the same. Sleep. Dream. Wake up. Have breakfast. Take a walk through the park. Ruminate. Marvel. Remember memories. Work. Breaks. Naps. Deadline energy. Going out to hear music or see a movie. Seeing friends. Reading. Traveling. The story is that.

JN: Can mistakes be useful in your work?

MK: My life is full of mistakes. The work is full of mistakes. "Mistakes Bring Good" is the anthem I salute.

JN: Your work uses color so beautifully. It reminds me of Fairfield Porter. What or who influences your use of color?

MK: I love color. But that is silly to say, since every artist must love color. Right now I am typing a list of every phrase using color in *Madame Bovary*. It feels like an important project. Maybe I will embroider the words onto fabric. Color is the essential expression of feeling. I spend a lot of time mixing colors and hoping to find the color that shows how I feel and see. Of course,

BETWEEN NOW and FIVE BILLION YEARS FROM NOW, SOMEONE WILL LOOK OUT OF THIS WINDOW.

MAIRA KALMAN, *Between Now and Five Billion Years*, 2007, gouache on paper

The pinky pink paté that totally wipes out the last vestige of malaise.

MAIRA KALMAN, *The Pinky Pink*, 2007, gouache on paper

MAIRA KALMAN, *A Large Stain*, 2005,
gouache on paper

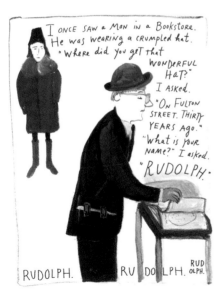

MAIRA KALMAN, *I Once Saw a Man*, 2007,
gouache on paper

there are the titans of influence: Matisse, Picasso, Cezanne, Van Gogh. Then there are the illustrator color influences: Ludwig Bemelmans, William Steig, Saul Steinberg.

JN: When you use colors—and maybe this applies in general to your whole process—do you find yourself making highly calculated decisions, or is it more instinctive?

MK: That is what is so wonderful about painting: You use your mind and your soul in equal measure. Sometimes one more than the other. But it is a fluid process that involves both.

JN: Is the handwriting in your drawings your regular, everyday handwriting?

MK: It is an exaggerated version of my normal writing.

JN: Handwriting is almost one of those proverbial lost arts.

MK: I weep for the lost penmanship art. But I don't like to look back. So, onward with whatever happens. I used to write with a Parker ballpoint pen, and the click of it when I clicked it open, the letters on the paper, filled me with calm and delight. That is how I view my writing. It is art to me. The typewriter is also wonderful, because you make a lot of unexpected delightful mistakes.

JN: How are painting and drawing different for you?

MK: Time plays a part. If you think something will take less time (like a line drawing)—perhaps the actual setting up is not so cumbersome—then there may be a

lighter feeling. I take my sketchbook with me wherever I go and do quick drawings. They are sometimes better than paintings I do. But having said that, a sense of lightness ideally will be in the paintings, too.

JN: Where do you usually work?

MK: I have a studio where I paint. It is a studio apartment with no phone, fax, food. No one ever comes there. Except for the dog. There is a chaise for the occasional nap interludes.

JN: Do you make extensive plans for your paintings before you do them?

MK: Everything is sketched some number of times. Then the final pencil is done before I paint. Then some changes are made while painting.

JN: Have you ever wanted to be just a writer?

MK: Before I began to draw, I was sure I was just a writer. But I don't think I am either now. I mean, I am both. No one knows what the future will bring, but I am very happy being able to do both.

JN: What about that relationship between text and image in your drawings—how would you characterize it?

MK: A family that lives together, for better or worse.

JN: How important is a sense of authenticity, or maybe I mean immediacy?

MK: There is something that happens with illustration that has a connection to speed. You think about things for shorter periods of time and comment on them in some way.

Themes repeat themselves and perhaps get deeper, or lighter, but there is a delight in the swoop of the moment. My handwriting is about making things simpler to produce. We do not need to set type. When I do set type, there is a reason for it and a pleasure in that as well. And the typewriter is right next to my pen and ink.

JN: Can you talk more about the "swoop of the moment"?

MK: Sometimes it is called being superficial or glib or flippant. And that happens sometimes. But as in all things, if you do it enough, sometimes you hit it happily right. We talk so much during the day; so many thoughts, sentences, ideas, stupidities tumble out all around us. It is hard to not to react to all that. Maybe reacting quickly is a tonic. It cleanses you, and you go on to the next thought with a fresh heart.

JN: Do you find yourself reacting more than you like to all the jabbering all around us?

MK: It is all a complete mystery to me. My moods change. Maybe an instinct takes over. In general, I have less patience for conversation. I really don't like to spend too much time talking to people. So how do I know what to respond to and how much? I like things that are funny, and have great pathos. And things that have air. Other than that, who knows?

JN: How would you describe the work in the apex show?

MK: I like to think of it all loosely in the bigger picture of narrative art. That is a term that makes me happy, and a lot of diverse art forms fit in that.

JN: What about narrative art makes you happy?

MK: If it is done well, a deep connection is made that gives you a sense of joy about being alive. It is not necessarily that the story depicted is happy. On the contrary, the story is often one of sadness and pain. But that is exactly what will resonate in the context of how we all cope with life. *Cope* is not a good word. *Live* life.

JN: Is your work autobiographical?

MK: It is all autobiographical. It is a narrative journal. I do have an imagination, but it springs from the world around me.

JN: Are there things that belong in art galleries that aren't there?

MK: Anything can be in an art gallery, of course. But do I want to see my work on the walls of someone's home? Not so much. I prefer the book.

JN: In *The Principles of Uncertainty*, you write about "the sexy Wittgenstein, who is thinking that ultimately what we say means nothing. Confusing, yet alluring. Somehow there may be more humor there." I think it relates to what we've been talking about. Could you say more about how there's "more humor there?"

MK: Maybe I am wrong, but he must have had some kind of humor. He was a hermit type, like Glenn Gould or J. D. Salinger. I don't think you can be that smart and not have a sense of humor.

"Sentence Fragment."

MAIRA KALMAN, *Sentence Fragment*, 2005, gouache on paper

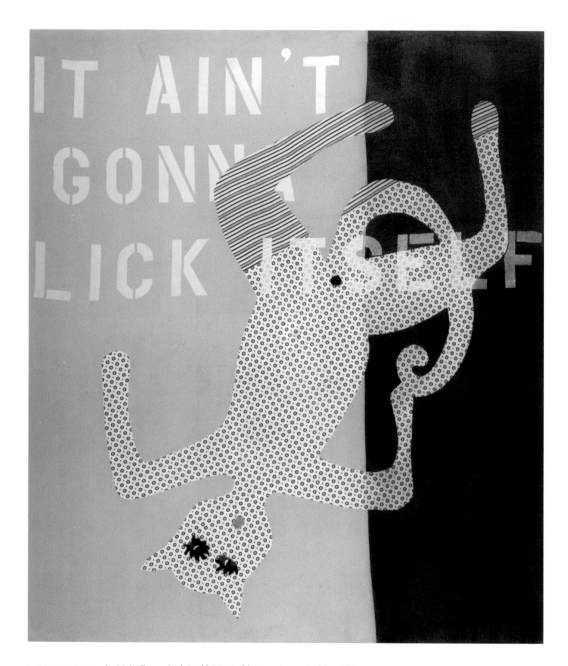

LARA SCHNITGER, *It Ain't Gonna Lick Itself*, 2005, fabric and wood, 66 × 56"

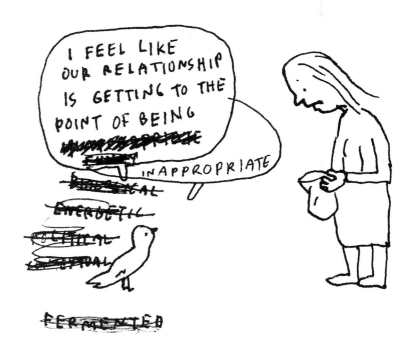

ANDERS NILSEN, untitled drawings from *Monologues for the Coming Plague*, 2004, ink on paper, 5 × 8"

BANKSY

188

Oh my God –
Thats exactly the same bowls we've got in the kitchen!

THIS ~~HERE~~ CHAIR LOOKS LIKE A LINE
DRAWING TO ME.

THANKS PAT.

THIS DRAWING WILL END UP IN
THIS BOX.

WE FOUND THIS CUBE IN THE TRASH.

JOEL HOLLAND, *This Chair Looks Like a Line Drawing To Me*; *Thanks Pat*; *This Drawing Will End Up In This Box*; and *We Found This Cube in The Trash*, 2007, ink on paper, 8 × 10"

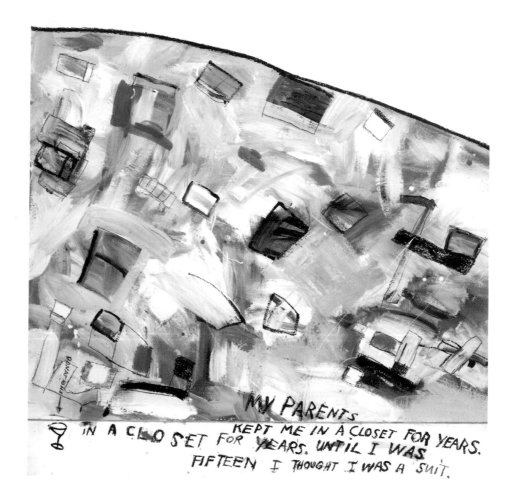

RICHARD PRINCE, *Untitled (abstract joke)*, 1992, acrylic and silkscreen on canvas, 62.25 × 48"

JASON POLAN, *I am so excited to be talking to you!*, 2008, ink on found newspaper, 4.5 × 5"

JASON POLAN, *The bulimic ½ empty glass*, 2006, pencil, photocopy, and ink wash on paper, 8.5 × 11"
STEVE POWERS, *Co-Defendant* (next page), 2006, enamel and spray paint on powdercoated steel, 24 × 24";
Puzzle Paradise (page 195), 2006, enamel on aluminum, 48 × 48"

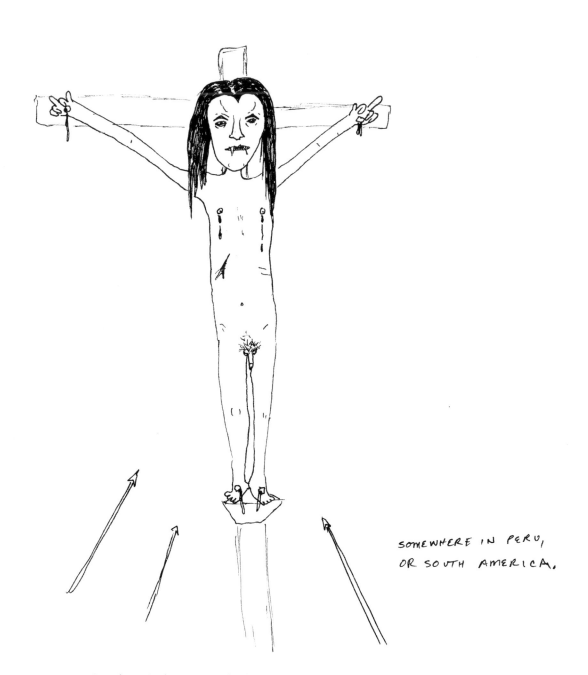

SOMEWHERE IN PERU,
OR SOUTH AMERICA.

LUIS CAMPOS, *Somewhere in South America*, 2004, ink on paper, 9 × 12"

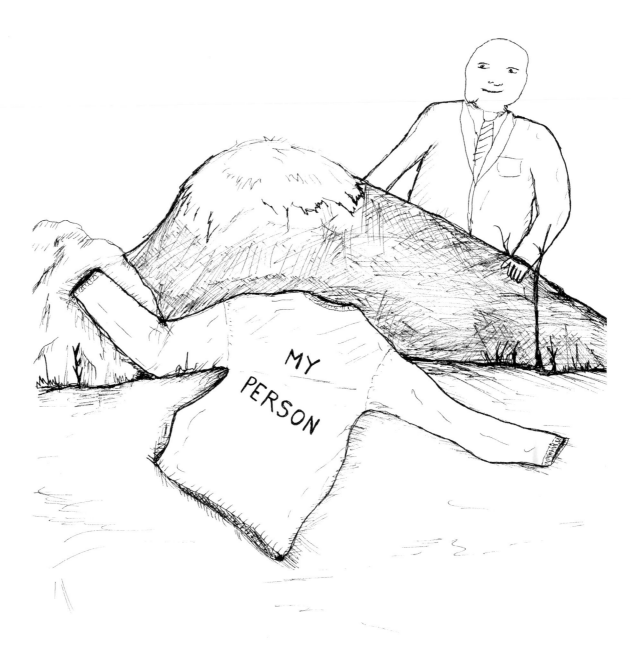

MY PERSON

LUIS CAMPOS, *My Person*, 2004, ink on paper, 9 × 12"

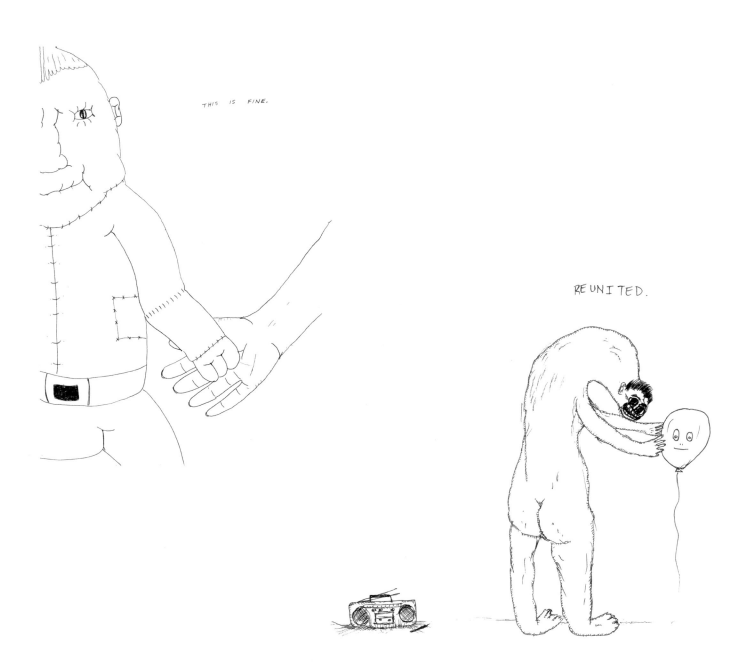

THIS IS FINE.

REUNITED.

LUIS CAMPOS, *This is Fine* and *Reunited*, 1994, ink on paper, 9 × 12"

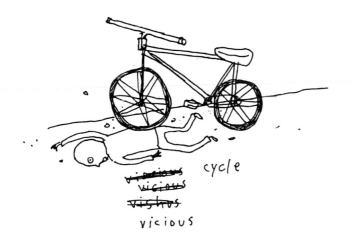

cycle

~~vicious~~
~~vicious~~
~~vishus~~
vicious

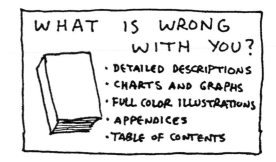

WHAT IS WRONG WITH YOU?
- DETAILED DESCRIPTIONS
- CHARTS AND GRAPHS
- FULL COLOR ILLUSTRATIONS
- APPENDICES
- TABLE OF CONTENTS

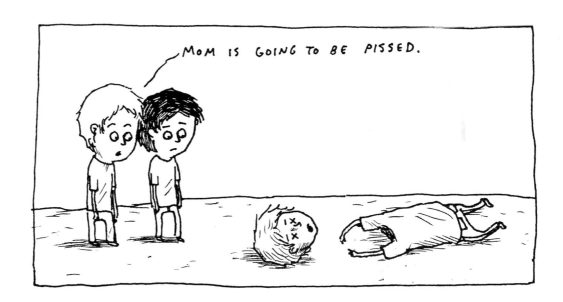

JEFFREY BROWN, *Vicious Cycle*; *What is Wrong With You?*; and *Mom is Going to Be Pissed*, 2002, ink on paper, 4 × 6"

PHILIP LARKIN, *Distressing Sartorial Affinities with Mr. W. B. Yeats*, ca. 1940–43, ink on paper, 5.8 × 4"

PHILIP LARKIN, *My dear, if that's the* civil service, *give me plain bad manners,* ca. 1940–43, pencil on paper, 8 × 5"

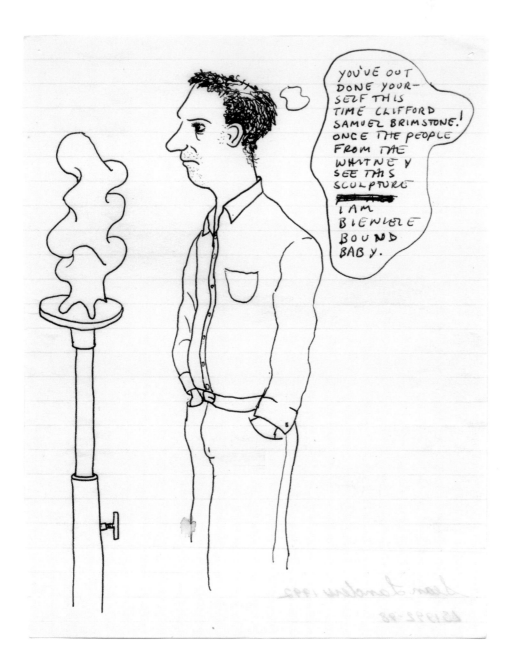

SEAN LANDERS, *Cartoon (I am Bieniele bound baby)*, 1992, ink on paper, 8.5 × 6.5"

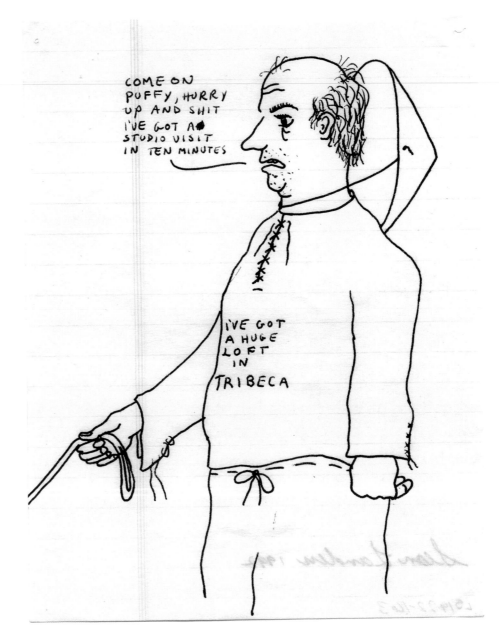

SEAN LANDERS, *Cartoon (I've got a huge loft in Tribeca)*, 1992, ink on paper, 6.75 × 5.25"

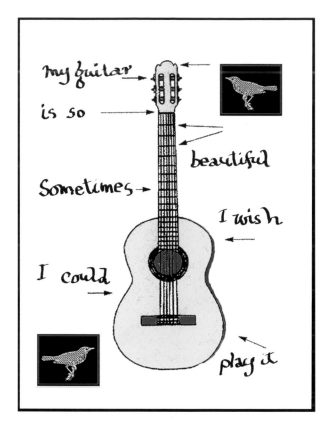

my guitar

is so

beautiful

Sometimes →

I wish ←

I could →

play it

"I draw to avoid working."
An interview with Leonard Cohen

Leonard Cohen was born in Montreal in 1934. His career as an artist began in 1956 with the publication of his first book of poetry, Let Us Compare Mythologies. *Cohen is the author of twelve books in all, and has made seventeen albums, of which the latest is* Dear Heather. *Cohen often draws on a Wacom digital tablet.*

JESSE NATHAN: What do you like to look at?

LEONARD COHEN: Skype.

JN: Have you always drawn?

LC: I draw to avoid working. So the answer is yes.

JN: What do you draw on?

LC: Luck. Maybe I'll have some.

JN: How—if at all—is making a drawing similar to making, say, a poem?

LC: I find that I sit down for both.

JN: Why do you draw?

LC: I like the gamble.

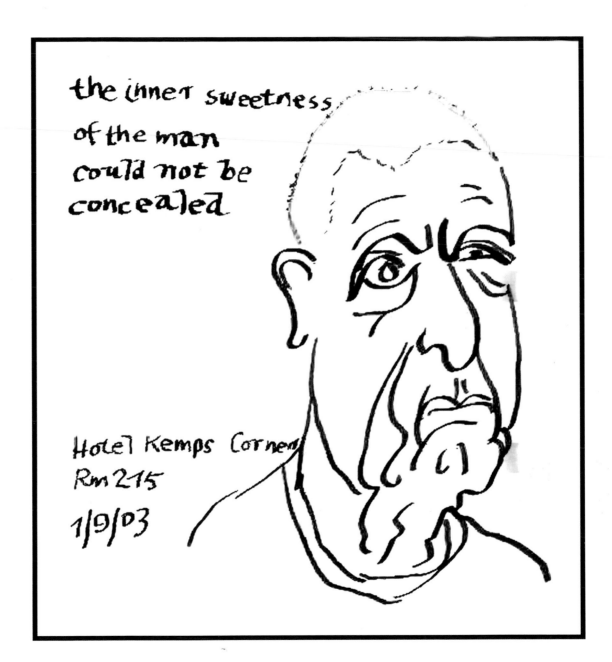

LEONARD COHEN, *Still Looking*, 2003, pigment ink print on paper, 12 × 15"

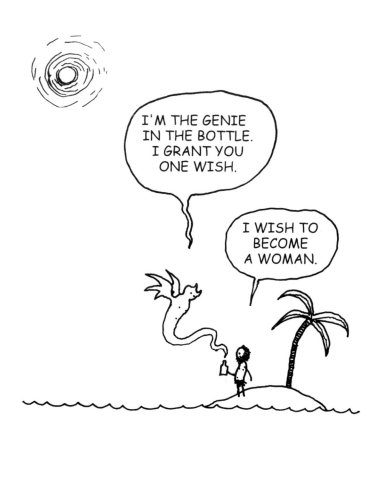

HUGLEIKUR DAGSSON, *One for Bridget; The wish*, 2004, ink on paper, 5.83 × 8.27"

A Beggar's Perspective. (The Eyes Have It.)

MATTHEW VESCOVO, *Beggar's Perspective. The Eyes Have It*, 2004, giclee print, 43 × 33"

People You Trust With Your Children. (The Revised List)

MATTHEW VESCOVO, *People you trust with your children. (The Revised List)*, 2004, giclee print, 46 × 22"

Customer Name:_____

MEATS:
____House Turkey
____Turkey
____Smkd Turkey
____Roast Beef
____Ham
____Pastrami
____Trky Pastrami
____Salami
____Corned Beef
____Other

Veggie/Salad:
____Avocado
____Tuna
____Chicken
____Egg
____Tofu Burger

CHEESE:
____Swiss
____Jarlsberg
____Mont.Jack
____Cheddar
____American
____Provolone
____Harvarti
____Dill Harvarti
____Pepper Jack
____Muenster
____Brie

Extras:
____Avocado
____Cranberry
____Pepperoncini
____Jalapeno Pepper
____Artichokes
____Salt
____Pepper

CONDIMENTS:
____Mayo
____Mustard
____Lettuce
____Tomato
____Pickle
____Onion
____Sprouts

ROLLS:
____Sour
____Seeded
____Sweet
____Dutch Crunch
____Onion
____Ciabatta
____Wheat
____Focaccia

BREADS:
____Sl. Sourdough
____Wheat
____Healthnut
____Oatnut
____White
____Light Rye
____Dark Rye

Additional Requests:

Clerk Initials:_____

BANKSY *(188–189)* is a graffiti artist whose work first appeared on the streets of England.

JEAN-MICHEL BASQUIAT *(10)* was born in 1960. His carefully orchestrated acts of graffiti first appeared in the late 1970s on the streets of SoHo. Basquiat's later paintings and drawings often recalled the commercial logos and street icons of his graffiti art. He died in 1988.

DAVID BERMAN's artwork, interview, and bio appear on pages 50–57.

JOE BRAINARD *(98–99)* spent much of his youth in Tulsa, Oklahoma. His collages and drawings have been shown at Tibor de Nagy Gallery, the Berkeley Art Museum, and many other places.

GEORGES BRAQUE *(8)*, was born in France in May 1882. He trained to be a house painter, as his father and grandfather had been, and studied art at night. In 1907 he met Pablo Picasso, and by 1908 the two were jointly experimenting with the geometries of objects. He painted prolifically until his death in 1963.

JEFFREY BROWN *(199)* was born and raised in Grand Rapids, Michigan. In 2008 he released *Little Things*, his first graphic memoir in several years. He has published nearly a dozen books.

DAVID BYRNE *(130–131)* is a musician, artist, and writer. He has published several books, including *Strange Ritual*, *The New Sins/Los Nuevos Pecados*, and *Arboretum*. He used to be in a band called Talking Heads.

LUIS CAMPOS *(196–198)* is thirty-four years old, works construction, and lives in Arden, North Carolina with his wife and daughter.

ENRIQUE CHAGOYA's artwork, interview, and bio appear on pages 86–91.

LEONARD COHEN's artwork, interview, and bio appear on pages 204–205.

R. CRUMB *(x)* lives in Southern France in a house bought with six notebooks of his work.

BRENT CUNNINGHAM *(138–139)* is a writer, publisher, and artist living in Oakland. His first book of poetry, *Bird & Forest*, appeared in 2005.

HUGLEIKUR DAGSSON *(206)* was born and raised in Iceland. He graduated from the Iceland Academy of the Arts in 2002 and has published various books of cartoons since. Three of them—*Should you be laughing at this?*, *Is this supposed to be funny?*, and *Is this some kind of joke?*—have been published in English.

SALVADOR DALÍ *(8)* collaborated with Luis Buñuel, Walt Disney, Man Ray, and many others. In 1934, Dali and his wife Gala attended a masquerade ball in New York dressed as the Lindbergh baby and his kidnapper. Dalí died in 1989.

HENRY DARGER *(15)*, a janitor in Chicago for most of his adult life, produced vast volumes of drawings and writings, all discovered after his death in 1973. There are only three known photographs of Darger, and his biography remains largely a mystery. Since the 1970s, his work has been exhibited around the world.

PAUL DAVIS *(156–157)* recently went to buy some cigarettes at his local shop. He was walking and then, next thing he knew, he woke up on a gurney being put in an ambulance, shouting, "What happened?" That's all he knows about it. The bruises were massive and they never caught the thugs. The next week was hilarious. Paul was invited to give a talk. You should have seen the consternation on the face of the immigration official at JFK when he looked at Paul's passport and then his face. "This looks nothing like you." "Yes, but I have a doctor's note—it's me, really." Paul is the drawings editor at *The Drawbridge*. He lives in Dalston, England.

NICCOLO DI TOMMASO *(12)* was an Italian painter and muralist. The dates of his birth and death are uncertain, but he worked in Florence from 1346 to 1376. He was also the architectural consultant for the cathedral of Florence.

MARCEL DUCHAMP *(8)* was born in 1887 and became famous for artworks that spoofed the pretentions of art and artists. He died in 1968.

MARCEL DZAMA *(82–83)* is from Winnipeg. He lives in New York City and is represented by the David Zwirner gallery.

CM EVANS *(136)* is a cartoonist, illustrator, and writer whose work has appeared in numerous publications. He is finishing *HOME*, his fourth book of poetry, stories, and illustrations.

SIMON EVANS *(ix, 30–31)* was born in London and works in Berlin. A former writer and pro skateboarder, Evans has been exhibiting work since 2003. His work usually involves diagrams, charts, maps, lexicons, diary entries, inventories, cosmologies, or epistolary entreaties.

PAUL FAASSEN *(154–155)* was born in the Netherlands in 1967. He works as an illustrator and art teacher. His new book, *Horizonvervuiling*, appeared in early 2009.

JEFF FISHER *(84–85)*, an Australian, lives in France. His work encompasses painting, book design, furniture, and illustration. He has recently tried to clean up his studio.

EDWARD GOREY *(110–111)* penned more than 100 titles, including *The Gashlycrumb Tinies* and *The Unstrung Harp*. He often used pseudonyms, such as Ogdred Weary, E. G. Deadworry, and Eduard Blutig. He died in 2000.

CHESTER GOULD *(2)* lived from 1900 to 1985. He was a cartoonist and the creator of the *Dick Tracy* comic strip, which he drew from 1931 to 1977. He loved colorful villains.

FRANCISCO JOSÉ DE GOYA Y LUCIENTES *(11)* lived from 1746 to 1828, working for much of that time as a painter and printmaker. He began as a court painter, but later drawings, like "Los Desastres de la Guerra" and "Los Caprichos," offer darker visions. He died in Bordeaux.

MUSA MCKIM GUSTON *(13)* studied at the Otis Art Institute in Los Angeles, where she met her husband, Philip Guston, and had an early career as a painter. She later turned to poetry. She died in 1992.

Born Philip Goldstein in 1913 in Montreal, PHILIP GUSTON *(13)* moved with his family to Los Angeles when he was a child. When Guston was ten, his father hanged himself and Philip found the body. Guston began painting at age fourteen, and in 1927 he enrolled in the Los Angeles Manual Arts High School, where he and Jackson Pollock studied under Frederick John de St. Vrain Schwankovsky. He died in 1980.

MATTHEA HARVEY *(34–35, 38)* is the author of three books of poetry. Her most recent, *Modern Life*, was a finalist for the 2008 National Book Critics Circle Award and a *New York Times* Notable Book of 2008. She teaches poetry at Sarah Lawrence College and lives in Brooklyn.

GEORGE HERRIMAN *(3)* lived from 1880 to 1940. He created the *Krazy Kat* comic strip.

JOEL HOLLAND *(190)* is an illustrator, pizza-maker, and former point guard. He lives in Brooklyn.

PAUL HORNSCHEMEIER *(115)* was born in Cincinnati in 1977. He began self-publishing his experimental comics series, *Sequential*, in college. His graphic novel is called *Mother, Come Home*.

JAY HOWELL *(174)* was born in Massachusetts and now lives and works in San Francisco. He produces a zine called *Punks Git Cut!* and runs the record label Mt.St.Mtn.

IAN HUEBERT *(116)* grew up in rural Nebraska and makes art in Berkeley, California. He is represented by Electric Works in San Francisco.

KENNETH KOCH *(120–123)* published eighteen volumes of poetry, including *A Possible World* and *The Art of Love*. Koch taught at Columbia for many years. He died in 2002.

TYMEK JEZIERSKI *(151)* was born in 1983. He lives and works in Warsaw. His drawings, illustrations, and cartoons appear regularly in Polish magazines.

CHRIS JOHANSON's artwork, interview, and bio appear on pages 58–65.

MAIRA KALMAN's artwork, interview, and bio appear on pages 178–185.

SEAN LANDERS *(202–203)* was born in Massachusetts in 1962. He lives and works in New York City.

PHILIP LARKIN *(200–201)* was a librarian at the University of Hull, in England, from 1955 until his death in 1985. He published critically acclaimed collections of poetry, including *The Whitsun Weddings*, *The Less Deceived*, and *High Windows*. Larkin declined the post of Poet Laureate later in life. He had a passion for jazz.

ROY LICHTENSTEIN *(2)*, along with Andy Warhol, made Pop Art famous. Appropriating images from comic books, he captured his subjects with hard edges and benday dots. He died in 1997.

JASON LOGAN's *(170–171)* work has appeared in galleries in Los Angeles, New York, and Dawson City. He is working on his third book.

JOHN LURIE *(132–135)* has been drawing and painting for over thirty years. Throughout the '80s and '90s, Lurie led The Lounge Lizards, a New York-based jazz group. His first painting exhibition opened in 2004 in New York. In 2006, P.S.1. Contemporary Arts Center staged a solo show. Lurie has published two art books: *Learn to Draw*, and *A Fine Example of Art*.

RENÉ MAGRITTE *(9)* reigned at the Royal Academy of Fine Arts in Brussels during World War I, coming under the influence of one of Belgium's leading abstract artists, Victor Servranckx. After his studies, Magritte did commercial work—illustrations, advertisements, window dressings, brochures—which he would later refer to as "idiotic work." He said of his art, "I have given my will to make the most familiar objects scream." He died in 1967.

DAVID MAMET *(153)*, born in 1947, is an author, essayist, playwright, screenwriter, film director, and draftsman. Mamet's work has landed him both Tony and Oscar nominations, as well as numerous other awards.

MAYA MILLER *(172)* left Maryland ten years ago to pursue art, music, and the study of politics in New York. She is an artist, a musician, and a designer of album covers, posters, and T-shirts.

QUENTON MILLER's artwork, interview, and bio appear on pages 66–71.

PETER MOORE *(214)*, a photographer, was born in London in 1932. He worked in the darkrooms of *Life* magazine and was an editor and columnist for *Modern Photography*. He died in 1993.

YOSHITOMO NARA *(173)* came to prominence in the 1990s during Japan's pop art movement. Situating big-eyed children in settings of hatred and boredom, his artwork critiques stringent social norms. He studied art in Japan and Germany, and now resides in Tokyo.

TUCKER NICHOLS's artwork, interview, and bio appear on pages 42–49.

ANDERS NILSEN *(187)* is the author and artist of graphic novels and comics including *Monologues for the Coming Plague* and the Ignatz award-winning *Don't Go Where I Can't Follow* and *Dogs and Water*. He lives with his wife and cat in Chicago.

HENRIK OLESEN *(14)* was born in 1967 in Esbjerg, Denmark. He lives and works in Berlin, and has shown his work all over Europe.

RON PADGETT *(16)*, a poet and a frequent collaborator with his good friend George Schneeman, has also worked with artists and writers including Jim Dine, Alex Katz, Ted Berrigan, and Joe Brainard. Padgett was born in 1942 and lives in New York City.

RAYMOND PETTIBON's artwork, interview, and bio appear on pages 20–29.

JASON POLAN *(192–193)* has exhibited work across the United States and Europe. He is a member of the 53rd Street Biological Society and the Taco Bell Drawing Club.

SIGMAR POLKE *(117)* was born in 1941 in Germany. He instigated the Capitalist Realism movement with Gerhard Richter. Polke works in various mediums, from screen printing to household materials such as glue. He lives in Cologne.

AMY JEAN PORTER's artwork, interview, and bio appear on pages 32–41.

STEVE POWERS *(194–195)* grew up in Philadelphia. After stints as publisher of *On the Go* magazine, writer of *The Art of Getting Over*, and fulltime graffitist, Powers began his studio practice in 1998. He has shown at the Institute of Contemporary Art in Philadelphia, Deitch Projects in New York, and the 49th Venice Biennale. As a 2008 Fulbright Fellow, he painted stories on walls in Dublin and Belfast.

RICHARD PRINCE *(191)* lives and works in upstate New York. His work is exhibited all over the world, including at the Guggenheim Museum and the Walker Art Center.

MAN RAY *(14)* was a photographer, painter, filmmaker, and draftsman. Born in Philadelphia to working-class immigrant parents, Ray lived in New York, Paris, Los Angeles, and then Paris again until his death in 1976.

STEPHANIE VON REISWITZ *(137)* lives in London. Her drawings and illustrations appear widely, including in *The Believer* and in books by Random House and Faber.

The ROYAL ART LODGE *(80–81)* collective was formed in March 1996, by Michael Dumontier, Marcel Dzama, Neil Farber, Drue Langlois, Jonathan Pylypchuk, and Adrian Williams. All were students of the University of Manitoba, in Winnipeg, Canada, and would meet once a week to make collaborative drawings. By 2003, only Michael, Marcel, and Neil remained, and their focus turned to small-scale collaborative painting. The Royal Art Lodge's retrospective exhibition, "Ask the Dust," toured in 2003.

ED RUSCHA *(16)* was born in Omaha, Nebraska. After graduating from the Chouinard Art Institute in 1960, he took a job at the Carson-Roberts Advertising Agency. He lives in Los Angeles.

PETER SAUL's artwork, interview, and bio appear on pages 140–147.

PETER SCHJELDAHL *(17)* is an art critic and poet. In the August 4, 2008 *New Yorker* he wrote, "Something is happening in artists' studios: a shift of emphasis, from surface to depth, and a shift of mood, from mania to melancholy, shrugging off the allures of the money-hypnotized market and the spectacle-bedizened biennials circuit." He has held posts as a critic

at the *Village Voice*, *Art in America*, and the *New Yorker*.

OLGA SCHOLTEN's artwork, interview, and bio appear on pages 124–129.

LARA SCHNITGER *(186)* was born in the Netherlands and studied art in The Hague, Prague, Amsterdam, and Japan. Her work has been exhibited in London, New York, and Paris.

SENGAI *(11)* was a Zen Buddhist monk from Japan who lived from 1750 to 1837. *The Universe* is one of his most famous paintings, consisting of a square, a circle, and a triangle.

GEORGE SCHNEEMAN *(16–17)* was born in St. Paul in 1934. In 2004, his collaborative work was exhibited at the Tibor de Nagy Gallery in New York, and appeared in a book called *Painter Among Poets*. He died in 2009.

LEANNE SHAPTON's artwork, interview, and bio appear on pages 72–79.

TAMARA SHOPSIN *(175)* is a cook, designer, and illustrator. She splits her time between New York and Scranton, Pennsylvania.

DAVID SHRIGLEY's artwork, interview, and bio appear on pages 100-109.

SHEL SILVERSTEIN *(112–114)* wrote *The Giving Tree*, *Where the Sidewalk Ends*, *A Light in the Attic*, and many other books of prose and poetry. He also wrote songs, penned cartoons, and had a good time. He died in Florida in 1999.

NEDKO SOLAKOV's artwork, interview, and bio appear on pages 160–169.

ART SPIEGELMAN's *(ix)* parents wanted him to be a dentist. Born in Stockholm, he immigrated to the United States as a small child and began

drawing professionally at age sixteen. His two-part graphic novel, *Maus*, won a Pulitzer.

RALPH STEADMAN's *(96–97)* drawings have appeared in *Punch*, the *New York Times*, and *Rolling Stone*. He illustrated Hunter Thompson's *Fear and Loathing in Las Vegas* and *On the Campaign Trail of '72*.

WILLIAM STEIG *(18)* was twenty-two when his first drawings were published in the *New Yorker*. "They were," writes Lillian Ross, "what are ordinarily called cartoons but what the people around the *New Yorker*, for some reason or another, call comic art. From the beginning, Steig's drawings, as a matter of fact, were comic and were art." Steig is also known for his children's books. He was ninety-five when he died in 2003.

SAUL STEINBERG *(18)*, a Romanian escapee from wartime Italy, arrived in the U.S. in 1942 after the *New Yorker* received some of his drawings and decided to sponsor his entry. He drew eighty-nine covers for the magazine, and his cartoons, features, and illustrations were a defining presence there. Steinberg died in 1999.

BEN VAUTIER *(5)* was born in Naples in 1935. He lives and works in Nice, and has made many text-based paintings.

MATTHEW VESCOVO *(207–208)* began as an art director in advertising. He created Instructoart, which has been shown in galleries, published in Instructoart books, and animated for MTV.

KURT VONNEGUT *(152)*, born in 1922 in Indiana, is best known as a prolific and witty novelist. His biting satire and genre-bending experiments in prose—in books including *Slaughterhouse Five* and *Breakfast of Champions*—changed literature. Vonnegut died in 2007.

KARA WALKER *(xi)* became the youngest recipient of a MacArthur Fellowship in 1997. She was 27 years old. She teaches at Columbia University, and her work is shown worldwide.

POROUS WALKER *(148–150)* was brought to life by Jimmy DiMarcellis in 2000 after a strange encounter with the ghost of Shel Silverstein. Living on a Navy lifeboat converted into a houseboat and docked in Sausalito, California, Jimmy was visited by Shel's ghost, who gave him a few tips. "It wasn't a dream," he insists, "because I was in the shower crying when he came and visited me."

CHRIS WARE *(x)* is the creator of *The Acme Novelty Library* and *Jimmy Corrigan, the Smartest Kid on Earth*. He plays the piano and banjo, and he lives in Illinois.

Better known as ANDY WARHOL *(9)*, Andrew Warhola was born in 1928, in Pittsburgh. He started out as a commercial illustrator, but eventually tried his hand at filmmaking, painting, record production, and writing. He died in 1987.

WILLIAM WEGMAN *(94–95)* is a Massachusetts photographer with a penchant for Weimaraners. His own Weimaraners, Man and Fay Ray, have been the subjects of many of his photographs and videos, as well as guest stars on *Sesame Street*. His work has been featured at the Los Angeles County Museum of Art and the Smithsonian American Art Museum.

ANDREW JEFFREY WRIGHT *(176–177)* was fired from Kentucky Fried Chicken in tenth grade. Later, he earned a B.F.A. in animation. *The Manipulators*, a short film he made with Clare E. Rojas, won the top prize for animation at the New York Underground Film Festival.

EXHIBIT THANK YOU

Steve Mockus and Brooke Johnson at Chronicle Books, Brian McMullen for his general excellence, Stephanie Long for her wizardry and diligence at the scanner, Britta Ameel and Apollinaire Scherr for copyediting the book, Steven Rand, Kerri Schlottman, and the staff at apexart, Jordan Bass, Andrew Leland, Eliana Stein, Chris Ying, Heidi Meredith, Angela Petrella, Barb Bersche, Darren Franich, Greg Larson, Laura Howard, Mimi Lok, Eli Horowitz, Richard and Noah Lang at Electric Works Gallery, Amanda Guccione and Margaret Senk at Artists Rights Society, Molly Cain and everyone at Distributed Art Publishers, the Berkeley Public Library, the San Francisco Public Library, Andrew Pierce and the librarians of San Francisco Museum of Modern Art's Contemporary Art Library, Ann Zerger, Todd Zuniga, Jared Hawkley, Jack Hanley, Patrick Ford, Galleri Nicolai Wallner, Pace/MacGill Gallery, Marianne Boesky Gallery, Pest Control Office, Pamela Caserta and the Walker Art Center, Ellie Bronson, Ron Padgett, Megan Rickel, John O'Conner, Daelyn Short, Kari Morris, Lora Fountain, Eric Brown, the taxi driver in Newark, Jeanne Steig, Jeremy Lawson, Rene Reyes, Andrea Rosen Gallery, Eric Reynolds and Fantagraphics Books, Regen Projects, Stacy Bengtson, Michael Clifton, Anton Kern Gallery, Kristina Ernst, Gallery Paule Anglim, ZicherSmith Gallery, Michael Werner Gallery, David Zwirner Gallery, McKee Gallery, Daagya Dick, Cassie Marketos, Tess Thackara, Hansjorg Mayer, Max Garland, Tom King, Julie Brown, Rick Meyerowitz, Michael Zelenko, Josef Reyes, Peter Buchanan–Smith, Lisa Pearson, Lida Sunderland, MoMA, The Berkeley Art Museum, Andrew Edlin Gallery, Michael Petit, Mt. Saint Mountain, J.X. Williams, Shelley Lee, Bettina Utz, Angela Feguson, The Roy Lichtenstein Foundation, Brea Souders, Katherine Chan and the David Nolan Gallery, Harold Gefsky, Bridgett Finn, Mary Dean, Barbara Krakow Gallery, Howard Junker, Karen Koch, Alice Notley, Mitch Myers, Michael Carr, Ruiko Tokunaga, David Billing, Pam Susemiehl, Sarah Fritchey, Lisa Kim, Jason Kaufman, Oriana Leckert, Kristin Rieber, R. Andrew Boose and the Edward Gorey Charitable Trust, Andreas Brown, Ariel Dill, Elisabeth Ivers, Fred Sasaki, Francine Nisly, James Orwin, Jean Hartley, Jeremy Crow, Lisa Dowdeswell, Sarah Lannan, Gretchen Wagner, Paula Mazzota, Maya Stendahl Gallery, Michelle Marton, Danielle Spencer, Elyse Marshall, Birna Anna Bjornsdottir, Suzanne Deitch, Casey Spooner, Tanya Brodsky, Angela Westwater, Jamie Alexander, Francoise Mouly, Holly Cushing, Jason Duval, Andrea Fryrear, Jonas Herbsman, Yoko Ono, Rudolf Frieling, Kyle O'Loughlin, New Lab, Jorge Pinto and Jorge Pinto Books, The Pub, Quimby's, Pegasus, Moe's, Park Life, and Printed Matter.

Return this Statement for Correction in Case of Error

..192

M **BIBLIOGRAPHY (PARTIAL)**

No. ...St.

To ...Dr.

Brin, David. Will Technology Force Us to Choose Between Privacy and Freedom?

Kendris, Christopher. 501 Spanish Verbs

Koeppel, Dan. Banana: The Fate of the Fruit that Changed the World

Shatner, William. How William Shatner Changed the World

Ovenden, Mark. Transit Maps of the World

Lutwack, Leonard. Birds in Literature

Weiss, Joseph. Business Ethics

Kant, Immanuel. Critique of Pure Reason